Situating Design in Alberta

Situating
DESIGN
in Alberta

Isabel Prochner &
Tim Antoniuk, Editors

Douglas J. Cardinal,
Foreword

 UNIVERSITY *of* **ALBERTA** PRESS

Published by

University of Alberta Press
1–16 Rutherford Library South
11204 89 Avenue NW
Edmonton, Alberta, Canada T6G 2J4
Amiskwacîwâskahican | Treaty 6 | Métis Territory
uap.ualberta.ca

LIBRARY AND ARCHIVES CANADA
CATALOGUING IN PUBLICATION

Title: Situating design in Alberta / Isabel
 Prochner & Tim Antoniuk, editors ;
 Douglas J. Cardinal, foreword.
Names: Prochner, Isabel, editor. | Antoniuk, Tim,
 editor.
Description: Includes bibliographical references
 and index.
Identifiers: Canadiana (print) 20210312688 |
 Canadiana (ebook) 20210312734 |
 ISBN 9781772125788 (softcover) |
 ISBN 9781772125979 (PDF)
Subjects: LCSH: Design—Alberta.
Classification: LCC NK1413.A3 S58 2021 |
 DDC 745.4097123—dc23

First edition, first printing, 2022.
First printed and bound in Canada by Friesens,
 Altona, Manitoba.
Copyediting and proofreading by
 Angela Wingfield.
Indexing by Adrian Mather.

University of Alberta Press gratefully
acknowledges the support received for its
publishing program from the Government of
Canada, the Canada Council for the Arts, and
the Government of Alberta through the Alberta
Media Fund.

This book has been published with the help
of a grant from the Canadian Federation for
the Humanities and Social Sciences, through
the Awards to Scholarly Publications Program,
using funds provided by the Social Sciences and
Humanities Research Council of Canada.

To the Alberta design community

Contents

Foreword

TO ME, the greatest natural resource in Alberta is its diverse people. I have experienced that all who live in Alberta have very strong and separate world views and cultures. I have seen that they all have very independent voices, which, coming together, create unique and creative solutions to serve their constituents and their communities. This resolve, and way of being, started even before Canada was a nation.

The first settlers came from the east. As part of the colonization of the land and its original peoples, the settlers required that the Indigenous Peoples give up their ceremonies, their culture, their spirituality, and their way of life. The spiritual leaders of the east were forced to take extreme measures to preserve *their* ancient knowledge. They packed all their ceremonial objects and spiritual culture in sacred bundles and decided to transfer their deep wisdom and customs to the Indigenous Peoples of the west. There was a prophecy and a deep understanding among the Anishinaabe[1] that the peoples of the west had to preserve the culture, ceremonies, sacred objects, and the knowledge of the elders of the east. Indeed, some of the elders themselves had to be transferred to the west for survival and safekeeping, establishing themselves particularly in Alberta and Saskatchewan.

There was also another transfer of knowledge. The expansion of the United States dictated the American takeover of the Indigenous Peoples' lands. A similar process endured when elders from the southern Indigenous territories of the United States were forced to move north and transfer their wisdom. Through this process the people of the prairies inherited Indigenous knowledge, wisdom, artifacts, and tremendously powerful Indigenous leaders. These traditions enriched the original culture of the peoples of Alberta and

made it even more powerful. This is what I was told by our Siksikaitsitapi (Blackfoot) grandmother and Kainai (Goodstriker) family members, as well as other Anishinaabe elders in the west and the east.

When the settlers came, they started to homestead the land. Families who had fled the tyranny of despots in Europe, they were fiercely independent. They were driven to prosper by preserving their independence and their religious beliefs through hard work and sacrifice. My German grandfather was one of them. Families from England and Ireland and particularly from Ukraine, Germany, Poland, and other northern, eastern, and southern European countries settled in Alberta next to the very strong and independent Indigenous nations. Since they all shared the same land and resources, they had to be highly innovative in coming up with new solutions for working together. My own parents materialized that new relationship, and I myself was raised in a world of new possibilities.

As a result of that diversity, the people of Alberta had to become more flexible, more purposeful, more creative, and more open to accept new ideas and new solutions. They created new ways of governance, new ways of solving problems, new economic models, and new institutions with diverse people administrating them. These innovations were forged quite independently from the rest of Canada. The diversity created in Alberta is not their weakness; it is precisely their strength.

Indeed, out of this diversity a pool of resources materialized; the people involved encouraged, accepted, and embraced ingenuous new solutions in the public and private sectors. New political parties such as the Social Credit and the Co-operative Commonwealth Foundation, and different platforms of the Conservative Party, emerged in Alberta. Even the New Democratic Party came from the spirit of community solidarity that was so necessary in the prairies of Saskatchewan and Alberta. The political groups of Indigenous Peoples also created their own organizations to represent themselves, such as the Indian Association of Alberta, the Métis Association of Alberta, and the National Indian Brotherhood (now the Assembly of First Nations). It was this environment that inspired me to take individual responsibility for developing my unique approach to the profession of architecture. It was a

place where I could acknowledge, express, and share my deep connection to the land and my own heritage, particularly because of my roots in both the settler and the Indigenous cultures. It was Alberta's unique diversity and vitality that encouraged me to develop my own individual approach to my profession.

I owe much to the people of Alberta. Innovative, forward-thinking peoples invested in my creative philosophy and helped me establish the foundation of my whole celebrated approach to architecture. It is the people of Alberta who have inspired my own resolve to strive for excellence and to design sustainable built environments that work harmoniously with Nature and our own human nature. It is these individuals who have propelled my ardent service to Alberta, Canada, the United States, and internationally. This legacy was based on the creative environment that nurtured, fostered, and helped me to develop as an architect of international renown. Indeed, I see the people of Alberta themselves as the best natural resource the province has to offer. This book, *Situating Design in Alberta*, eloquently edited by Isabel Prochner and Tim Antoniuk, precisely shows that. In my experience, Alberta is a very fertile land for design and creativity.

Douglas J. Cardinal, OC, PHD (*honoris causa*)
Ottawa, October 15, 2020

Note

1. The Anishinaabe is the largest group of culturally related Indigenous Peoples based on Anishinaabe languages or the Algonquian language family. Meaning "the good humans," it defines living the good path in a good way, engaging a spirituality of reciprocal relationship between all peoples and with the natural environment. The diverse cultures span Canada and the United States from the Atlantic (Mi'kmaq) through the Subarctic and central Canada (Cree, Algonquin, Oji-Cree, Ojibwa), to the prairies up to the Rocky Mountains, and south of the border (Prairie Cree, Blackfoot, Arapaho), to mention a few.

Acknowledgements

THIS ANTHOLOGY would not be possible without the efforts of all the contributing authors and designers, whose hard work and enthusiasm throughout the project testify to their passion and dedication to design in Alberta.

We are also grateful to our colleagues at the University of Alberta, Université de Montréal, Syracuse University, and Concordia University for their support, helpful advice, and smart questions that pushed this project to its fullest potential. Isabel Prochner thanks especially Denyse Roy and Christopher Moore, as well as Leslie Prpich and Natalia Rice, for their help during the editing process. She also thanks the Social Sciences and Humanities Research Council of Canada, which supported her research and groundwork for this anthology.

Lastly, we express our deepest appreciation to our family and friends. Isabel thanks Danny Godin, Larry Prochner, and Barbara McPherson for their encouragement. Tim Antoniuk thanks his wife and three children for their endless support, patience, and inspiration, which drive him to envision more sustainable futures.

This layout represents my view of what it means to situate design in Alberta. I see this process as an infinite and ongoing task of construction, refinement, and boundary crossing. Design and its visual language have power, reach, and universality that can blur boundaries and bring cultures closer together. For instance, design in Alberta is unique in its individual and localized expressions—specific to the province of Alberta—but it is also universal, given its ties to the roots of design disciplines. Design in Alberta has much to offer to the world, extending its ideas to other countries and their design communities, companies, and institutions. Where there is much to offer, however, there is also much to learn. One way would be to take the best design theories and practices from abroad and integrate them at home in Alberta, while we share our approaches, methods, aesthetics, and ideas with others around the world.

MARIA GONCHAROVA

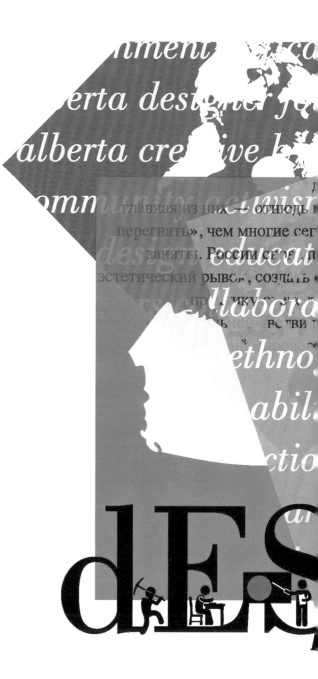

Introduction

nalysis ... *tion*

ers start up revolution e

ity education meets cultu

масса проблем, но
ловутое «догнать и
ольно или невольно
ит сделать идейно -
енную идеологию и
о дизайна — новой
ьного ствола идей и
перского процесса.

ve outlier ins

designers ea

esign slow a

inable desig

exp ... *sions teachi*

con ... *ity incorpo*

ictu ... *ldings for*

or ... *ic shift o*

Introduction

DESIGN IN ALBERTA is hard to grasp. On the one hand, there are many innovative local designers, design theorists, and educators and ever-increasing recognition and value of Alberta's creative industries. At the same time, however, local designers can struggle to establish their place and careers. As an example, Chris Chevalier, an architecture student, was quoted as saying, "I want [Edmonton] to be my first choice [in which to practise design], but we'll see. Depends how much of a martyr I want to be."[1] Further to this, there has been disregard of or an often careless and ambivalent attitude toward design throughout much of Alberta's recent history. Many buildings and neighbourhoods have been constructed with little attention to design detail, well-being, inclusivity, and aesthetic pleasure. Indeed, it is hard to forget the infamous declaration by urban affairs critic James Howard Kunstler that Calgary's suburbs are the "North American tragedy in microcosm."[2]

This paradox prompts the questions of how local designers can find their place, what stumbling blocks are in their way, and what the future direction of design in Alberta might be. The anthology is a step toward answering these questions and bringing attention to the tensions, by situating design in Alberta.

The word *situating* used here and in the title draws on its common definition: to locate or position. The book locates and identifies design in Alberta—local design work, local professionals, local specializations, local approaches to design education, and so forth. It also positions these topics in an Alberta context, considering social, cultural, historical, physical, geographic, and economic factors.

The task of situating applies as well to broader discussions, which include such topics as the creative economy, design for sustainability, and universal design. Authors explore how these big ideas apply in Alberta and how local applications can inform general understandings of these topics.

This is a unique exploration; there are few surveys of design in Alberta, let alone analyses of local design work. The focus of the book, as one of the first publications on the subject, is necessarily broad. It provides a lay of the land to characterize design in Alberta and to highlight important issues for the local design community and for local arts, culture, industry, and planning.

The word *situating* also hints at the concept of situated knowledge, often employed in socially engaged and critical writing. *Situated knowledge* refers to understandings informed by context: personal experience, culture, and geographic location, for example. Contributors to the book have strong Alberta connections and write from their perspectives as local designers, researchers, educators, and design students. This range of experience helps anchor discussions on topics of local interest and relevance and includes reflections on local culture, studies of successful (and less successful) companies, critiques of design training, calls to action, and visions of future practice.

The situated focus provides an important counterpoint to large, generalized, and globalized conceptions of design and its practice, education, and research. In the context of globalization, the "grobalization" or growth and spread of mass culture is countered by the re-embedding and emphasizing of local or "glocal" identity.[3] This book contributes local perspectives to these broader discussions and is part of the movement to "glocalize" design work. Individual chapters also introduce perspectives toward local-global connections, and authors debate the extent to which local designers can and should engage with global networks.

Local creative culture and the diversity of products, services, and experiences that designers co-develop are becoming increasingly valuable assets as globalization brings about the growth and spread of mass and highly segmented consumer culture. Celebrating and investing in regional arts

and design not only creates economy but also helps create industries and a stronger sense of place and well-being.

Overall, the book explores the unique local contexts—social, cultural, historical, physical, political, and economic—of Alberta design and the resulting strengths, challenges, and opportunities. Our aim is for this study to inform the local design community, highlight their voices and experiences, bring value to their work, and set the stage for a successful future. We also hope that it creates new dialogue about the ever-increasing importance of design in our province and the lessons that Alberta design can offer to broader design communities.

Situating Design in Alberta was written for local designers and design students to inform their practice, but it also has broader relevance and applications. As one of the first collections of Alberta design research and writing, it will inform design scholars and educators looking for writing on this specialized topic. We hope that members of the broader Alberta community and those working in policy, government, and industry will also find it useful. It is an overview of an important industry that has an impact on Alberta culture, cities, landscapes, community, well-being, and prosperity. Design affects the way we see ourselves and how others view Alberta. This inward and outward role emphasizes the importance of this topic and serious discussions about design work in Alberta.

The anthology will guide understanding of design in Alberta and hopefully inspire interest, engagement, appreciation, and support for design work. Individual chapters introduce histories of iconic buildings and artifacts, the current and potential economic impact of design, and possibilities for industry collaboration.

Outside the province the book contributes to understandings of Canadian design and is part of these broader discussions. We see relevance to Canadian historians, design scholars, and design aficionados, and for the planning of national policies and programs for creative industries. This anthology is also part of global dialogue on design and can serve as a regional case study within the global landscape. It can offer a comparison of models of practice, education, or industry relationships in the context of

Alberta's location, economy, or social landscape. This could be especially relevant for regions with similar design contexts (e.g., a remote location, small population, or fluctuating economy).

Although there are plenty of examples of local design work, it would be reasonable to say that Canada is not a widely recognized design centre. This is even more the case for Alberta, which is at the periphery of Canadian design industries. Despite the strength of its creative industries in the global economy, Canada lags behind. As Tim Antoniuk explains in his chapter "Expanding the Creative Economy in Alberta: Creative Hybridity from Small Producers," Canada is behind other developed nations in the growth of creative exports and has had negative export growth of creative goods and services in recent years.

Further, a 2015 thematic issue of the *Canadian Art Review* (RACAR), which focused on design studies in Canada, stressed that design studies was a nascent field and was even more so in Canada. The relative shortage and diversity of design studies is exponentially worse in Alberta; it is a little-explored issue in a region not typically associated with design and in a country that is sometimes on the edges of these rapidly evolving fields.

Design in Alberta is an outlier in many senses. This term is used by Tyler Vreeling in his chapter "From the North: Perspective of an Outlier" and is a fitting description of local design. It could refer to Alberta design practice within Canada or in the global landscape, as well as to designers who do not always see themselves in broader design communities, as was also Vreeling's experience.

While there is value in situating design in Canada, a regional focus on Alberta is especially relevant. As the report *Shaping Canada's Future by Design* explained, "[t]he sheer size of Canada means that Canadian designers are geographically dispersed across the country...The strength of the design sector will come from the abilities of designers in various regions to take advantage of local opportunities."[4] A one-size-fits-all solution is not necessarily appropriate or desirable in this country.

Part of building a better understanding of Canadian design involves exploring design work in the country's various regions, which is a

recognized limitation of existing Canadian design studies. In his editorial introduction to the RACAR thematic issue, Bresnahan noted that Canadian design studies often focused on mid-century design and work in Ontario and Quebec and was missing an understanding of other design histories and contexts.[5]

This book helps establish a better understanding of Alberta design in particular. The regional focus can inform local design communities by providing models of success and showing the value and place of local work in a global context. The celebration of new local thinking and action can also be empowering to designers by encouraging their own innovations. This is particularly important for designers who may not see themselves or their ideas in larger arenas.

Situating Design in Alberta aligns with contemporary initiatives in fields like design history and design studies to better represent design from different locations around the world. Many efforts are being made to re-embed and emphasize regional arts and design industries and their unique approaches.

This anthology takes a broad view of design and brings together the voices of local design professionals and design researchers from a variety of fields, ranging from visual communication design, to industrial design, to architecture, to service and experience design. This provides a broad and complex perspective on local design practice, exploring more and less common areas of specialization. It helps unite a discussion on Alberta design disciplines and highlight similarities and differences between fields.

It was important for us to include different narratives and experiences. Tone and writing style change between chapters, and this reflects each author's voice. The approach to writing, the methods, the inclusion of design theory or academic research, and the approach to analysis also depend on the writer's perspective and background. We invited practising designers to write about their work, and design researchers to present academic projects. Authors had the option of providing a full-length paper or shorter personal narratives or editorials.

Of course, there are omissions, and we recognize that certain topics are given more attention than others. Chapters focus on professional forms of design work, rather than on non-professional, informal, or interdisciplinary applications. Discussions on fashion design, game design, and UI/UX design are minimal or omitted. These and other topics should be explored in future projects, and hopefully this book will provide a foundation for such conversations. Authors work in different fields and across the province and have diverse lived experiences. That said, the voices included in this anthology are somewhat limited. This collection represents an often Western and colonial perspective toward Alberta design and local histories. While some authors address this issue through their writing and examples, it is a shortcoming that must be addressed in subsequent conversations and inform the structure of discussions moving forward.

The chapters are broken into four sections. The first section, "Past, Present, and Future Innovation in Alberta," explores the history and emergence of local design industries, the current realities, and the opportunities for the future. The second section, "Education Meets Culture and Community," focuses on local design education and its social and professional contexts. The third section, "The Creative Economy and Design Work in Alberta," explores local design practice and the systems where it operates. Finally, the last section, "Sustainable Design Practices in, for, and from Alberta," centres on design for sustainability, especially environmental and social dimensions and inclusive design. However, there are no strict divisions between sections and chapters, and many authors address several topics at once.

The many perspectives on design in Alberta offer a relatively comprehensive view of local design, a range of situated knowledge, and an understanding of the similarities and differences within and between local design fields. In order to bring attention to these broader insights, each section begins with an illustration that has been prepared by a local visual communication designer in response to the section's content.

Maria Goncharova created the illustration for this introduction, which represents boundary crossing and the ongoing development of design

industries worldwide. Goncharova is a multitalented designer and educator with expertise in sustainability and participatory practices.

The first section, "Past, Present, and Future Innovation in Alberta," provides an overview of design in Alberta that touches on its history, current practices, and promising future directions. Andrea Hirji, a graphic designer at West Canadian Imaging in Calgary, created the illustration, which represents the Alberta landscape and a history of local urban growth.

This section's first chapter, "Reset: Changing the Built Environment in Alberta," is written by Barry Johns, a celebrated Edmonton architect who has held positions at the Royal Architectural Institute of Canada and the Alberta Association of Architects. He explores a history of architecture and urban design in Alberta, in particular the relationship between design and place. Alberta has a striking natural landscape, and early regional design responded to this environment through, for example, the use of local materials. Over the years, architects who trained abroad introduced global design styles and ideas to the province.

Johns explains that cycles of boom and bust encouraged fast and often unreflective development, followed by periods of stagnation. This resulted in sprawling cities without a unique character or a strong downtown core. In his conclusion Johns encourages designers to give greater consideration to place in their work. This would enrich local design and create more sustainable cities.

Johns also introduces the idea of prairie character, which has been built on hard work and independence. In his view this has traditionally worked against the development of a strong art and design community through lack of interest and a lack of respect for architectural heritage. Isabel Prochner and Lyubava Kroll also hint at this issue but note that population growth and diversification, seen especially during boom periods, are associated with greater support for creative industries.

Prochner and Kroll collaborated on the next chapter, "Visualizing Industrial Design and Its History in Alberta." Prochner prepared the text, while Kroll developed an illustration of its key points. Prochner is a design researcher with expertise in socially and community-oriented industrial

design practice. After having lived and worked in Alberta and Quebec, she is now an assistant professor in the School of Design at Syracuse University in the United States. Kroll is a visual communication designer, illustrator, and researcher now overseeing branding at the United Nations Global Compact.

Their chapter explores a history of industrial design practice in Alberta, focusing on its development, orientations, strengths, and challenges. Although the development of industrial design takes place in the same provincial context as that of the architecture and urban design discussed in Johns's chapter, the industrial design industry appears to be weaker and more vulnerable. Industrial design has less direct local applications and supporting conditions in the province. Prochner explains that there have never been many industrial design jobs. Traditionally, those that exist have aligned with the oil and gas industry, office furniture design, and studio-manufacturing practices.

The industrial design industry emerged slightly later than architecture and urban design. As in other design fields, an economic boom and the broader emergence of Canadian design supported its development. However, a government economic diversification program and design education also played key roles. As the industry moves forward, Prochner and Kroll recommend building on its areas of strength, while remaining mindful of its realistic limits.

The second section, "Education Meets Culture and Community," provides further background for design in Alberta through discussions on design education, a major driver for the industries. Skye Oleson-Cormack represents a designer's tool kit—including education, networking, technology, and sustainability knowledge—in her illustration. Oleson-Cormack is a local designer, illustrator, and photographer.

In the section's first chapter, "An Inside-Outside View into Design Education in Alberta," Megan Strickfaden provides a broad and contextualized overview of design education. Strickfaden is a design anthropologist and professor in the Department of Human Ecology at the University of Alberta (UAlberta). Her chapter provides a thorough discussion of design

education and its application in Alberta. She introduces typical approaches to curriculum development and explains how values are anchored in each education program.

Strickfaden's recommendations for the future development of design education in Alberta mirror Prochner and Kroll's suggestions for design practice. Both chapters suggest enhancing communication within and between design communities, fostering stronger connections between design and industry, and better communicating the value of design for industry. Finally, Strickfaden hints at the potential for locally trained designers to work internationally. This idea is taken up in subsequent chapters by Tim Antoniuk and Ken Bautista where both note the potential of local designers to apply their skills to a global creative community.

Also in this section, Tyler Vreeling, a vibrant young designer, with extensive experience across the province, outlines his journey from industrial design student to entrepreneur. In the chapter "From the North: Perspective of an Outlier," he discusses his experience of studying and working in industrial design in Alberta. Vreeling now works as an independent consultant at his own firm.

Further to Johns's discussion of prairie character, Vreeling introduces his rural background and mindset and notes their disconnect from a more artistic vision of industrial design. However, he also stresses his dedication to design in Alberta and his tenacity in pursuing education and starting a company.

Vreeling critiques the lack of understanding of industrial design, and its shortage of connections to other local industries, an argument also seen in other chapters. Greater recognition of industrial design and an understanding of its value could improve its place in the province. Vreeling also stresses both the weakness of the local design industry and a designer's feelings of isolation. In his view, a brain drain of design talent undermines the local design community and the development of a regional form of design. However, his work demonstrates an effort to define Albertan and Canadian design and strengthen local design industries.

The third section, "The Creative Economy and Design Work in Alberta," outlines the current design-practice context. Courtenay McKay, an Edmonton-based visual communication designer, represents an Alberta creative in her illustration. This sets the scene for chapters by Tim Antoniuk and Ken Bautista.

Antoniuk is an associate professor of industrial design at UAlberta and was a co-founder of the Alberta-based Hothouse Design Studio, which operated in the 1990s and early 2000s. In his chapter, "Expanding the Creative Economy in Alberta: Creative Hybridity from Small Producers," Antoniuk stresses the importance of having outstanding local design industries and brings attention to the billions of dollars that Canada is losing because of declining creative economy exports. He explores the changing global system and its impact on design. Factors like globalization, an increasingly digital era, and a move toward a creative economy are expanding the role and responsibility for designers. Antoniuk argues that this new form of industrial design is misunderstood, under-supported, and under-exploited in Canada and in Alberta.

That said, new models for design practice could be especially promising. Local and situated knowledge from Alberta could offer valuable contributions to broader creative communities. This new value for Alberta design knowledge aligns with Johns's call for design that is responsive to the local environment and with Vreeling's critique of the disconnect between local values and broader design culture. Reframing the role of designers and local-global connections could also address some of the challenges associated with traditional industrial design practice as discussed in Prochner and Kroll's work.

The next author is Ken Bautista, an entrepreneur who has founded or co-founded significant local businesses including Rocketfuel Games, Startup Edmonton, and Makespace. His chapter, "Designer Founders and the Start-Up Revolution," exemplifies many ideas explored in Antoniuk's writing. Bautista discusses the expanding role of designers, which is increasingly complex and sophisticated. Designers take part in a great variety of projects, become involved at the front end, and engage in

collaborations. This could be a way for designers to participate in the broader creative economy and avoid some of the issues traditionally associated with design in Alberta, including problems linked to Alberta's isolated location and sometimes weak local support for creative work.

Although Bautista supports the development of a local design community, he encourages designers to look beyond local opportunities and participate in global creative networks. He also suggests a proactive approach for growing the local design community. Instead of waiting for government support, the design community could establish its own support networks and look for financing elsewhere. This provides a different perspective from that of other chapters in which authors have focused on regional design opportunities and the need for government support.

Finally, the last section, "Sustainable Design Practices in, for, and from Alberta," stresses the value of sustainable design in education and practice, and positions sustainability as an area of priority for design in the province. Elizabeth Schowalter explores the complex relationships between sustainability pillars and Alberta's oil industry in her illustration. Schowalter is the director of operations at Berlin Communications, an advertising agency in Edmonton.

The province of Alberta has a complex and difficult relationship with environmental sustainability, given its strong ties to oil and gas. It has one of the largest oil reserves in the world, and its oil and gas industry has been a huge contributor to the Alberta economy. At the same time, these industries have a high environmental cost associated with extraction, transportation, and use. Like designers across the world, Alberta designers have a responsibility to practise environmentally sustainable design. This is especially important, but somewhat ironic, in the provincial context.

The written section begins with Carlos Fiorentino's plea for greater environmental sustainability in Alberta design. Fiorentino is a design educator, researcher, and practitioner. He teaches at UAlberta and Grant MacEwan University and is a co-founder of Biomimicry Alberta's regional network. Fiorentino discusses environmental sustainability in his chapter "Sustainability

in Alberta: Experiences and Impressions by Design." Like other writers who explain that Alberta sometimes lacks a design mindset, he explains that it also lacks a sustainability mindset. Local industries, activities, and lifestyles are major contributors to unsustainability. Fiorentino encourages sustainable design but also the application of design thinking toward sustainability issues. He writes, "Our choice is to either change by design or change by disaster," which shows the urgency of this issue and also stresses that the province and Alberta designers have the necessary resources to make this change a reality. Designers can be involved in redesigning our cities as well as our economy and ways of life.

Fiorentino's writing parallels other chapters that raise the issue of sustainability. Like Johns, Fiorentino problematizes urban sprawl in Calgary and Edmonton and suggests drawing on sustainable reference points in design, such as the local natural environment. Furthermore, similar to other authors, he encourages collaborative work and stresses the need for political will and leadership in sustainability. This chapter and subsequent chapters that deal specifically with sustainability demonstrate that Alberta needs not only to embrace design culture but also to support a reframing of design for greater sustainability.

The next chapter, "The Forgotten Sustainability: A Socially Conscious, Paradigmatic Shift in Design," was co-authored by Janice Rieger and Mark Iantkow. Rieger is an advocate of people with disabilities and has been widely recognized for her inclusive design work. She is now a faculty member in the School of Design at the Queensland University of Technology in Australia. Iantkow has worked on access design for many years, including with the Canadian National Institute for the Blind and with Parks Canada.

In this chapter Rieger and Iantkow discuss socially sustainable design, especially its emphasis on universal and inclusive design. They argue that social sustainability is often left out of sustainability discussions although there has been a history of this work in Alberta. They present a history of thinking about accessible design in Alberta, which has moved toward greater inclusion and a greater response to the complexities and paradoxes of human needs.

Rieger and Iantkow explain how these concepts are applied in design education and note that there is an increasing social consciousness of accessibility. However, the authors stress that this is not enough. Local environments are not adequately accessible, which will become increasingly clear with the aging population. The authors underline the need to "future proof" our environments by addressing "long-term functionality and relationships between the user and the space."

Like other authors in the anthology, Rieger and Iantkow discuss local mindsets toward design. They note that Albertans are becoming ever more aware of accessibility issues and expect accessible environments, but that this could go further. It is also important to encourage the population to adopt new ways of understanding the built environment and to demand innovation and forward thinking in design. The authors note that "it is often a new design or a technological advancement—and change agents willing to experiment—that stimulates the marketplace."

The last chapter in this section and the anthology is titled "It Is Just Good Design!," by Ron Wickman. Wickman is the principal at Ron Wickman Architect and has expertise developing affordable, accessible, and adaptable housing. In this chapter he presents concepts for inclusive design, illustrated by his local architecture projects. Among many important points, Wickman stresses that inclusive design is critical for the quality of life of people with disabilities, but it also benefits a range of different users. He addresses misconceptions by showing that inclusive design can be beautiful and "is not a look or a style; it is an approach to design." His work responds to Rieger and Iantkow's call for more inclusive design in Alberta.

Moving beyond this introduction to each chapter, the following is a discussion of the context, strengths, challenges, and opportunities for Alberta design. These insights are drawn from the chapters and are explored in detail throughout the book.

Although the anthology explores design work as a whole, there are different local conditions and experiences depending on the design field. Some fields are stronger and more self-sustaining than others. An important factor may be whether local design work is actually required or whether,

by contrast, design artifacts can easily be imported from outside the province, which is the case for a field like industrial design. Another factor is the presence of local production facilities and markets. Without these, it is impossible to achieve an entirely Alberta-focused design industry—if this was indeed the goal.

Design practice is based on strong global connections. Many designers want national or international contracts and collaborations, and external production and sales. And reaching beyond Alberta could be key to long-term success. As Ken Bautista and other authors emphasize, there is promise for digital design fields and remote work in Alberta.

Tyler Vreeling notes differences between design fields in his chapter but also explains that Alberta designers can survive in many fields: "there have been many successful businesses in Alberta offering design as a service. Architecture, interior design, and visual communication design firms have all experienced success. Firms that have industrial design as their focus usually struggle and dry up in a few years, or their members move on in search of more impressive opportunities. Consequently many people wonder if good industrial designers can survive here. In my opinion, we absolutely can survive in Alberta, but it takes guts to stay."

Despite differences between design fields, there are similar conditions, as well as shared local priorities, that affect design practitioners and design work across the province. In "A World History of Design," Victor Margolin explains that local design practices are structured by factors including the local environment, culture, values, and economic and political plans.[6] Indeed, these factors play a significant role in design in Alberta.

Within the contemporary history of Alberta design, local designers have tended to ignore the physical environment, although there are exceptions, and this trend is beginning to change. For instance, architects Barry Johns and Ron Wickman both note the importance of Alberta light in their practice. As Johns writes, "[l]ight here—even the lack of it—is our obsession." Building on their writing in this work, there is a strong call for architecture and urban design that respond to the local environment and support environmental sustainability needs.

Beyond the physical environment, location has also played a big part in Alberta design. Alberta's relative isolation and distance from other major urban centres hinders the development of design networks and can make designers particularly dependent on local industries and local consumer bases. That said, ever-increasing connectivity and digital networks could provide new possibilities and ways of working.

We also have incredible local resources. Barry Johns references peace, freedom, good quality of life, and the beautiful natural environment, which make Alberta a fine place in which to live and work. Carlos Fiorentino explains the potential of solar power in Alberta for sustainable innovations and more sustainable living in the province. Tyler Vreeling and Tim Antoniuk also discuss the local knowledge and skills that designers may bring to projects. In their views, prairie character provides perseverance and grit; local knowledge systems can provide new ways of looking at the world; rural Albertans may have greater familiarity with certain equipment, materials, and construction; and designers from small centres may work more holistically and empathetically than their big-city counterparts do.

In terms of culture and values, all too often there has been a disconnect between a prairie attitude and art and design, in which Albertans have not always supported innovative design work or they have sought the cheapest design solution. Yet, today Alberta has an increasingly diverse and engaged population that has different expectations of design work. In his chapter Vreeling points out that the public and clients are becoming more and more aware of the value of design. Strickfaden also notes that Albertans have "a vibrant and dynamic acceptance of design as a career."

The contemporary population seems ever more ready to support new types of design practices that will help push design in more responsible and engaging directions. With these changes, Albertans may start to demand new forms of design work, which could include projects rooted in sustainable practices and accessibility—issues that have been at the forefront of public consciousness in recent years.

That said, design communities need to strengthen their networks and connections. This includes communicating better with the public in order

to understand its needs, wants, and concerns; communicating the value of design work better to government and industry; and forming stronger local design networks to support local initiatives, collaboration, and inter-disciplinary work. New forms of overt design leadership also need to occur in which the voices of designers are more clearly heard, whether they be farmers or chief executives.

On the tough topic of the economy, recent statistics show that there is the potential for design in Alberta to be a much larger and more powerful industry. As Antoniuk writes, "we underestimate the tangible and intangible value of creative work and good design." He notes that "creative industries are one of the strongest, most durable, and most dynamic sectors in the contemporary global economy." However, local conditions still dictate the directions that this growth will take and the approaches that will be most successful.

Many authors call for greater funding and policy support for design, or for designers to explore alternative funding options. Regardless, these supports need to be strategic and consistent to support local design growth. We also need leadership, clear plans, and decisive action for the future. As Antoniuk writes in his chapter, "Alberta and Canada need to look more seriously at how to fund, leverage, and promote exceptional Albertan and Canadian design."

Falling oil prices and the current recession seem to necessitate a renewed vision of the local economy. Design industries and creative work could be leveraged in this plan, and design thinking could help re-vision industry and labour creatively in the province. However, design industries are heavily dependent on the local economy and investments. Like jobs across the province, much design work is linked directly or indirectly to the oil and gas industry. Economic weaknesses and restructuring could have a significant impact on design industries, so this domino effect would need to be part of long-term planning.

Of course, local design practices are also inspired by external influences. Throughout the history of design in Alberta these external factors

have included the knowledge and skills of designers and design educators coming to Alberta from abroad; larger design movements and trends; technological advancements; and design work happening elsewhere.

A powerful contemporary example is the global emphasis on sustainability, which has inspired local discussions on design. Nearly every paper in this anthology stresses that Alberta designers must work sustainably in some manner. Furthermore, globally, the meaning of design and design practice is changing to become more open and flexible. As a result, designers increasingly consider engaging in multidisciplinary work, collaborations, and non-traditional specializations like the design of systems or new technology. These creative forms of practice are also areas of potential for Alberta designers that could allow them to compete in local and international markets. Their potential is discussed in several chapters in this anthology.

That said, local designers also contribute to the global design community. We bring unique skills, perspectives, and world views to our work. In his chapter Tim Antoniuk encourages drawing on local knowledge, and references one of his projects, a design visit to an Inuit community in Nunavut. He explains: "There is a wealth of knowledge and experiences across the world. It is our responsibility to continuously seek, learn from, and be inspired by these ideas, while remaining conscious of the give-and-take in relationships and ethics of exchange."

The tension in wanting to develop a local-global balance will always be dealt with by individual firms and designers: they see what is being done elsewhere, while they are developing a locally anchored design practice based on, in this case, Alberta's environment, economy, industry landscape, and design community. This balance allows a greater synergy to develop.

There is value in strengthening this regional design community and working locally, but also in contributing to larger creative networks. Exchange can encourage innovation, which often occurs in the confrontation of different ideas and perspectives. This potential shows the importance of regional design centres, communication, collaboration, and open minds.

Though more slowly than some may like, design in Alberta is diversifying and transitioning from being obscure and largely misunderstood to being an important part of everyday life. *Situating Design in Alberta* shows what we instinctively know: there is a robust Alberta design history and an exciting local design community. We have the resources and foundations for a stronger future.

Insights pertaining to design in Alberta are explored and further developed throughout the anthology. This collection of writing provides information about Alberta design that can help local designers find their place and develop the potential of design industries. Many of these proposed directions are not widely known or applied, so the next step is to put them into action. The anthology also introduces many subjects for future exploration. For instance, topics mentioned earlier like the realities of design practice in Alberta, the boundaries of design, and sustainable design challenges are just beginning to be uncovered.

We hope this study will not only help situate design in Alberta but also improve understanding of regional design, inform design practices, and foster a more inclusive view of Canadian and global design. We encourage you to continue this conversation, and we hope that the anthology will inspire new ideas about Alberta design and spark further research and writing on this rich topic.

Design work in Alberta needs to grow organically, but it could also benefit from the development of a more robust strategy for moving forward. We need an Alberta design future that acknowledges our past and our many local experiences and cultures, while looking beyond our borders. Tim Antoniuk ends his chapter by explaining that Albertan and Canadian designs lack an identity: "Canada has not been branded or constrained by a man-made aesthetic or by a past trendy era. We seem to be defined by our natural landscape, by a sense of integrity, and by simple, honest living...This is an incredible opportunity for our people, communities, and businesses, both inside and outside of the Albertan and Canadian creative communities. It is something we can collaboratively expand, leverage, and develop."

As Albertan designers, we are in a fortunate position of being able to define local design work, make our own identity, and bring it to the world stage on our terms. We can define our future and make our own goals. Whether they be reliable and long-term work, greater wealth and stability, meaningful and impactful projects, a culture of innovation, more visibility of good design or greater recognition, an important question remains: What will encourage bright young designers to stay and work in Alberta? As Vreeling stresses in his chapter, "[i]f talent continues to leave, we will simply continue importing design and ways of thinking that do not fit our climate, culture, or people."

Postscript

The future is exciting and unknown, and design disciplines, practices, norms, and expectations continue to change, as does life in Alberta. However, as we were working on the final revisions to the anthology in the summer of 2020, the world was living through the COVID-19 pandemic, a health disaster that massively changed our ways of life and disrupted the global economy. Design work has been affected by job losses, stretched budgets, and funding freezes. Many designers have also redirected their work to help with the coronavirus response, for instance, by designing and producing masks and face shields.

Life in Alberta has certainly changed, and the future is still unknown. Moreover, it has become more ominous and difficult to predict. Although it feels somewhat inappropriate to speculate on the future during this time of crisis, the pandemic may be the moment to rethink our norms and ways of doing things.

Philosopher Bruno Latour wrote: "[W]e have actually proven that it is possible, in a few weeks, to put an economic system on hold everywhere in the world and at the same time [this is] a system that we were told... was impossible to slow down or redirect."[7] His statement hints that there is the potential to draw on new ideas as we restart and rebuild the Alberta economy. The process could draw on creative design thinking and leverage the potential of creative economy exports.

Communications with contributing authors have also highlighted other possibilities. Wickman noted that our current experiences with distance work and education can teach us how to interact more inclusively, enabling people with disabilities to participate from the environments of their choosing. In turn, Barry Johns reflected on links between the pandemic and the natural world, including cleaner air and clearer skies related to our reduced travel. He wrote, "[A]rchitects and architecture [must] address design ethics in this context—in Alberta and elsewhere. It is overdue but never too late to commit to sustainable, regenerative, resilient, inclusive, safe and humanistic buildings, communities, and cities."

With this in mind, we reframe our original conclusion and now state that it is hard to know where the next few years will take us, but we believe that design has a central role to play, inspiring and leading positive change and a good future in Alberta.

Notes

1. Chevaliera, quoted in Fong, "If We Build it, Will They Come?," para. 1.

2. Kunstler, "The Clusterfuck Nation Chronicle."

3. Ritzer, *The Globalization of Nothing*, 15.

4. Price Waterhouse, *Shaping Canada's Future by Design*, 97.

5. Bresnahan, "Introduction."

6. Margolin, "A World History of Design," 441–42.

7. Latour, "What Protective Measures Can You Think of So We Don't Go Back to the Pre-crisis Production Model?," 1.

Bibliography

Bresnahan, Keith. "Introduction: Design Studies in Canada (and Beyond): The State of the Field." *Canadian Art Review* 40, no. 2 (2015): 5–14.

Fong, Jennifer. "If We Build It, Will They Come?" *Edmonton Journal*, January 30, 2010.

Kunstler, Jim. "The Clusterfuck Nation Chronicle: Commentary on the Flux of Events." October 10, 2005. http://kunstler.com/mags_diary15.html.

Latour, Bruno. "What Protective Measures Can You Think of So We Don't Go Back to the Pre-crisis Production Model?" [in French]. Translated by Stephen Muecke. http://www.bruno-latour.fr.

Margolin, Victor. "A World History of Design." In *The Routledge Companion to Design Studies*, edited by Penny Sparke and Fiona Fisher, 435–44. London: Routledge, 2016.

Price Waterhouse. *Shaping Canada's Future by Design: Detailed Report*. Ottawa: Human Resources Development Canada, 1996.

Ritzer, George. *The Globalization of Nothing*. Thousand Oaks, CA: Sage, 2004.

This illustration represents the growth and changes that Alberta has gone through, from the Indigenous Peoples who first settled on the plains of Alberta, to the pioneers who established roots along the North Saskatchewan River, and all the way to the development of our prospering cities that will continue to grow.

The illustration revolves around a timeline that passes through the Albertan landscape: the Rocky Mountains, the foothills, and the North Saskatchewan River that runs through Edmonton and then north and east. The timeline has a representation of a pioneer settlement, its growth into a small western town, and the development of a large cityscape. Of course, the timeline does not end at the city stage; the red arrow that leads the eye across the page shoots up into the sky, just as Alberta's innovations will hopefully grow into the future.

ANDREA HIRJI

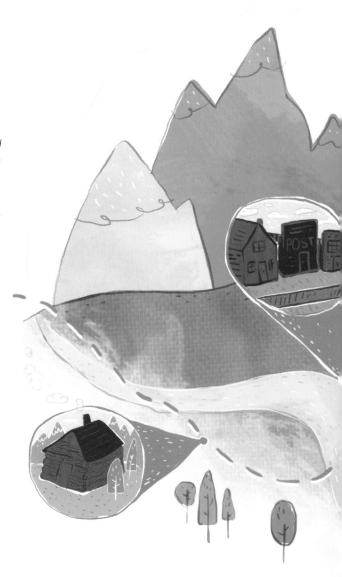

Past, Present, and Future Innovation in Alberta

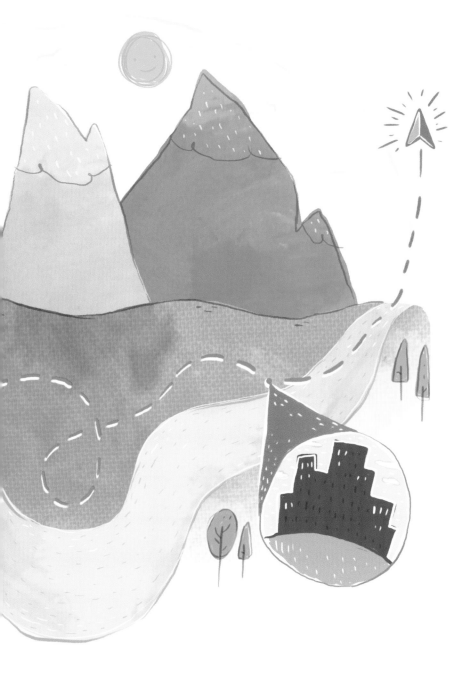

Architecture must now construct anew the whole social pattern of our time
as a new order of the human spirit.

 —FRANK LLOYD WRIGHT (1936), cited in Pfeiffer, *Frank Lloyd Wright*

ARCHITECTURE AND URBAN DESIGN in the province of Alberta are explored in this chapter through the eyes of a private practitioner who has been based in Edmonton since 1979. Specific historic and architectural influences are examined to build on the idea of an emerging new response to place in the first quarter of the twenty-first century; this perspective differs from that of an Alberta historically recognized by its pioneering, discount-oriented culture of "Do it now, fast and cheap." Buildings and significant architecture in the province are also surveyed alongside an analysis of the city, framing the proposition that it is time to reposition a province symbolized by its conservative, agrarian past, suburban sprawl, and automobile reliance into a knowledge-based leader in new, responsive, sustainable, resilient architecture and urban ecology.

The discussion focuses on the city of Edmonton but references the province of Alberta and the global context to support the argument.

Prairie Roots

The Canadian prairie is a region unique on earth. As an architect, one quickly comes into contact with and learns a deep appreciation for its vernacular culture and harsh climate. With hot, dry summers and cold,

3

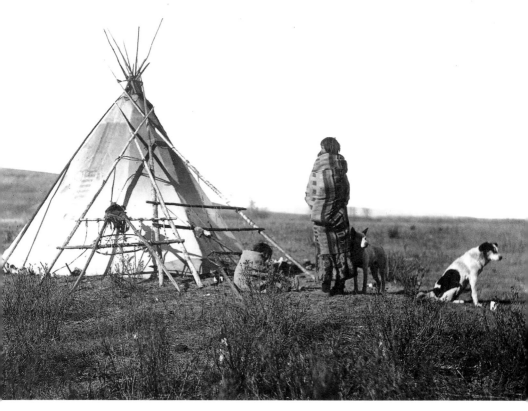

FIGURE 1.1. *Cree woman and children in front of tipi, Calgary, Alberta, 1887. Photograph by William McFarlane Notman. Used with permission of the McCord Museum* VIEW-1821.

windy winters, we are influenced by the desire of its first inhabitants to live in harmony with the land.

The big sky—closer to us on the Alberta prairie than anywhere in Canada because we are situated 2,500 feet above sea level, on average—yields intense sunlight, violent storms, and other phenomena such as sun dogs, chinook arches, the phantasmagoric northern lights, the moon, and a star constellation that clearly illuminates the snowy winter landscape.

Light here—even the lack of it—is our obsession. It is a surprise to those living at sea level and used to Arthur Erickson's fond description of the soft, "milky white light" of Canada's sodden coastline, to discover the relentless intensity of the sun in this place and the depth of its natural colour palette, where sunglasses and solar protection are prerequisites year round.

I consider this light as a building material that animates our architecture when the sun is so strong and the sky so clear. It penetrates

deep inside our buildings, casting dappled shadow patterns while roof profiles play with razor-sharp precision against the northern sky.

Into this environment, Indigenous building traditions date back ten thousand years when architecture was created entirely from nature. Nomadic First Nations honoured its bounty, building only with sticks and skins. The tipi is the simplest and best example of all structures—organic, structurally stable, windproof, waterproof, warmed by an internal fire, cooled by natural ventilation, portable, and reusable for many seasons (see figure 1.1). The original sustainable architecture, it touched lightly on the earth, an enduring symbol of exploration and human settlement in the west.

European settlers and railwaymen who arrived on the prairie had little option but to work with the land. Log and sod houses were carved out of their immediate surroundings of forests and plains. This would become a craft-based culture—with the use of wood in Canada now legendary— honed by new tools and equipment made of iron, perhaps best exemplified by the beautiful avalanche sheds that were hewn out of necessity and constructed by the Canadian Pacific Railway in the verdant, snow-engorged passes of the Rocky Mountains (see figure 1.2).

Prior to the first settler building boom, the design of prairie settlements was entirely pragmatic, with survival and shelter being the basic requirements. At the time of the province of Alberta's founding in 1905, the combined population of Montreal, Ottawa, and Toronto was already more than one million, whereas there were only forty thousand homesteads and a few trading posts (but more than fifty startlingly diverse ethnic or cultural groups) making up this place. Thoughts of cities and urban life would come much later.

Capital Modern: A Guide to Edmonton Architecture & Urban Design alludes to this stark contrast of Canadian cultural geography.[1] A definition of pioneer culture is attributed to Marshall McLuhan (who spent many years in Edmonton and Winnipeg); he observed that "the non-specialization of life on the prairies (a harsh landscape and extremely low population densities forced farmers to be meteorologists, mechanics, accountants, botanists, veterinarians, builders, managers, politicians and poets) imparted an admirable independence of thinking among its residents."[2]

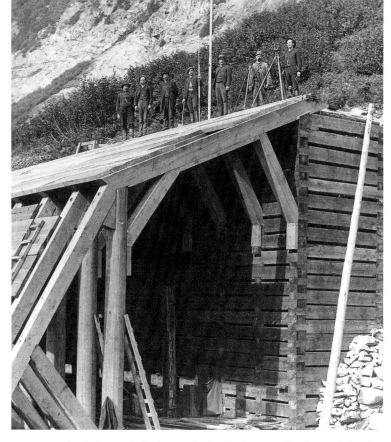

FIGURE 1.2. *Historic photograph, glass lantern slide, showing the construction of a snow shed on the Canadian Pacific Railway, Glacier Park, British Columbia, 1887; copied ca. 1902. Note the size of the milled timbers compared with the diminutive scale of the railwaymen on the roof.*
Used with permission of the McCord Museum N-0000.25.1060.

This culture breeds a self-deprecating and pragmatic self-confidence—prairie people eschewed the need for personal promotion while frowning on those who succumbed to it. It took boldness, innovation or invention, and back-breaking hard work to settle and prosper here; there was no time for anything else. As a transplanted easterner, I see courage, leadership, hard work, and innovation to be the least understood but most endearing of traits among prairie residents with a deeply rooted family history.

Another essential trait of the isolated settler population of farmers, ranchers, and merchants is, of course, a fierce independence. Often the freedom that comes with this independence enables a community, once established, to continually reinvent itself through growth while subconsciously sticking to its habitual norms and resisting change, often without discipline.

Early Albertans perceived that there was enough discipline already employed by the Dominion land surveyors and the Land Titles Act, which legally partitioned the province into large agricultural sections and smaller parcels of land for private ownership and real estate development. A surveyor's grid superimposed at varying scales across the entire country-side established both law and order and, in effect, controlled a pattern for the growth of settlements into larger communities.

Ironically, the lovely natural surroundings that interrupt (yet today, define) prairie grid cities—their rivers and ravines—had little early influence in the actual design of places. Driven initially by the fur trade, then by a need to move agricultural products to market, cities like Edmonton evolved during the first real-estate building boom prior to the First World War, around commerce and the railway. The rivers were service conduits—the first facilitators—for transport and water; they were not heralded for their intrinsic beauty.

The prairie city also evolved piecemeal through economic boom-and-bust cycles, with sporadic development. Edmonton experienced discontinuous and incomplete urban development—a lacuna city in an organic sense—throughout the entire twentieth century, with interrupted periods of intense activity producing only pockets of concentrated development on cheap land in commercial, retail, industrial, and housing sectors. As well, unlike cities such as Halifax, Vancouver, or Toronto, where the sea, the mountains, or great lakes militate against growth in every direction, naturally promoting densification, a prairie river city freely expands in all directions, deep into the hinterland. Once begun, this pattern becomes an entitlement, a land avalanche of habitual and exponential consumption fed by boom-cycle industrial development and suburban growth.

The most fertile soils of the hinterland are sacrificed in the process for these same suburbs, industries, and even airports. The unintended consequence of this growth is that Edmonton today, at approximately five people per acre, has one of the lowest population densities, yet it is the largest consumer of land of any city in Canada.[3] Strathcona, the west end, and other new suburbs with their own town centres around the periphery of the city, each suffer the underdeveloped gaps between them, leaving behind an eclectic patchwork-quilt aesthetic that is difficult to perceive as a whole, as a harmonious or contiguous place. Density, since it is not geographically mandatory, does not naturally fit the prairie zeitgeist.

Such was the fate of the first one hundred years of many prairie cities—a generic image around its built form, with modest downtowns and skylines. Calgary's urban profile, while much more expressive than Edmonton's, still relies on the distant Rockies for its primary identity. It is only the verdant and bucolic North Saskatchewan River valley in Edmonton that provides a city-scaled, iconic constant. Likewise, the rivers and valleys are important to Red Deer, Saskatoon, Regina, and Winnipeg, contributing more to place than the cities' architecture.

Suburbia

The exemplification of the North American Dream—a family, a car, a house, a yard—is right here on the prairie. As a desired way of life in the mid-twentieth century, this ideal continues to extend the patchwork quilt of the city today as a primary pattern.

Edmonton and Calgary were originally compact cities, each with a river and a railway running through them. As they comprised smaller land tracts and leafy neighbourhoods within relatively easy walking distance of each other, there was rendered an identity or sense of place with clearly defined zones for living and working—all seamlessly integrated by the grid. However, three booms (the discovery of oil in Leduc in 1947 and the growth of an industrial employment base; the post–Second World War baby boom; and the building boom it caused) proved a combined force so strong as to move the province away from its agrarian past and tightly woven young

cities within a generation. The need for new housing to accommodate a rapidly expanding population, and massive government road-building projects, combined with the encouragement of car ownership, spread new families further into the hinterland, completely decentralizing the prairie city. Unencumbered geography also led to a limitless ability to annex cheap agricultural land—where parcels could be purchased by the acre—resulting in an even more fertile setting for suburban growth. The pattern continues today.

This rapid expansion for housing, commerce, and industry followed the rest of North America but was geographically unfettered on the prairie. Suburban neighbourhoods could increase in size, scale, and population (some eventually reaching sixty thousand inhabitants). Achingly monotonous "megahoods" now surround cities with their superblocks, disorienting cul-de-sacs, automobile-oriented streets, homogenous shopping centres, and colour-matched, so-called architectural controlled suburban rooftops. Each is linked by expressways, the pedestrian all but forgotten, yet remain disconnected from the city and its cultural amenities—except, of course, by car. The car, celebrated as a progressive symbol, enables living in one place and working in another, expanding the mantra of space, individuality, and freedom. Over time, the automobile becomes essential to city living on the prairie. To be without one is to be essentially disconnected from everyday life.

With low density and cheap land, Alberta quite naturally subscribed to the new age of suburbia. Even in cities the idea of large-tract land owner-ship that was so deeply rooted in a pioneering culture proves just too compelling, if not essential, for prairie people. Prairie cities would not thus be naturally urbanized—either by desire, geography, increasing popu-lation, or even the advent of mass transit. In contrast to the much larger, constrained eastern cities of Montreal and Toronto, with more than one hundred years of established mixed-use urbanization before Alberta was founded, prairie downtowns were not considered beyond their traditional singular role as employment centres for decades.

The Modern Movement

Prairie settlers were not particularly aware of or interested in the origins of modern design that emerged in the nineteenth century when Joseph Paxton's 1851 Crystal Palace in London and the 1889 Eiffel Tower in Paris celebrated the new mechanized spirit of the Industrial Revolution. The stripped-down aesthetic that followed in Europe with the founding of the Bauhaus in 1919 was a significant departure from the comfortable symmetry and decorative tradition of neoclassical and Beaux Arts styles. This modernist philosophy of breaking with history and dismissing what was seen as useless, non-functional decoration became a series of theoretical positions in all of the arts—including, of course, architecture, where its protagonists aimed to completely change and reform public opinion.

While new materials of iron, steel, and glass combined with mass production and technology would change almost every preconception about building design, industrialization and the new modern ideals to follow were initially adopted out of necessity on the prairie, not as stylistic or artistic conceit.

Again, it was the Canadian Pacific Railway (ironically the developers of magnificent baronial and "châteauesque" hotels across the country) that, perhaps inadvertently, introduced the first ideas of modernism to Alberta. A succession of beautiful railway bridges eliminated unnecessary embellishment through pragmatic engineering. Structure was expressed in its pure nakedness, inherently celebrating space and light in the process, and the bridges' lacy horizontal profiles registered against the sky and aligned with distant horizons. The 1909 Oldman River Trestle Bridge in Lethbridge was the longest and highest of its type in North America when completed (see figure 1.3). The 1913 double-decked High Level Bridge in Edmonton, accommodating trains, streetcars, automobiles, and pedestrians, was the first modern urban infrastructure, embracing utility and beauty long before the impact of modernism on prairie architecture.

Prairie cities did include government or corporate commitments to the public realm but did not originally follow these new ideals. In Edmonton,

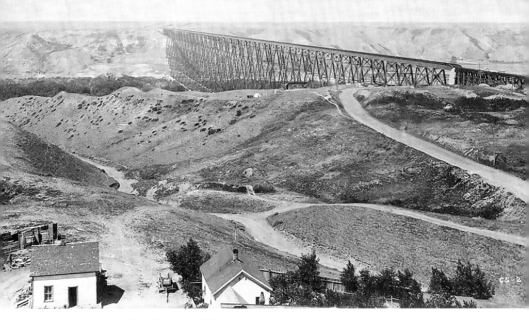

FIGURE 1.3. *Oldman River Trestle Bridge, Lethbridge.*
National Film Board of Canada. Photothèque / Library and Archives Canada / PA-044741.

buildings such as the Provincial Legislature, the early academic buildings of
the University of Alberta (UAlberta), and the railway hotels (the MacDonald
in Edmonton and the Palliser in Calgary) followed the same design tenets
as those in bigger cities, generally retaining traditional styles.

Beaux Arts design traditions were eventually shed after the 1930s as the
architecture profession secured a position and established strong periods
of growth. Despite interest in the modern movement in architecture from
the 1930s elsewhere in Canada, modernism and the impact of its heroes—
Walter Gropius, Le Corbusier, Ludwig Mies van der Rohe, Peter Behrens,
Eero Saarinen, and Frank Lloyd Wright—would not be significant until
some twenty-five years later in Alberta, with the post-war building boom.
The inaugural Banff Session in 1956[4] and the introduction to Alberta of the
Austrian-American architect Richard Neutra, one of the leaders of early
European modernism, fuelled an intellectual path of scholastic inquiry

FIGURE 1.4. *Edmonton City Hall, designed by Dewar Stevenson and Stanley Architects and demolished in 1989–90. Used with permission of the City of Edmonton Archives EA-20-990.*

by prairie architects wishing to explore new ideals and materials. This spawned a generation of experimentation among the province's better architects, and the modern movement became the cradle for it.[5]

In the modern period, lasting well into the 1960s, architects who had struggled in prior years were finally rewarded with a new and much higher demand for their services, and most of the province—certainly its cities—was built during this time. With an influx of new practitioners from abroad, including a few iconoclasts and new graduates from Canadian schools of architecture such as the one at the University of Manitoba, the ideals of modernism began to manifest in new public buildings. These included schools and office or industrial buildings and, as they were gradually accepted, high-rise, even iconic skyscraper, office buildings like Edmonton's CN Tower and daring 1957 City Hall (see figure 1.4).

Fondly remembered as a superior example of modernism in Edmonton and inspired by the United Nations Headquarters in New York City, the City Hall featured a curtain-wall window-cladding system and brise-soleil (sun screens). The Council Chamber was raised on support columns, or pilotis.

The modern movement thus generated an extensive archive of modernist buildings in Alberta. Excellent examples remain in the cities of Edmonton and Calgary. Interestingly, only a few innovative architects working in the province—Peter Hemingway, Arthur Erickson, Jack Diamond, Barton Myers, Douglas Cardinal, and Don Bittorf, all of whom were trained either abroad or at schools outside the province, especially eastern schools—would command national or international attention and forge the underpinnings of a recognized design culture in the province.

Despite the deep influence of the modern movement on Alberta's architecture, an enduring pedagogy has been denied by a general public that has systematically allowed the demolition of many of the best buildings of the period—those from the 1950s, 1960s, and even the 1970s.[6] Only in recent years has their historic value been recognized. The image or messaging that each embraced was neither familiar nor universally accepted by a conservative population. New ideals and intellectual pursuits agitate one's sense of comfort, one's independence. This is another part of the prairie zeitgeist—a pioneering spirit founded on hard times, where change (inherent to innovations in art and architecture), after years of hardship caused by ongoing cycles of boom and bust, is more often met with skepticism or stubbornly dismissed altogether.

Further, recognition of architecture as a catalyst to improve one's quality of life is a premise not intellectually saluted on the prairie. I attribute this attitude primarily to the lack of identity and coherence in the city structure. The emphasis on individual lifestyle choices as embodied by the car and the suburbs—with few truly engaging public buildings and transformative urban spaces—meant there was actually little public engagement with architecture.

This situation changed with increased air travel, public exposure, and continued growth into the late 1960s when the prairie loomed as a place of

enormous opportunity. The recognition of Canada due to its world exposition in Montreal in 1967 saw the emergence of architecture on stage. Architecture exploded as an identifier of regional culture, of just who we are. While the diverse Canadian mosaic emerged as a conversation across the country, architecture also acquired new meaning and *gravitas* in prairie cities.

Expo 67

The extremely optimistic era of the 1960s culminated in Canada's centennial celebrations and the world's fair known as Expo 67 in Montreal. The exposition featured ninety pavilions representing themes around "man and his world," sixty-two nations, corporations, and industries on two small islands in the St. Lawrence River that had been enlarged by excavated material from the construction of the underground Montreal metro.

For six months Canada shone on an international stage that many countries would later declare as the most successful exposition of the twentieth century. In terms of political and cultural context, Canada had come of age with a landmark moment in its young history.

The Canadian pavilion, designed by an architectural consortium including Arthur Erickson, featured a bold inverted pyramid that showcased Canadian forestry and wood products as large-scale structural building materials (see figure 1.5). The diverse landscapes and cultures of each region of Canada were explored in provincial pavilions and other theme buildings. Contemporary architecture in Canada emerged for the first time, almost instantly, in public conversation.

Canadian construction expertise and indigenous materials—from zinc and wood to Tyndall limestone and Quebec granite—introduced a wide-eyed public to a stunning array of pavilions never before seen. Even the use of poured-in-place, precast, and post-tensioned concrete garnered special attention. As a teenage Montrealer student armed with a youth passport that allowed access to the site, I viewed the exhibition every day that summer. This incredible collection of inhabitable art proved too powerful; it was clear that architecture was my path to pursue.

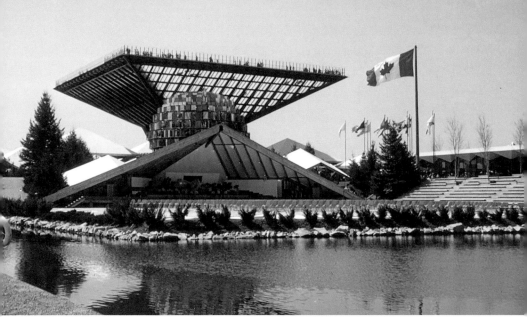

FIGURE 1.5. *The Expo 67 Canadian pavilion, known as Katimavik (gathering place), was designed by an architectural consortium consisting of Roderick Robbie, Colin Vaughan, Paul Schoeler, and Matt Stankiewicz, with Evans St. Gelais and Arthur Erickson as consulting architects.* Photograph by Laurent Bélanger, Creative Commons Licence CC BY-SA 3.0.

The national centennial celebration accompanying Expo 67 lasted an entire year, with special events in all areas of the country. In Alberta alone, more than four hundred projects ranging from works of literature, to music and the visual arts, to parks development, to new buildings and infrastructure all contributed to the country's collective pride around innovation, new directions, and hope for a prosperous future.

While architects experimented widely at Expo 67, the provinces also experienced a sea change in the awareness and acceptance of modern architecture as part of the public realm. In Edmonton a public debate resonated with the completion of such varied works as the conservative Centennial Library and the Provincial Museum versus the boldly quixotic Coronation Pool by Peter Hemingway.

The late 1960s, as a result, fomented a new-found boldness of spirit that enabled—even encouraged—new architect intellectuals to innovate. Architecture emerged with art, theatre, music, and literature as an important cause—a culture of modernism and a passion that insisted

this mattered. I studied the impact of modernism in architecture school in the early 1970s. It held significant promise, a breakthrough in Canada. However, as professionals in Alberta, architects continued to struggle to secure an enduring presence among the general population.

The Iconoclasts

Despite the large body of modernist work completed along the Edmonton–Calgary corridor, it is clearly the late modernism of the 1960s and 1970s that can be claimed as the most meaningful in Alberta's short history. Innovative architects of the time explored a local form of modernism that contrasted with universal modernism. It was design that followed the basic tenets of the modern movement but reflected the surrounding environment through interpretation of form, materials, or symbolism. However, these architects also demonstrated currency with other new ideas and buildings that were developing around them elsewhere in the world. This strong emphasis on a universal or global form of expression is perhaps another reason that Albertans have generally not hesitated to replace their built history. Born from European ideals and employed around the world, much of the modern movement was simply not their own.

Space limitations in this chapter preclude a broader investigation of buildings and their architects from this period, especially given that these investigations exist elsewhere. However, the first meaningful and unique design culture in the province can be positioned squarely among the iconoclasts of the late modern movement who were working in Alberta. Of the many important architects who have contributed to the positioning of modern architecture in Alberta, only a few favourite examples are referenced here: Peter Hemingway, Jack Diamond, Barton Myers, Arthur Erickson, and Douglas Cardinal.

Peter Hemingway

Introduced to Edmonton from England via Alberta Public Works, Peter Hemingway catapulted individually to pre-eminence with the Massey Medal–winning Coronation Pool in 1967 and his Stanley Building in 1968.

FIGURE 1.6. *Coronation Pool, a centennial project in 1967–70, now the Peter Hemingway Fitness and Leisure Centre, Edmonton. Photograph by James Dow.*

The pyramidal Muttart Conservatory came later, another iconic building that continues to symbolize Edmonton. Each is a vivid reminder of the optimism of Edmonton during the 1960s.

Coronation Pool (see figure 1.6) is a dramatic, tensile structure, conceived and engineered without the use of computer-assisted, three-dimensional drawing. It owes a debt to the Metabolist architect Kenzo Tange and his 1964 National Olympics gymnasium and pool in Tokyo, a much larger complex with a similar, fluid roof profile. Nested into a bucolic park, Coronation Pool is a technical improbability using a steel-cable roof-support system never before attempted in the cold Canadian climate. The building is one of the city's most popular icons—a habitable sculpture that was eventually renamed in honour of its architect,[7] and received the prestigious Prix du XXe Siècle Award from the Royal Architectural Institute of Canada in 2012.

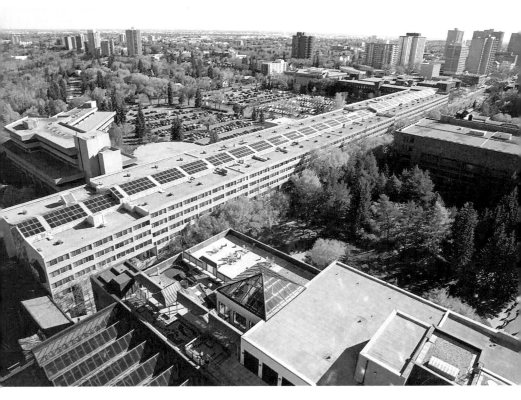

FIGURE 1.7. *The mall of the Housing Union Building (HUB), 1968–73, University of Alberta, Edmonton. HUB, as its acronym suggests, was conceived as a central gathering place for students and the university community. Photograph by James Dow.*

Diamond and Myers Architects

The Toronto firm of Jack Diamond and Barton Myers (both influenced by working with the acclaimed architect Louis Kahn) developed an entirely new paradigm for student housing with its Housing Union Building (HUB) of 1968–73 for UAlberta (see figure 1.7).

This was a time of major institutional growth, experimentation, and widespread student unrest fuelled by the now infamous Kent State University shootings and protests about the war in Cambodia and Vietnam. The building was an opportunity to put in place a new sense of order and democracy. The project was completed with Edmonton architect R. L. Wilkin and addresses living in a cold climate through multi-storey housing units arranged above a necklace of support services along a 1,000-foot-long

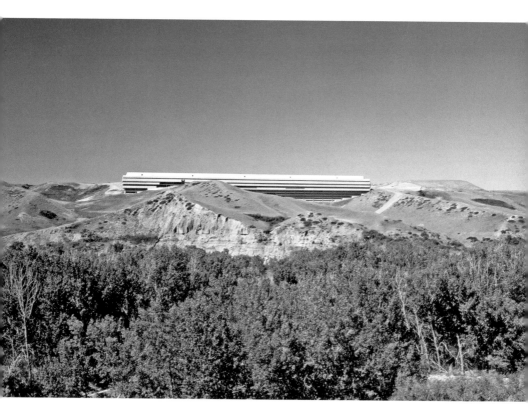

FIGURE 1.8. *University Hall, 1969–71, University of Lethbridge. University Hall is a fitting response to the terrain in which it is found. Photograph used by permission of Simon Scott.*

interior skylighted galleria. It was conceived as the first phase of a long-range campus plan for the institution. The original concept envisioned a myriad of such buildings connecting existing academic buildings on the campus. HUB, as a prototypical indoor community, is an innovative, regional invention about habitation, climate, and place. It is the only truly original modernist thesis in the province. Despite ongoing changes and alterations that have an impact on this oeuvre, the complex endures today.

Arthur Erickson

The "greatest architect we have ever produced,"[8] Arthur Erickson is a Canadian architect synonymous with the integration of architecture and nature. Influenced by the majestic surroundings of his native British

Columbia and his travels, Erickson's best work is always associated with site, light, and cadence. The 1969 University Hall on the University of Lethbridge campus engages the rolling coulees of the Oldman River like a steady ocean liner on a stormy sea (see figure 1.8). The building is completely nested into its unique natural setting; no other architecture in Canada so completely and timelessly resonates with its natural surroundings. In a city famous for its severe, windy climate and dry, almost desert-like summers, the building is protected from the wind by its low profile below the brow of the coulee hilltops on campus. Its pilotis superstructure hovers slightly above the terrain to minimize disturbance to the drought-tolerant fauna and ground covers that characterize this eco-sensitive area of the prairie.

Douglas Cardinal

The modern movement in Alberta at times showed respect for early First Nations' building traditions, particularly a reverence for nature. Nowhere in Alberta's architectural history is there a more original or formidable example of this respect than Douglas Cardinal. His Métis and Blackfoot heritage inspired a love of harmonious curvilinear form, a natural system based on the simple notion that there is no straight line in nature. Thus began a deeply personal, holistic philosophy around organic architecture, pioneered and lionized by Frank Lloyd Wright. However, unlike Wright who used the horizontal planes of prairie landscapes to ground his buildings and integrate them into their natural surroundings, Cardinal develops "object" or sculptural buildings on the ground.

The most original architect to come out of the province, Cardinal continues this oeuvre in new projects around the world. His office was an early adopter of computer-generated design and was inspired by the free-formed possibilities of moulded plastics. His first major commission—St. Mary's Church in Red Deer in 1968 (see figure 1.9)—could not have been built without computer-assisted design. This iconic project established his career, and, for many today, it remains one of his most striking buildings.

Douglas Cardinal completed many other works in Alberta, such as the Grande Prairie Regional College and the Ponoka and St. Albert town and

FIGURE 1.9. *St. Mary's Church, 1968, Red Deer. The curvilinear and spiral brick walls have a complex roof slope that required computer calculations to resolve.* Photograph courtesy of Douglas Cardinal and taken by Hugh Hohn.

government service centres. In later years he completed the Canadian Museum of Civilization, in 1989 (renamed the Canadian Museum of History in 2013), and designed the Smithsonian National Museum of the American Indian in Washington, DC, completed in 2004.

These architects of the late modern movement, iconoclasts each, showed commitment to the social ideal that architecture should deeply influence and change our lives. Their brilliant individual design skills—while all different—derive nevertheless from many tenets of the modern movement. This is the great architecture of Alberta, confidently establishing a sense of place—unique, authentic, and timeless in its setting.

Downtowns with lively streets, communal settings, parks, public art, buildings, skylines, and people contribute to a great city, regardless of location.

While splendid natural surroundings such as those found in Vancouver and Hong Kong are of iconic importance, great cities around the world share common values of people-friendly environments and streets, efficient movement systems, a clear self-image, cultural significance, and a confident sense of place. From Paris, San Francisco, and Copenhagen to smaller urban centres like Quebec City and Halifax, each demonstrates some, if not all, of this embodied energy through its downtown.

Prairie cities, aside from their own natural surroundings, rarely possess such character. Just as suburban housing development is so dramatically conspicuous in a prairie city, so too is the reckless pattern of shopping-mall development that systematically interferes with urban life and the quality of its growth.

Essential services are necessary in each suburb to enable comfort, convenience, and a complete lifestyle. With schools, churches, libraries, community parks, and playgrounds, prairie suburbs eventually grow into small towns. As they have the shopping district and town centre close by, the need for a lively, centralized downtown is eroded unless one actually works there.

In a typical suburban development of cul-de-sacs, limited sidewalks, and automobile-reliant families, the convenience of being able to access services with free parking by the front door proves irresistible, especially in winter. Shopping centres, once small and neighbourhood oriented, became larger regional centres with major grocery stores serving an increased catchment area. The appeal and value of a suburban neighbourhood, now largely homogenous, controlled, and fenced in, is often measured by its proximity to these retail centres. This is further reinforced by the even cheaper "power centre" of big-box stores built in the past fifteen years. An even better solution for developers, they offer greater convenience with the maximum number of cars being parked right at the front door.

Shopping downtown in bigger department stores could only hold its appeal for so long and is doomed when parking is hard to find or requires payment. The growth of the suburban shopping mall eradicated most leisure-time interest in a city's downtown, except for perhaps weekend theatre or concerts. Lacking a residential base, downtown development remained primarily focused on the workday. This resulted in a steady decline of downtown areas, exacerbated when economies stagnated, with pockets of expensive developable land left vacant or used as surface parking lots. The suburbs, in contrast, endured relentless growth further and further from the core. By the 1980s, prairie downtowns had effectively died.

During the 1970s and 1980s many cities across Canada devised urban redevelopment schemes aimed at luring people back downtown by increasing the retail mix and building their own upscale malls—climate enclosed, connected to office buildings, and offering underground parking, theatres, and restaurants. As most of these facilities ignored the street, pedestrian activity moved indoors, and downtowns were still left with open-space parking lots and undeveloped surrounding areas, now even more isolated. In prairie cities without a resident downtown population to support this infusion, since people were clearly not lured back from the suburbs, this was by and large a failed experiment.

Nowhere in Canada would the shopping-mall phenomenon be taken to such an extreme as in Edmonton. Already awash in strip malls and regional shopping centres in the late 1970s,[9] and with marginal retail activity downtown, the city approved yet another regional mall development, this time on an unprecedented scale. West Edmonton Mall (WEM) was devised to reinvigorate a flagging economy and collect much-needed tax revenue during the downturn of the early 1980s. It was an entirely new paradigm that illustrated a complete lack of understanding of the basic principles of urbanization and balanced growth. In a few short years it added to an already oversupplied retail inventory, becoming the world's largest shopping mall—in a city of less than one million people.

Opened in 1981, WEM ultimately changed the face of Edmonton and set back the cause of downtown redevelopment by twenty-five years. It

obligated the city's engineering and transportation departments to cope with focused infrastructure development to accommodate a plethora of new roads and services in the west end at the expense of other areas of the city. It altered the city's budget priorities, especially concerning downtown development. This mall as lifestyle, however, was a game changer—artificial, plastic, climate controlled, and manipulative, it enabled an escape from hot summers and cold winters and further alienated the street and places where people lived, worked, and played.

WEM arrived fully equipped with a whopping six million square feet of theatres, restaurants, nightclubs, the world's largest indoor water park with beaches, wave pools, slides, and sun-tanning areas, an indoor National Hockey League–sized ice rink, an indoor roller coaster, pirate ship, submarine fleet, aquarium, zoo, hotel, convention facilities, chapel, eight hundred stores, and its own police force.

Turning its back on the community and isolated from the rest of the city with its protective cocoon of blank walls and multi-storey parking garages, WEM invited people to frolic year-round inside this ultimate anti-urban experience.

And people came by the thousands.

Supporters claim that the enormous tourist boost and the mall's terrific economic impact trump everything the project leaves in its wake. WEM's regular catchment area includes families from across Alberta, Saskatchewan, and British Columbia who "power shop" in bulk for themselves and their friends—alternating monthly to gather months of communal supplies at a time—while taking in a movie, the beach, or a Roman bath–themed hotel room for the weekend. The mall's mass appeal is unmistakable, yet its true net negative impact on architecture and urban design has never been openly debated.

WEM was valued at more than C$900 million in 2007, and I asked the question then, while lamenting the myriad empty buildings and storefronts along a long stretch of Jasper Avenue: What if this investment had instead been made downtown? At the time, the existing light-rail-transit (LRT) infrastructure along the Jasper Avenue corridor, the empty buildings,

and the surface parking lots were fertile ground desperate for a lively mix of commerce and residential development, active streets, gathering areas, parks, public art, and, finally, more people.

If we wish to understand why we are now well into a new century and the topic of urbanizing the residential population is only just gaining traction in the prairie city, we need look no further than the full parking lots of the regional shopping mall and power centre.

World View and Influences on Alberta

The science of climate change notwithstanding, there can be no argument that we no longer live in a stable environment; catastrophic climate events affect humankind as never before. We must reset the goals and objectives of good design as a means to being more responsive to the world community and the environment.

Since the beginning of my own career I have regularly compared architecture in its current state with its beginnings, when built form was very simple—providing shelter against the elements. I continually contend that architecture from the nineteenth century through to our current social-media-obsessed information age has generally ignored climate and culture in the making of places and architecture authentic to its surroundings.

Today the built environment relies heavily on technological solutions to keep out the weather and provide what is hyped as state-of-the-art environmental control. We have seen this pattern exacerbated by "signature," form-based, self-absorbed architecture, fuelled by the architecture press, and driven by celebrity architects. "Starchitecture" is the result, from sculpted, impossible parametric forms into which myriad functions are programmed and shoehorned, to tall buildings and new cities that completely ignore their climate and place. These overstimulated constructs continue to perpetuate the placelessness of cities in every hemisphere, from Toronto to Shanghai to Sydney to Dubai, where buildings so similar compromise the integrity of architecture as a cultural expression or a reflection of its place.

Two Solitudes

As the province of Alberta settled into yet another cycle of its boom-and-bust history (this time a bust) from the 1980s until the millennium, the design professions and those who educated designers fell into a period of less certainty. No equivalent to the power of the modern movement emerged in Canada or around the world. In my view, even postmodernism proved facile—a weak, short-lived counterpoint to the austere style of modernism and its urbanistic failings. Today the design profession exists in tension between two philosophical architectural solitudes: the objectification of design largely as fashion and form, and a more self-effacing sustainability or resiliency agenda.

For architects, this represents a crossroads, and we must choose between intellectual but culturally insufficient, self-indulgent exercises in the promotion of form and surface (the object building) and the making of places and architecture with redeeming socio-cultural, economic, and environmental value (more design, less technology).

The Object Building

The building industry has experienced incredible internationalization through the Internet. Advances in building materials and computational parametric processes now enable complex construction just about anywhere. International offices work twenty-four-hour days in continuous rotating shifts to enable project teams to synchronize in real time with their offices around the globe. Complex projects can be assembled by remote control and robotics anywhere a GPS signal can be received. The opportunities presented by this sophistication in the digital age are staggering.

Yet these technological advancements continue to expose greater indifference to local geography and climate. One need only examine Dubai, home to some of the most exuberant and tallest buildings, as exemplar of architecture as fashion, resplendent in delicate western-hemisphere skin and superimposed into a 50°C, sun-baked, desert environment. These super tall buildings in the desert can only admit a fraction of the blinding,

existing light indoors and must at the same time reject tremendous solar energy due to their excessive height. They rely solely upon expensive, foreign, high-technology products and building systems to enable basic comfort within, while their embodied carbon footprint is enormous. Meanwhile their design principles remain mute about their location or culture.

Inherently working against the forces of nature, these buildings deny the existence of climate altogether. By contrast, a desert souk stays naturally habitable from the sea or desert breezes that are induced to flow through it. This becomes a basic issue of appropriateness and authenticity. In this context, architecture as fashion that yields a disharmonious relationship with nature has migrated a long way from the tipi.

More Design, Less Technology

The use of more design and less technology is environment oriented; it is the exploration of an entirely different approach to contemporary architecture and urban design. This approach was exposed on a large scale in 2012 at the Biennale Architettura in Venice, Italy, the widely recognized world olympics of architecture. Here, every two years, architects from fifty-two countries around the world exhibit their current work and examine noticeable trends and significant issues within their profession internationally. The Biennale is intended to be an ongoing dialogue in which architecture positions itself and sets its course for the future.

At the 2012 edition of the Biennale, recurring primal themes of sustainability, adaptive reuse, and even traditional building methods were woven through the various pavilions. As I wandered the grounds, I observed an underlying coherence from all corners of the globe, calling for a wholesale re-evaluation of the underlying principles of architecture. It was a convincing reminder that, as architects holistically trained, we are ethically bound to examine the complex forces that shape the world and the environment into which we place our buildings.

This culminated in the Lion d'Or–winning Japan exhibition that focused on sustainable housing and community through reuse of salvaged

coastline materials in the wake of its 2011 tsunami. The message was that architecture must not lose its way and instead must declare a more self-effacing search for meaning about sustainable design, place making, and resiliency in the twenty-first century.

Unlike the energy crisis of the 1970s that spawned the rise of eco-activists like Greenpeace, the movement toward a greener future and addressing climate change now has an intellectual *gravitas* that transcends the activist, demanding worldwide discourse and new public policy.

Since buildings on average represent 50 per cent of all energy consumed in developed countries, much of this from non-renewable resources, performance matters. Building performance measuring tools such as LEED (Leadership in Energy and Environmental Design), Green Globes, and other initiatives such as the Living Building Challenge and Architecture 2030 validate the green movement and its buildings as mainstream. Cities and governments around the world now mandate reductions in energy consumption, greenhouse gas emissions, and carbon footprint. Leaders are now developing regenerative design, where buildings create more energy or enviro-by-products (e.g., clean, harvested water) than they consume.

Currently, despite (or perhaps because of) its former resource wealth beget by non-renewable energy sources, Alberta is having to respond to this challenge amid significant public pressure. The province aims to be a world leader for the future, before its non-renewable resources are depleted. The design profession in Alberta, alongside the vast majority of colleagues in Canada, has embraced the ideals that clearly support the environment, the second solitude.

The future of architecture here is inexorably linked to an environmentally sustainable agenda. A young generation of Albertans have shown in recent years a clear sensitivity and commitment in this regard.

A Time to Abandon

This is a pivotal time for the general architectural profession, which, as mentioned, embraced the ideal of treading lightly on the earth with the emergence of the green movement alongside the alarm bells of climate

change and the need for resilient, low-carbon buildings. The increasing lack of support for the energy sector—while at times misplaced—is proof that the environmental agenda is now mainstream. There are a significant number of energy-certified and renewable-resource buildings in Canada and Alberta that rival the best of green buildings around the world. As such, sustainable design objectives provide a noble cause to re-energize the profession in Canada, after a generation of underfunded cities and government deficits in the 1980s and 1990s, and architects are responding.

It is not only architecture that is benefiting from this new attitude in Alberta. The idea of city is changing in the twenty-first century, more than in the boom of the 1950s and 1960s. In Alberta, the cities of Edmonton, Calgary, and Fort McMurray (recently devastated by wildfires and floods) are finally realizing that the costs of unfettered expansion—with infra-structure capital requirements and long-term maintenance—are no longer sustainable, and they are seeking alternatives through urbanization, densi-fication, new housing models, and downtown residential development to address these issues.

Progress here is painfully slow while we continue to suffer from annex-ation and suburban growth into fertile farmlands. One nevertheless senses an undeniable paradigm shift in the way that prairie cities are contem-plating their futures. The city of Edmonton has embraced urban infill and walkable neighbourhoods while developing Blatchford (see figure 1.10), an international competition–winning master plan, into a sustain-able, carbon-neutral, mixed-use, medium-density, walkable residential community for thirty thousand people and ten thousand jobs on its former municipal airport lands. Incredibly, the location of this site is in the heart of the city, a short eight minutes from its downtown. This entirely new community incorporates transit-oriented development; LRT; urban agricul-ture; recreation; health care and commercial services; primary, secondary, and post-secondary education; and a regional park at its epicentre. The original Blatchford master plan envisioned combining sustainable build-ings and Blatchford's own renewable energy systems for heating and electricity, with biomass and deep geothermal energy plants on site. The

FIGURE 1.10. *Blatchford, a sustainable community in Edmonton, 2011–13. Perkins+Will Architects, Group2 Architecture Interior Design, Barry Johns Architecture Limited, Civitas, Phillips Farevaag Smallenberg. Reproduced with permission from architect Barry Johns.*

regional park is part of this working infrastructure. It includes a man-made lake and a wind-protecting hillside, natural habitat areas for migrating birds and waterfowl, and a variety of natural water reclamation, treatment, and management strategies that could ultimately yield a completed development beyond carbon neutral. Its 520 acres is a fraction of the size of every Edmonton subdivision and is designed to be pedestrian and bicycle oriented, actively discouraging automobile use with narrow, leafy residential streets, small blocks, broad sidewalks, and public gathering places.

In many ways, the plan goes back to the future, reinventing the city as it once was—walkable, integrated, intimate, and connected. It is a new precedent for urban design in the city.

Calgary and Edmonton have also invested billions in the last decade to bring housing and increased density—and more festivals—to the downtown core. This residential influx especially is changing the prairie downtown as expected. Alongside the development of a new arena district in Edmonton and another planned for Calgary, there is finally a palpable interest in the design of public amenities. There is certainly room for the abandonment of sprawl economics in Edmonton, where there is traction around resetting downtown with the expansion of a pedestrian-friendly rapid-transit system, funicular and overhead trams, downtown markets, and temporary street closures such as those observed during the Jasper Avenue Open Streets Festival in the summer of 2019.

Architects are born optimists, and, as such, many of us have joined with others to combat climate change by promoting new sustainable and resilient development. Alberta is a province of almost limitless future opportunity blessed with peace, freedom, clean air, water, and space. It has a new generation of young, affluent multiculturals, an increasingly better educated and talented work force, and a knowledge base rapidly creating new industries in health care, e-commerce, and artificial intelligence. With many of these enterprises located downtown and fuelling new residential urban development, all are capable of demanding that it is neither too late to envision doing the right thing in building the city nor too soon to meet head on the complex needs of this new millennium.

Are We Ready?

There is still a gap between reality and this fresh and necessary attitude.

Despite the fact that Edmonton and Calgary have among the lowest population densities of cities in Canada,[10] developers continue to lobby for suburban growth and increased consumption of agricultural land. The City of Edmonton, despite its commitment to building Blatchford, still annexed

more land to the south in 2019, a few years after approving an area structure plan for new suburban housing in the northeast, areas each with a historic agricultural base. There was a time when Edmonton's and Calgary's international airports were deemed to be unacceptably distant from the city. Now the two cities are rapidly enveloping them.

The home building industry is a significant lobby, slow to change, and governments are quick to support it. Eventually the city will reach its borders and simply run out of options.

Government must be better committed to a consistent set of principles.

It makes little sense to promote densification and a sustainable design agenda, especially on long-term economic principles, while at the same time continuing to approve new subdivisions on superior agricultural soil. Doing the right thing inside the city core does not go hand in hand with continuing the status quo outside of it. It positions the city as philosophically weak and awkwardly behaving, as if there really was no impact from increased physical growth. This policy has dire infrastructure cost and servicing consequences over the long term—where citizens, no matter how far from the centre they might live, expect the exact same amenities and services to be provided. This expansion also continues to threaten the biodiverse nature of prairie cities at their edges. It becomes clear that an "end of growth" land-acquisition freeze is a logical and necessary next step for our long-term future.

The power of social media has reawakened environmental awareness, and climate change is now living-room conversation. This, as previously noted, is challenging the future of the fossil fuel industry and fossil fuel dependency—despite increasing worldwide demand and the necessity to feed global markets and sustain an economy. Environmental standards must be continually improved and managed. These are enormous, complex socio-cultural-economic and environmental concerns that at once pressure cities to engage better and more efficiently their resources to streamline infrastructure and urban development. Edmonton is expanding its LRT network at great cost, yet ridership has plateaued, and its underground network along the Jasper Avenue corridor remains, to this day, woefully

under-utilized. Edmonton, like other cities, is unique, and with this unique-ness comes the need for innovative local solutions, not universal ones. As a result, here and elsewhere, local civic priorities are being actively debated like never before, driven by a lack of faith in the political class and by increased activism at the local level of public engagement, which is changing the dynamic of city building.

Finally, while the impact of COVID-19 has not yet been fully absorbed, it has changed the world.[11] In just a few short months with normal daily life effectively shut down, the atmosphere around the globe has suddenly yielded cleaner air and clearer skies. This phenomenon is a disturbing reve-lation about how humankind wreaks havoc on the environment daily.

We need to seriously examine how we should live together in the future. It is a prerequisite for architects and architecture to address design ethics in this context—in Alberta and elsewhere. It is overdue but never too late to commit to sustainable, regenerative, resilient, inclusive, safe, and human-istic buildings, communities, and cities. These must improve our collective quality of life and, like our forebears, touch lightly upon the planet. Never has the epigraph from the beginning of the chapter carried more meaning: "Architecture must now construct anew the whole social pattern of our time as a new order of the human spirit" (Frank Lloyd Wright).

Notes

1. Crowston, *Capital Modern: A Guide to Edmonton Architecture & Urban Design, 1940–1969*.

2. Cited in Boddy, "Edmoderntown," 8.

3. Smith, "Edmonton's Suburban Explosion, 1947–1969," 43.

4. The Banff Session is a conference series of the Alberta Association of Architects that has taken place in Banff, Alberta, since 1956.

5. Many early modernists in the province would follow Richard Neutra, who returned to Alberta many times. For a listing of Alberta's early modern architects, see Murray and Fedori, "Overview of the Practice of Architecture in Edmonton, 1930–1969."

6. Trevor Boddy claims in the postscript to *Capital Modern: A Guide to Edmonton Architecture & Urban Design, 1940–1969*, referring to Edmonton in particular, that "the city stands out for conspicuously destroying its finest architecture" (155).

7. The building formerly known as Coronation Pool is the first and only building in Canada thus far to be named after its architect. It is now known as the Peter Hemingway Fitness and Leisure Centre.

8. Adrienne Clarkson, quoted in Martin, "The Greatest Architect We Have Ever Produced," para. 10.

9. Routinely and historically holding the top position in Canada for per capita retail sales, Edmonton is a favoured target market for new retail chains and trend testing for specialty stores in North America.

10. The 2016 Canadian census available through Statistics Canada shows that Edmonton occupied 768 km^2 of land, compared to the City of Toronto at 630 km^2. The Edmonton population in 2016 was 932,516, or 1,214 people per km^2, compared to that of Toronto at 2,731,571, or 4,335 people per km^2. Calgary occupied 825 km^2 with a population of 1,239,220 or 1,501 people per km^2 in 2016.

11. Johns had the opportunity to revise his writing in the summer of 2020 and reflected on the current and future impact of COVID-19.

Bibliography

Boddy, Trevor. "Edmoderntown: Four Factors Shaping Edmonton Architecture." In *Capital Modern: A Guide to Edmonton Architecture & Urban Design, 1940–1969*, edited by Catherine Crowston, 5–14. Edmonton, AB: Art Gallery of Alberta, 2007.

Crowston, Catherine, ed. *Capital Modern: A Guide to Edmonton Architecture & Urban Design, 1940–1969*. Edmonton, AB: Art Gallery of Alberta, 2007.

Martin, Sandra. "The Greatest Architect We Have Ever Produced." *Globe and Mail*, May 21, 2009.

Murray, David, and Marianne Fedori. "Overview of the Practice of Architecture in Edmonton, 1930–1969." In *Capital Modern: A Guide to Edmonton Architecture & Urban Design, 1940–1969*, edited by Catherine Crowston, 23–42. Edmonton, AB: Art Gallery of Alberta, 2007.

Pfeiffer, Bruce Brooks. *Frank Lloyd Wright: On Architecture, Nature and the Human Spirit*. Petaluma, CA: Pomegranate Communications, 2011.

Smith, Troy. "Edmonton's Suburban Explosion, 1947–1969." In *Capital Modern: A Guide to Edmonton Architecture & Urban Design, 1940–1969*, edited by Catherine Crowston, 43–50. Edmonton, AB: Art Gallery of Alberta, 2007.

Statistics Canada. "Data Products, 2016 Census." September 17, 2019. https://www12.statcan.gc.ca.

Visualizing Industrial Design and Its History in Alberta

ISABEL PROCHNER with LYUBAVA KROLL

THE FOLLOWING STATEMENT by architecture student Chris Chevalier reflects my thinking about design practice in Alberta: "I want [Edmonton, Alberta,] to be my first choice [in which to practise design], but we'll see. Depends how much of a martyr I want to be...Edmonton's got a lot of potential. It's just the trick of whether I want to stick around and wait for that to happen."[1] The experience of wanting to stay and work in Alberta but worrying about a lack of opportunities inspired the research behind this chapter and the anthology as a whole.

After studying industrial design at the University of Alberta (UAlberta), I worked as a designer in Edmonton and Calgary and have been involved in local design and creative communities. Through these experiences I recognize the vibrant design community in Alberta, but I also understand the challenges facing local designers. There are few industrial design jobs and little support for designers. After graduation I struggled to find relevant employment and found it difficult to understand how to apply industrial design education and experience to Alberta's workforce, economy, and socio-cultural context. I believe this experience is shared by my classmates, and many have since left the province or trained in other fields.

There is limited serious or in-depth attention, research, and writing about industrial design in Alberta. This lack contributes to a situation in which the industry is misunderstood, even by local designers. Designers must make decisions regarding their practice without current, accurate, or complete information about the industry, its areas of specialization, its strengths and weaknesses, and its place in Alberta.

These issues inspired me to explore Alberta's industrial design industry in my master's thesis, "Understanding the Past to Imagine the Future: The History of Industrial Design Practice in Alberta," completed at the Université de Montréal in 2012. Like many before me and many since, I left Alberta to work in design. However, the province has remained important to me, guiding my thesis and research in the past decade.

The goal of my thesis was to establish a foundation of information about industrial design practice in Alberta to assist local designers and help change the situation for future graduates of design programs. I documented a history of industrial design practice in Alberta and identified trends and driving forces in its development. Knowledge of design history helps structure contemporary thought, establish traditions, and add coherence to design activities.[2] As Brian Donnelly wrote in "Locating Graphic Design History in Canada," a recorded history unites designers and enables them to "consider the past...and imagine their future."[3]

Understanding and recognizing this history can inform individual designers and also help design practice in the province move forward. We can build on previous work and strengths, avoid known pitfalls, and bolster underdeveloped areas. While acknowledging weaknesses in local industrial design practice, I also recognize its strengths, potential, and promising directions for future development. Research outcomes can assist local industrial designers in making informed decisions about their practice and provide information to strengthen the industry and indicate its future directions.

The major results of this chapter's study are outlined in Lyubava Kroll's illustration. Kroll represents my key research findings in a chronological map of industrial design in Alberta. This complements the history component of my writing that fills the first half of the chapter. The second part of the chapter explores trends in the history, current practices, and my recommendations for the future of industrial design practice in Alberta.

The chapter is based on the major outcomes of my graduate research, conducted from 2010 to 2012, which included both primary and secondary research. *The History of Industrial Design in Alberta, Canada: 1900–1992* by

Denis Gadbois was a key resource. However, my research extended well beyond this work to include additional details and more recent events. I drew on sources including books, newspaper reports, archival documents, statistics, and interviews I conducted in 2011 with local design practitioners, technicians, and educators.[4] While I updated the writing and sources whenever necessary and possible, much of the chapter draws on this original work.

A History of Industrial Design Practice in Alberta

For the first half of the twentieth century, Alberta's major industries were cattle ranching and agriculture. There were few manufacturing industries, so facilities and support for industrial design work were minimal. As Denis Gadbois explained in *The History of Industrial Design in Alberta*, early industrial designers were untrained; they were "handymen" who created designs to facilitate their everyday lives and livelihoods. Their work typically involved adaptations of or modifications to imported agricultural machinery to address Alberta's climate or landscape. Examples include work by Frank and R. A. Van Slyke, Roy Mills, and Charles Sherwood Noble: respectively, Van Slyke Breaking Plow in 1910, Mills Wire Weeder in 1927, and Noble Blade Cultivator in 1936.

The exception to the lack of industrial design work and manufacturing was the ceramics industry in Medicine Hat, which was driven by local clay deposits and natural gas in the first half of the twentieth century.[5] Initially, the industry specialized in engineered building materials, including sewer pipes and bricks, but in 1915 the Medalta Stoneware Company (renamed Medalta Potteries in 1924) was among the first to expand production to household goods.[6] Medalta's industrial design products included jugs, kitchenware, and decorative painted pottery.[7]

In his *History of Industrial Design in Alberta*, Gadbois identified Thomas Hulme, art director and designer for Medalta Potteries from 1929 to 1954, as Alberta's first industrial designer.[8] Medalta operated until 1954, when it closed because of increased costs and competition.[9]

Following the discovery of large deposits of oil in Alberta in 1947,[10] the province's manufacturing industries, particularly those that served the oil and gas industry, grew and transformed.[11] Industrial design work remained scarce, but industrial designers occasionally collaborated on design and manufacturing of vehicles and shelters to enable access to resources in remote locations.[12] Examples include Hay and Harding's Alberta Bus (1958) and, though engineering based, Bruce Nodwell's Nodwell Tracked Carrier (1950s).[13]

In the 1950s, Alberta's cities experienced a building boom.[14] In Calgary and, to a lesser extent, Edmonton, suburban living surged.[15] In the new suburbs, Albertans sought space and quality of life rather than high design.[16] People purchased modern appliances and conveniences, but the majority of these products were designed and manufactured outside the province.[17]

The introduction of industrial design education programs in Alberta was the first step in developing Alberta's local, professional industrial design industry. This coincided with the emergence of professional industrial design practice in Quebec and Ontario. Across Canada, industrial design associations, education institutions, and studios were formed in the 1950s and 1960s.[18]

UAlberta in Edmonton introduced an industrial design undergraduate program in 1968 and a graduate program in 1970.[19] They were based in the Department of Art and Design, and students graduated with a bachelor of fine arts or a master of fine arts degree.[20]

In an interview with me, Jacques Giard, an industrial design instructor at UAlberta from 1975 to 1979, described the program's early development.[21] He explained that the Department of Art and Design was based on a British model of art and design education in which schools taught fine arts together with a design component. When first established at UAlberta, industrial design courses focused on arts and crafts rather than professional practice.

Giard trained in furniture design at the Institute des Arts Appliqués in Montreal and industrial design at Birmingham Polytechnic in the United Kingdom. He was the first industrial design practitioner to teach at UAlberta

and felt that previous instructors did not fully understand the field of industrial design. He noted a lack of attention to manufacturing, materials, processes, human factors, anthropometrics, and ergonomics: "By November, I can tell you, I wanted to get out of that place as fast as I can...I'm thinking to myself, they don't know what they are doing. It was a circus."

In 1976, Giard became design unit coordinator and implemented changes to the department. Under his leadership the industrial design program became more technical, though it remained predominantly arts based. Giard explained that in the 1970s when UAlberta's industrial design program was first established, "the whole concept of industrial design in Canada, more so in western Canada, was relatively new." In Alberta, he said, "You are in the middle of nowhere as far as industry...[so] there wasn't much work to be had." Giard ultimately left the program in 1979. As he explained, "it's one thing to be teaching industrial design at a university, but it's something else to not actually see it around you."

During this period, clients for industrial designers were limited to several companies: Abacus Engineering (pump jacks and pipe-painting machines for the oil fields), Climax Industries Ltd. (garbage can trolleys), Clobbergampe of Edmonton (display systems), Hoverlift Systems of Calgary (hovercrafts), International Brick and Tile of Edmonton (ovenware), International Quality Foods (bakery equipment), Kellough Brothers (ploughs), Leisure Ltd. (band saws and pottery wheels), Skyline Imports (horse whips), and Western Urethane Panels (modular homes).[22]

That said, the situation began to change when the Alberta government started planning the diversification of the provincial economy. Alberta was seen as too dependent on natural resources and the energy sector, which put the province at risk of a boom-and-bust economy.[23] Further, discussions were increasing about a national energy program that was projected to result in lower oil production and job loss in the province.[24]

With federal government support, Alberta explored ways to diversify its economy in the 1970s and 1980s.[25] This included collaborations between the government's Alberta Research Council and UAlberta and the University of Calgary (UCalgary),[26] as well as investment in new industries.

UCalgary started offering industrial design graduate degrees around 1980.[27] The new program focused on research, sustainable design, multimedia, design entrepreneurship, and human factors.[28] The diversification initiative may have driven its establishment. Denis Gadbois, senior instructor at UCalgary, started teaching in the industrial design program in 1989 after training at the Université de Montréal and Cranbrook Academy of Art in the United States.[29] In an interview he said: "The program was not a reaction to industry because industry never needed industrial design. We were supposed to increase diversity by producing industrial designers." The difficulty, he explained, was, "with manufacturing and industrial designers – which comes first?...How can we place our industrial designers except in companies?" At the time, Alberta had few manufacturing companies, and those that existed were not interested in working with industrial designers. Gadbois explained that the impact of the program "was supposedly to diversify industries in Alberta...The industry didn't respond well. They never really diversified in the way it was supposed to be."

Some diversification initiatives were more successful, however. This included certain investments in up-and-coming industries and export-oriented manufacturing industries, the latter being a category that was uncommon in Alberta at the time.[30] Of relevance to industrial designers was a focus on high technology, telecommunications, and electronics and microelectronics.[31] The medical device industry was also chosen because of its relation to these industries.[32]

Alberta's electronics industry thrived, aided by provincial tariff support, from 1988 to 1996.[33] Primary markets were the petroleum industry, computer industry, telecommunications, agriculture, and defence.[34] Employment for industrial designers was based primarily in Calgary. Several designers were active in telecommunications and worked for NovAtel Communications and Northern Telecom (Nortel).[35]

NovAtel Communications was established in 1983 through collaboration between Nova Corporation and Alberta Government Telephone.[36] NovAtel specialized in cellular technology and manufactured cellphones and cellular radio systems.[37] The headquarters were in Calgary, and there

was a manufacturing facility in Lethbridge.[38] The provincial government assumed full ownership in 1989, but NovAtel struggled because of financial and management issues.[39] The provincial government sold the company to the private sector in 1992 for a significant loss.[40] Part of the company was sold to Nortel, and part to an investor who transformed the company and its focus.[41]

In turn, Nortel was founded as a digital technology company in 1976.[42] It produced a range of telecommunications products including equipment and software.[43] Though not based in Alberta, at its peak in 2000 Nortel had three manufacturing facilities, and a research and development office in Calgary.[44] In 2009, the company filed for bankruptcy[45] and withdrew from Calgary.[46]

Alberta's electronics industry continues to exist. In 2011, I interviewed Rob Gallant, a machinist who worked at NovAtel and who works with industrial designers in Alberta's electronics design and manufacturing industry.[47] He said that the electronics industry had expanded across Alberta but remained based primarily in Calgary. At the time of the interview the Alberta electronics industry was focused on telecommunications equipment, consumer products, and, to a lesser extent, the oil and gas industry.

Aided by provincial support and grants, the medical device industry also thrived, beginning in the 1980s.[48] Robert Lederer, a medical designer and a faculty member in industrial design at UAlberta, described the development of the industry.[49] The medical device industry focused on a variety of types of medical design. Product development was conducted through private practice and university research. Unlike Alberta's other design and manufacturing industries, the medical device industry is distributed across Alberta and has been relatively stable. PriMed Medical Products is an example of a company that has experienced enduring success in Alberta.

Office furniture is a category of industrial design and manufacturing that has developed independently and experienced success, especially in Calgary. Several companies have designed furniture and workspaces for Calgary's corporate offices and headquarters. SMED is a key example of an office furniture company that was active in the 1990s and 2000s. It was

established by Mogens Smed in 1996.[50] The company designed custom office interiors and office furniture.[51] SMED had a large manufacturing plant in Calgary and was known to employ alumni of UCalgary's industrial design program.[52] In 2000 the company was purchased by Haworth, an American office furniture company, which closed the Calgary plant in 2009 and moved its North American manufacturing operations to Michigan as a cost-saving measure.[53]

Edmonton has been recognized for design of contemporary furniture and home decor and for studio manufacturing and craft-based design practices. Studio manufacturing "bridges craft and industry"; a studio manufacturer is a designer-manufacturer who "acquires finished components, or else subcontracts these to small specialized industries, then assembles and fine-tunes the product in [their] studio."[54] Studio manufacturing has limited production and is often developed because of limited manufacturing opportunities.[55] In Alberta it is often a craft-based design practice. While it responds to manufacturing opportunities, studio manufacturing also reflects appreciation for handmade production methods.

Hothouse and Pure Design are examples of companies that reflected these specializations, especially in their early days. Both were established by UAlberta industrial design graduates and were active in the 1990s and 2000s. They specialized in contemporary furniture and home products made from metal and wood and were ground breakers in Edmonton.[56] Tom Sharp of Hothouse explained, "There was really no one to model ourselves on, and there certainly wasn't anyone knocking on the door looking for protegés."[57]

I met with Tim Antoniuk of Hothouse and Geoffrey Lilge of Pure Design in 2011 to discuss the development of both companies. Hothouse was formed in 1993 by seven graduates of UAlberta's industrial design program and one graphic designer who had studied at Grant MacEwan University in Edmonton.[58] Antoniuk explained: "[W]e formed a collective and were very idealistic about what we were going to do...[W]e all had our own designs, our own little businesses, but we [worked] under the Hothouse name."[59] In 1994, members Geoffrey Lilge, Dan Hlus, and Randy McCoy left

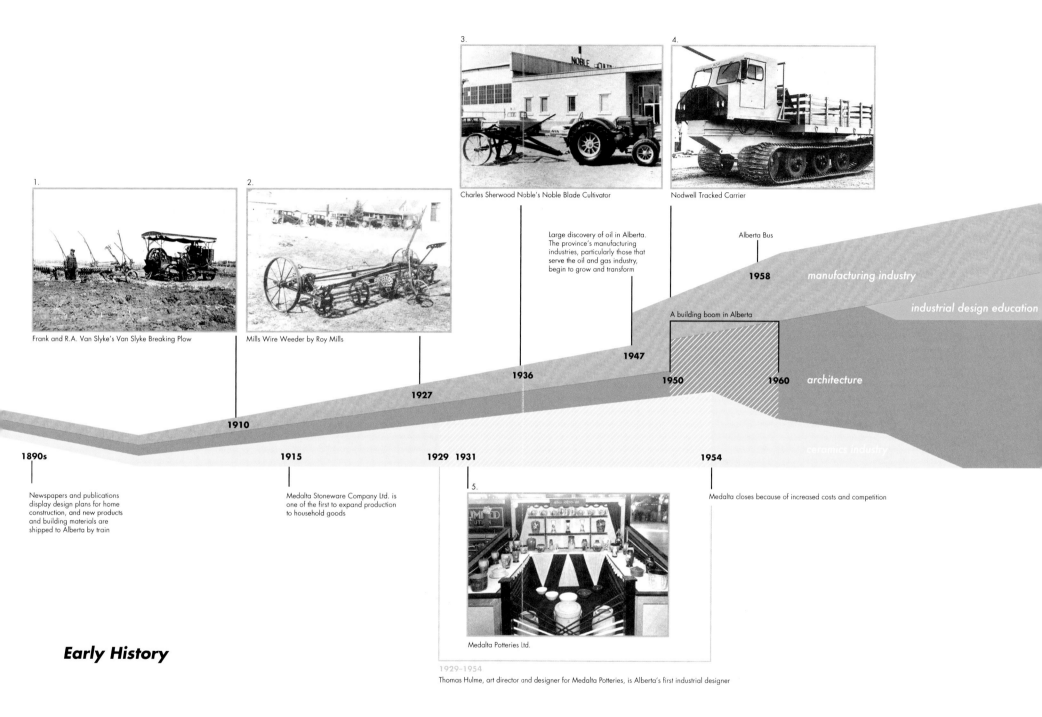

3.

Charles Sherwood Noble's Noble Blade Cultivator

4.

Nodwell Tracked Carrier

1.

Frank and R.A. Van Slyke's Van Slyke Breaking Plow

2.

Mills Wire Weeder by Roy Mills

Large discovery of oil in Alberta. The province's manufacturing industries, particularly those that serve the oil and gas industry, begin to grow and transform

Alberta Bus

1958

manufacturing industry

industrial design education

A building boom in Alberta

1947

1936

1950

1960

architecture

1927

1910

1890s

1915

1929 1931

1954

ceramics industry

Newspapers and publications display design plans for home construction, and new products and building materials are shipped to Alberta by train

Medalta Stoneware Company Ltd. is one of the first to expand production to household goods

Medalta closes because of increased costs and competition

5.

Medalta Potteries Ltd.

1929–1954

Thomas Hulme, art director and designer for Medalta Potteries, is Alberta's first industrial designer

Early History

FIGURE 2.1. *Visualizing Industrial Design and Its History in Alberta (pp. 43–46).*
Design by Lyubava Kroll.

1. *Van Slyke Breaking Plow by Frank and R. A. Van Slyke, 1910. Photograph courtesy of the Glenbow Archives NA-2292-1.*

2. *Mills Wire Weeder by Roy Mills, 1927. Photograph courtesy of the Glenbow Archives NA-3345-5.*

3. *Noble Blade Cultivator by Charles Sherwood Noble, 1942. Photograph courtesy of the Glenbow Archives NA-4884-29.*

4. *Nodwell Tracked Carrier designed by Bruce Nodwell and manufactured by Robin-Nodwell Manufacturing Ltd., 1960s model. Photograph courtesy of the Glenbow Archives NA-2408-22.*

5. *Medalta Potteries Ltd.'s booth at "Produced in Alberta" exhibition in Edmonton, Alberta, 1931. Photograph courtesy of the Glenbow Archives ND-3-5905.*

6. *Hothouse Otter Compact Disc Rack, 1995. Photograph used by permission of Tim Antoniuk.*

7. *Jim Stool by Scot Laughton and James Bruer for Pure Design, 1997. Photograph used by permission of Offi & Co. and www.puredesignonline.com.*

8. *Bongo Lamp/Stool by Karim Rashid for Pure Design, 1999. Photograph used by permission of Offi & Co. and www.puredesignonline.com.*

9. *XL Hole Slab designed by Geoffrey Lilge and manufactured by OnOurTable. Photograph used by permission of Geoffrey Lilge.*

10. *Sealed Fusion by Lawrence Ly, 2011. Photography used by permission of Lawrence Ly.*

11. *Chicago Green Learning Center by DIRTT, 2013. Photograph used by permission of DIRTT.*

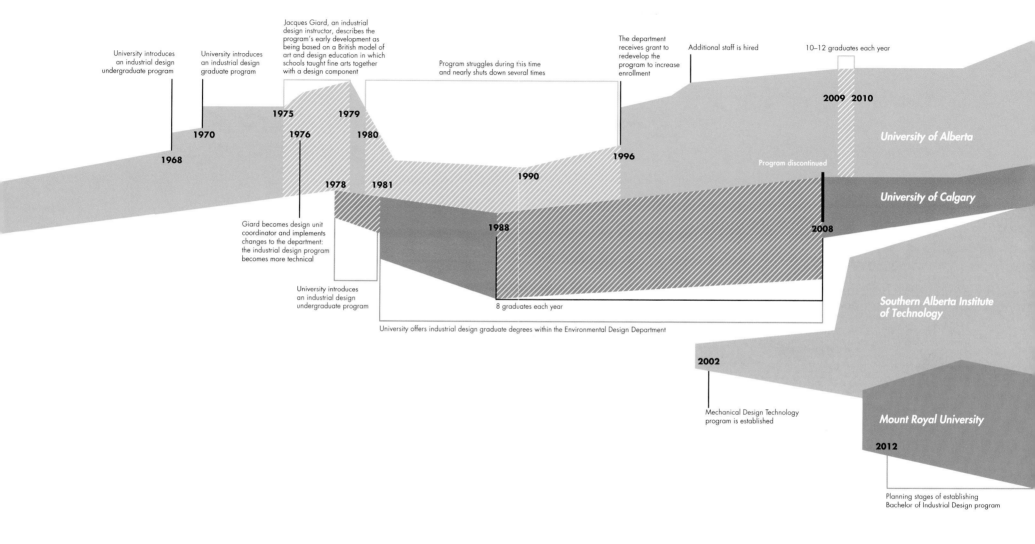

University introduces an industrial design undergraduate program

University introduces an industrial design graduate program

Jacques Giard, an industrial design instructor, describes the program's early development as being based on a British model of art and design education in which schools taught fine arts together with a design component

Program struggles during this time and nearly shuts down several times

The department receives grant to redevelop the program to increase enrollment

Additional staff is hired

10–12 graduates each year

2009 2010

1975

1979

1970

1976

1980

University of Alberta

1968

1996

1990

Program discontinued

1978

1981

University of Calgary

Giard becomes design unit coordinator and implements changes to the department: the industrial design program becomes more technical

1988

2008

University introduces an industrial design undergraduate program

8 graduates each year

University offers industrial design graduate degrees within the Environmental Design Department

Southern Alberta Institute of Technology

2002

Mechanical Design Technology program is established

Mount Royal University

2012

Planning stages of establishing Bachelor of Industrial Design program

Industrial Design Education

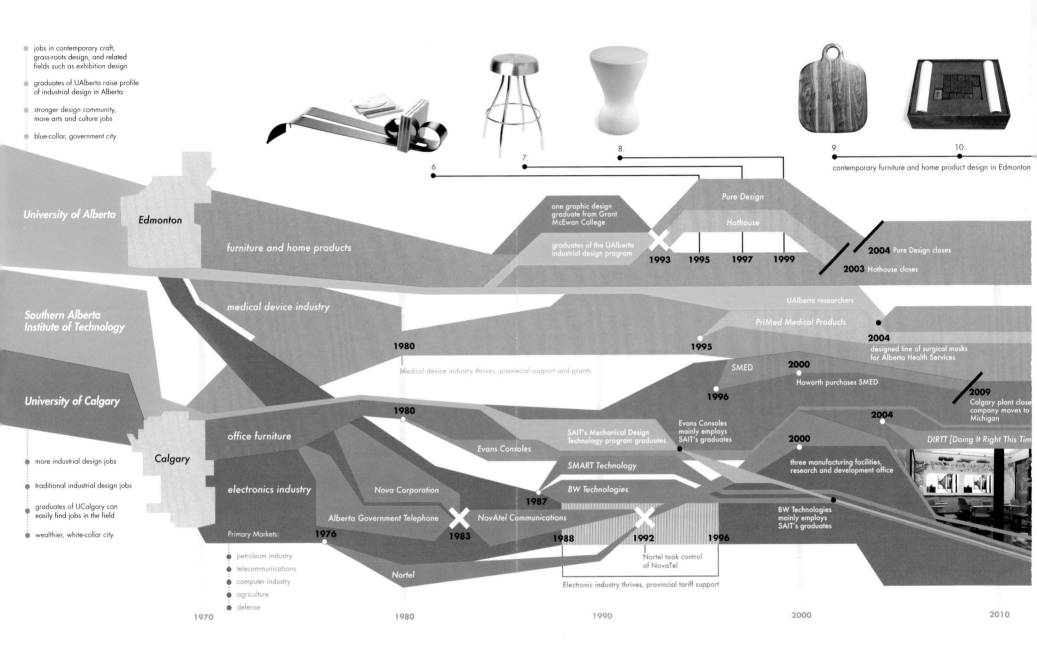

jobs in contemporary craft, grass-roots design, and related fields such as exhibition design

graduates of UAlberta raise profile of industrial design in Alberta

stronger design community, more arts and culture jobs

blue-collar, government city

6. 7. 8. 9. 10.

contemporary furniture and home product design in Edmonton

University of Alberta Edmonton

furniture and home products

one graphic design graduate from Grant McEwan College

graduates of the UAlberta industrial design program

Pure Design

Hothouse

1993 1995 1997 1999

2004 Pure Design closes

2003 Hothouse closes

Southern Alberta Institute of Technology

medical device industry

UAlberta researchers

PriMed Medical Products

2004 designed line of surgical masks for Alberta Health Services

1980 **1995**

Medical device industry thrives, provincial support and grants

SMED **2000** Haworth purchases SMED

1996

University of Calgary

office furniture

SAIT's Mechanical Design Technology program graduates

Evans Consoles mainly employs SAIT's graduates

2004

2009 Calgary plant close company moves to Michigan

1980

Evans Consoles

SMART Technology

2000 three manufacturing facilities, research and development office

DIRTT [Doing It Right This Tim

Calgary

electronics industry

Nova Corporation

BW Technologies

1987

BW Technologies mainly employs SAIT's graduates

more industrial design jobs

traditional industrial design jobs

graduates of UCalgary can easily find jobs in the field

wealthier, white-collar city

Alberta Government Telephone

NovAtel Communications

Primary Markets: **1976** **1983** **1988 1992 1996**

Nortel took control of NovaTel

petroleum industry
telecommunications
computer industry
agriculture
defense

Nortel

Electronic industry thrives, provincial tariff support

1970 1980 1990 2000 2010

Relationship between Industrial Design Education and Current Practices

Hothouse and started their own company called Pure Design.[60] Lilge said that they wanted a more professional shop and to "take it to the next level of manufacturing."[61]

Hothouse and Pure Design were stylistically different with different marketing strategies, "but essentially...were pretty similar."[62] Pure Design designed as a group rather than as individuals.[63] It had a diverse collection of products and a marketing plan that involved working with outside designers, including Karim Rashid, Scot Laughton, and Richard Hutten.[64] Antoniuk explained that when Pure Design was formed, the remaining members of Hothouse followed its model and began to design collectively.

Both companies experienced success. It was difficult to find interesting products outside major cities, so "if you had something new at the time, you would just sell tons."[65] Hothouse and Pure Design exploited popular new product categories. Lilge said that, for both companies, the "bread and butter products in the first five years were CD racks...CD racks were a niche that we really needed. We exploited it, and it was very profitable."

In the late 1990s, Hothouse and Pure Design expanded throughout Canada and the United States.[66] Pure Design continued to make its products in-house, but Hothouse began to send production to eastern Canada and Saskatchewan and experiment with offshore manufacturing.[67] Hothouse established two retail stores in Edmonton and one in Calgary and sold to customers across Alberta.[68] Antoniuk noted, "We sold in way more places in Alberta than a company from Toronto could have sold in Edmonton." However, the majority of their sales were international, with 60 per cent of sales going to the United States. Pure Design did not have retail stores, and 80 per cent of its sales went to the United States.[69]

Both companies ceased operations in the early to mid-2000s because of a "perfect storm of different economic conditions."[70] These included an increasingly sophisticated and competitive market, decreased exports to the United States after September 11, 2001, and a stronger Canadian dollar.[71] Hothouse closed in 2003,[72] and Pure Design in 2004.[73]

Looking back, it is clear that industrial design practice in Alberta follows
local industries. Practice has related to the agricultural and oil and gas
industries and to the presence of manufacturing. Changes to Alberta's
industries, and fluctuations in the provincial economy, have an impact on
the focus and strength of the industrial design industry.

Alberta's industrial design industry is vulnerable because of its location,
small local market, and often low profile of industrial design work. These
vulnerabilities are significant when a company conducts design and manu-
facturing locally. Although Alberta companies may have a local advantage
for contracts and sales, companies must often ship their products to major
centres in Quebec and Ontario, and some have been dependent on exports
to the United States. There are also many cases where offices and manufac-
turing facilities have left Alberta to set up in cheaper locations.

Another trend in this history is the important role of design education.
The establishment of the industrial design program at UAlberta corresponded
with the appearance of some of the first industrial design practitioners in
the province. Although there are other industrial design–related higher
education programs in Alberta,[74] the programs at UAlberta and UCalgary
were especially significant because they were in operation for decades and
began when the field was emerging in western Canada. While UAlberta's
program still operates, UCalgary's industrial design program was discon-
tinued in 2008.[75]

UAlberta and UCalgary had a different focus and made different contri-
butions to industrial design practice in Alberta. UAlberta's industrial design
program has been seen as arts-based and theoretical, while UCalgary's
program was more technical and focused on research. The social, cultural,
and economic contexts in Edmonton and Calgary inspired the programs,
and in turn, the programs influenced industrial design practice in each city.

Edmonton and Calgary have a different approach to design and
different opportunities for designers. There are more industrial design
jobs in Calgary, but Edmonton has a stronger design community and more
arts and culture jobs.[76] Industrial designers in Calgary occupy traditional

industrial design jobs, while in Edmonton they often work in contempo-
rary craft, grassroots design, and other related fields, including exhibition
design.[77] Interviewees linked this to the different characters of the two
cities: Edmonton as a blue-collar, government city and Calgary as a slightly
wealthier, white-collar city.[78]

Related to this last point, the social landscape in Alberta also has a big
impact on local design industries. From the 1990s, Alberta's creative indus-
tries and industrial design industry started to develop a higher profile. This
was partly due to population growth, increased social and cultural diver-
sity, and resulting societal changes. Fluctuations in the provincial economy
affected population growth and migration to the province. During booms,
Alberta's population increases, and its cultural and creative industries thrive.

More recently, the Alberta economy has experienced a downturn, and
the industrial design industry is developing slowly. In a 2011 interview,
Gadbois explained that the growth of industrial design practice in Alberta
"is not exponential at all...There are no more designers here than there
were in 1990...I have the impression that industrial design in Alberta will
always be marginal."[79]

Government support programs for industrial design were implemented
as part of provincial economic diversification policies in the 1970s and 1980s.
These programs were successful in developing several design specializa-
tions in Alberta, but they were unevenly implemented and were not long
term. Alberta's economic diversification strategy did not fully encourage
the growth of local manufacturing industries, with the exception of elec-
tronics and medical design.

Today industrial designers in Alberta continue to work in similar fields,
and similar distinctions exist between practice in Edmonton and practice
in Calgary. At the time of my research, there were less than fifty traditional
industrial design jobs in Alberta.[80] These jobs exist primarily in Calgary and
are based in large companies with design offices, in spin-off companies
from the oil and gas industries, or in office furniture design companies.[81]
The remaining industrial designers often form small design collectives,
conduct studio manufacturing, or apply their skills to other fields. The

following companies were mentioned by interviewees and are some high-profile examples of current industrial design work in Alberta.

SMART Technologies is a Calgary-based company that was founded by David Martin and Nancy Knowlton in 1987.[82] The company was originally a distributor for an American projector company, but in 1991 Martin and Knowlton designed one of the world's first interactive whiteboards.[83] Their SMART boards are sold internationally to education facilities, public institutions, and private companies.[84] Foxconn, an international electronics company, acquired SMART Technologies in 2016.[85] However, SMART Technologies remains a leader in its field.

PriMed Medical Products was founded in 1995 in Edmonton.[86] The company designs and manufactures disposable medical products, including surgical masks and gowns.[87] In 2004 it designed a line of surgical masks in collaboration with UAlberta researchers and Edmonton's Capital Health,[88] now Alberta Health Services. The company operates manufacturing facilities in China.[89]

Evans Consoles was established in 1980 in Calgary.[90] The company is based in Calgary and has a local manufacturing plant, but has subsidiaries across the world.[91] It designs and manufactures custom control-room furniture and consoles for settings including data processing centres, call centres, and air traffic control.[92]

BW Technologies was established in 1987 in Calgary.[93] It is based in Calgary but was bought by First Technology PLC,[94] and later Honeywell in 2006.[95] The company designs and manufactures gas-detection instruments for industrial applications.[96]

DIRTT, or Doing It Right This Time, was founded by Mogens Smed of SMED in 2004.[97] The company is based in Calgary and has manufacturing facilities there and in British Columbia and the United States.[98] It designs and manufactures modular office walls.[99] DIRTT has corporate clients in Alberta and across North America.[100]

Finally, Geoffrey Lilge is the founding designer of OnOurTable, a wooden-cutting-board design and manufacturing company. Tim Antoniuk suggested that Lilge's business provides a good example of studio

manufacturing in Edmonton.[101] Lilge explained: "[I] designed a company that I wanted to operate. I wanted to design my own lifestyle and my own way of doing business...I'm not doing trade shows and not getting a ton of publicity, but I'm selling enough so I can make a living."[102] OnOurTable sells to retailers in Canada and to individual consumers in the United States through its website.

Recommendations and a Vision for the Future

Considering the history and these examples, there is a relatively good precedent for industrial design practice in Alberta. Companies have been successful and delivered good products, at least for a little while. However, the estimations of the low number of industrial design jobs and the eventual shuttering of many companies are concerning. From my perspective, few Alberta industrial design companies have experienced big success and significant external recognition. Based on this research and analysis, I have some recommendations for the future development of industrial design practice in Alberta.

First, the industry must continue to build on its areas of strength and promise. Alberta's industrial design industry has several specializations with long-standing success. These include electronics design, medical product design, office furniture design, contemporary craft, and alternative models of industrial design practice. Building on these successful specializations may be a promising strategy. Another good option would be to choose strategically a new design specialization. For example, digital creation or projects that enable remote work could be appropriate given Alberta's location and local context.

My second recommendation is to strengthen relationships between education, practice, and industry. Alberta's manufacturing industry is not always welcoming or appropriate for industrial designers, yet benefits exist for both parties to improve this situation. Designers can provide a valuable workforce and bring unique expertise into industry. In addition, strengthening the relationship between design education and professional practice would be valuable to help students apply their skills to the workforce.

Technical skills are highly valued in industrial design practice and are a significant factor in the employment of industrial designers in Alberta. The industrial design programs at UAlberta and UCalgary have been critiqued for lacking technical training.[103] I believe that a balance must be struck between teaching technical skills that are valuable to industry, and supporting the value of design and creative skills in industry.

Third, we must unify the local design community. Designers maintain strong links and a sense of community within their city and academic institutions, but there are few connections across the province and between Edmonton and Calgary. For example, no students at UCalgary's graduate-level industrial design program were ever graduates of UAlberta's undergraduate industrial design program.[104] A stronger and more unified industrial design community would support designers, enable the sharing of information, and continue to raise the profile of industrial design practice in Alberta.

Finally, we need stronger funding and policy support for design. Government funding has been successful in supporting industrial design practices, which have now become specializations in the province. Wider and more consistent funding and policies would have a major impact on industrial design practice.

My view is that each of these recommendations is possible and would have a significant impact on industrial design practice in Alberta. Nevertheless, Alberta's context poses limitations that restrict and guide the development of Alberta's industrial design industry. Although it would be nice to see, I suspect that significant government or policy support for design is unlikely. With this in mind, contemporary craft and grassroots design practices have great potential. While other design specializations, such as electronics design, medical product design, and office furniture, would likely depend on significant support to grow, contemporary craft and grassroots design can develop independently in the local design community and through collaboration with local academic institutions. In addition, design practices of this kind can help create an Alberta design identity and contribute to a collection of work with a national or international reputation.

Some local designers and design educators are optimistic about the potential of these specializations.[105] As Tim Antoniuk explained, "we're not designers of the next iPhone or the next Wii...We don't have any of the infrastructure to really support that."[106] He added that "alternative creative clusters make a lot of sense for Edmonton...that's where the potential of Edmonton is and largely Calgary." However, others point out that these specializations are fringe practices that may only have a small impact on the local economy.[107]

Although this anthology has many audiences, this chapter has been written especially for local designers. I hope the research will inform and inspire their work. Local designers struggle from a lack of information about the industry, its areas of specialization, and its strengths and weaknesses. This study provides a foundation of information and indicates promising directions for future development to help guide industrial design practice and develop further Alberta's industrial design industry. I believe that Alberta designers should be confident in their practices and careers and recognize the importance and value of their work. However, they must be mindful of the limits of local practice resulting from complex social, economic, political, and geographic factors.

Notes

1. Chevalier, quoted in Fong, "If We Build It, Will They Come?," para. 1.
2. Dilnot, "The State of Design History: Part 1, Mapping the Field"; Margolin, "Design in History."
3. Donnelly, "Locating Graphic Design History in Canada," 288.
4. Interviewees included Gadbois, Tim Antoniuk, John Greg Ball, Alan Boykiw, Cezary Gajewski, Rob Gallant, Jacques Giard, Robert Lederer, Geoffrey Lilge, and Sean Maw. They all work or have worked in Edmonton or Calgary, and most have experience in both industrial design practice and design education.
5. Hayward, *Alberta Pottery Industry*.
6. Hayward.
7. Hayward.
8. Details about Thomas Hulme's employment at Medalta Potteries are taken from Hayward, *Alberta Pottery Industry*.

9. Hayward, *Alberta Pottery Industry*.

10. Hanson, *Dynamic Decade*.

11. Alberta Heritage, "Home and Lifestyle"; Gadbois, *History of Industrial Design in Alberta*.

12. Gadbois, *History of Industrial Design in Alberta*.

13. Gadbois; Alberta Heritage, "Alberta Inventors and Inventions."

14. Boddy, *Modern Architecture in Alberta*.

15. Boddy; Forseth, "Curator Statement"; Stamp, "Suburban Modern."

16. Stamp, "Suburban Modern."

17. Alberta Heritage, "Home and Lifestyle"; Stamp, "Suburban Modern."

18. In *Design in Canada since 1945: Fifty Years from Teakettles to Task Chairs*, authors Rachel Gotlieb and Cora Golden explain that industrial design practice in Canada began to emerge after the Second World War. The federal government supported industrial design as part of a post-war reconstruction policy. The Industrial Design Information Division, a federal government committee focusing on industrial design issues, was formed in 1947. It was later renamed the National Industrial Design Committee, the National Industrial Design Council, and then Design Canada. According to an Association of Canadian Industrial Designers (ACID) history text, ACID and the Ontario and Quebec versions, ACIDO and ADIQ respectively, were established in the 1950s and 1960s. Industrial design education programs were established beginning in the late 1960s. ACID, "A Short History."

19. University of Alberta Archives, *From the Past to the Future*.

20. University of Alberta Archives. According to Jorge Frascara in "Rethinking Design," the program changed in the 1990s, and UAlberta started offering design degrees.

21. Jacques Giard, interview by author, October 6, 2011.

22. "Companies in the News: International Brick," *Globe and Mail*, July 8, 1978; C. French, "Shipping: Lang Expected to Call Tenders Soon for Construction," *Globe and Mail*, March 29, 1979; Jacques Giard, interview by author, October 6, 2011; J. R. Hughan to A. Vanterpool, June 8, 1978, index 86.521, box 18, Provincial Archives of Alberta.

23. Canada Western Diversification Office, *A Framework for Diversification in Western Canada*.

24. Foster Research and SRI International, *Re-assessment of the Elements of an Economic Strategy*; Goyette and Roemmich, *Edmonton in Our Own Words*; Voisey, "Alberta." In "National Energy Program," author Bregha explains that the program was established in 1980 to help anchor oil production in Canada through greater federal control over production, additional royalties and taxes, and lower local prices. As predicted in Alberta, it was a blow to the provincial economy. It also coincided with a global recession, which made matters worse. Although the National Energy Program was quickly dismantled, it remains a sore spot for many Albertans to this day.

25. A. Vanterpool to K. H. G. Broadfoot, December 4, 1980, index 86.521, box 3, Provincial Archives of Alberta.

26. Foster Research and SRI International, *Re-assessment of the Elements of an Economic Strategy*.

27. Conflicting dates are provided for the beginning of the industrial design program at UCalgary. They range from 1978, in Price Waterhouse, *Shaping Canada's Future by Design*, to 1981, in Gadbois, *History of Industrial Design in Alberta*.

28. Gadbois, *History of Industrial Design in Alberta*.

29. Denis Gadbois, interview by author, October 7, 2011. The interview was conducted in French and English. I translated French statements into English for this text.

30. Foster Research and SRI International, *Re-assessment of the Elements of an Economic Strategy*.

31. O. S. Hnatiuk to A. Vanterpool, February 19, 1980, index 86.521, box 2, Provincial Archives of Alberta.

32. Fontana, "A Development Strategy for a Medical Device Industry in Alberta."

33. Denis Gadbois, interview by author, October 7, 2011.

34. Electronics Industry Association of Alberta, *Electronics Industry*.

35. Alan Boykiw, interview by author, October 25, 2011; Denis Gadbois, interview by author, October 7, 2011.

36. Auditor General of Alberta, *Report on NovAtel Communications*.

37. Auditor General of Alberta.

38. Electronics Industry Association of Alberta, *Electronics Industry*.

39. Auditor General of Alberta, *Report on NovAtel Communications*; Rob Gallant, interview by author, December 12, 2011.

40. Gignac, "No Wires in Nortel's Future"; Nelson, "NovAtel."

41. Rob Gallant, interview by author, December 12, 2011.

42. MacDonald, *How Innovation and Vision Created a Network Giant*.

43. Austen, "Nortel Seeks Bankruptcy Protection."

44. Alberta Economic Development, *Electronics and Telecommunications*.

45. CBC News Business, "Key Dates in Nortel Network's History."

46. Teel, "Nortel Pulling Out of Calgary."

47. Rob Gallant, interview by author, December 12, 2011.

48. Robert Lederer, interview by author, November 29, 2011.

49. Lederer, interview.

50. Verburg, "His Party, Your Hangover."

51. Verburg.

52. Denis Gadbois, interview by author, October 7, 2011.

53. CBC News Business, "600 Calgary Jobs Lost."

54. Gotlieb and Golden, *Design in Canada since 1945*, 34.

55. Gotlieb and Golden, 34.

56. Phillips, "Hothouse Grown."

57. Cited in Phillips, "Hothouse Grown," p. F1.

58. Geoffrey Lilge, interview by author, October 20, 2011.

59. Tim Antoniuk, interview by author, October 13, 2011.

60. Alberta Heritage, "Pure Design."

61. Geoffrey Lilge, interview by author, October 20, 2011.

62. Lilge, interview.

63. Tim Antoniuk, interview by author, October 13, 2011.

64. Antoniuk, interview.

65. Antoniuk, interview.

66. Antoniuk, interview.

67. Antoniuk, interview.

68. Antoniuk, interview.

69. Geoffrey Lilge, interview by author, October 20, 2011.

70. Lilge, interview.

71. Tim Antoniuk, interview by author, October 13, 2011; Geoffrey Lilge, interview by author, October 20, 2011.

72. Antoniuk, interview.

73. Geoffrey Lilge, interview by author, October 20, 2011.

74. This includes the Mechanical Design Technology program at the Southern Alberta Institute of Technology, which focuses on product development and the technical functionality of products. Mount Royal University also considered establishing a bachelor of industrial design program.

75. Denis Gadbois, interview by author, October 7, 2011.

76. Tim Antoniuk, interview by author, October 13, 2011; John Greg Ball, interview by author, October 25, 2011; Denis Gadbois, interview by author, October 7, 2011.

77. Antoniuk, interview; Gadbois, interview.

78. Antoniuk, interview; Gadbois, interview; Statistics Canada, "Population of Census Metropolitan Areas."

79. Gadbois, interview.

80. Alan Boykiw, interview by author, October 25, 2011; Denis Gadbois, interview by author, October 7, 2011.

81. Boykiw, interview; John Greg Ball, interview by author, October 25, 2011.

82. SMART Technologies, "The History of SMART."

83. SMART Technologies; Alan Boykiw, interview by author, October 25, 2011; Alberta Heritage, "The SMART Board."

84. Toneguzzi, "SMART Sets Sights on $1-Billion Mark."

85. Stephenson, "SMART Technologies to Be Acquired."

86. Sammer, *Cool Companies*.

87. Sammer.

88. Sammer.

89. Sammer.

90. Evans Consoles, "Our Company."

91. Toneguzzi, "Global Command Central."

92. Evans Consoles, "Our Company."

93. BW Technologies, "Company Profile."

94. Gignac, "BW Technologies Acquired for $260M."

95. BW Technologies, "Company Profile."

96. Gignac, "BW Technologies Acquired for $260M."

97. DIRTT, "Company."

98. Toneguzzi, "DIRTT Succeeds."

99. Mayle, "DIRTT Manufacturing Plant."

100. Toneguzzi, "DIRTT Succeeds."

101. Tim Antoniuk, interview by author, October 13, 2011.

102. Geoffrey Lilge, interview by author, October 20, 2011.

103. John Greg Ball, personal communication, October 25, 2011; Sean Maw, interview by author, October 25, 2011.

104. Denis Gadbois, interview by author, October 7, 2011.

105. Tim Antoniuk, John Greg Ball, and Geoffrey Lilge.

106. Tim Antoniuk, interview by author, October 13, 2011.

107. Alan Boykiw and Denis Gadbois.

Bibliography

ACID. "A Short History." July 24, 2006. http://www.designcanada.org/history.html.

Alberta Economic Development. *Electronics and Telecommunications: Alberta Directory*. Edmonton, AB: Alberta Economic Development, 2000.

Alberta Heritage. "Alberta Inventors and Inventions." 2005. http://www.abheritage.ca.

———. "Home and Lifestyle." 2005. http://www.abheritage.ca.

———. "Pure Design." 2005. http://www.abheritage.ca.

———. "The SMART Board." 2005. http://www.abheritage.ca.

Auditor General of Alberta. *Report of the Auditor General on NovAtel Communications Ltd.* Edmonton, AB: Alberta Legislature, 1992.

Austen, Ian. "Nortel Seeks Bankruptcy Protection." *New York Times*, January 14, 2009.

Boddy, Trevor. *Modern Architecture in Alberta*. Regina, SK: Canadian Plains Research Centre, University of Regina and Alberta Culture, 1987.

Bregha, François. "National Energy Program." *The Canadian Encyclopedia*, April 4, 2016. https://www.thecanadianencyclopedia.ca.

BW Technologies. "Company Profile." Accessed February 20, 2012. http://www.gasmonitors.com.

Canada Western Diversification Office. *A Framework for Diversification in Western Canada*. Ottawa, ON: Western Diversification Office, 1987.

CBC News Business. "Key Dates in Nortel Networks' History." CBC News, January 14, 2009.

———. "600 Calgary Jobs Lost in Haworth Plant Closure: Tax Incentive Program Lures Manufacturing to Michigan." Last updated August 18, 2009. https://www.cbc.ca/news.

Dilnot, Clive. "The State of Design History: Part 1, Mapping the Field." *Design Issues* 1, no. 1 (1984): 4–23.

DIRTT. "Company." Accessed February 20, 2012. http://www.dirtt.net.

Donnelly, Brian. "Locating Graphic Design History in Canada." *Journal of Design History* 19, no. 4 (2006): 283–94.

Electronics Industry Association of Alberta. *The Electronics Industry, Alberta, Canada*. Edmonton, AB: Electronic Industry Association of Alberta, 1988.

Evans Consoles. "Our Company." Accessed February 20, 2012. http://www.evansonline.com.

Fong, Jennifer. "If We Build It, Will They Come?" *Edmonton Journal*, January 30, 2010.

Fontana, P. G. "A Development Strategy for a Medical Device Industry in Alberta." 1981. Index 86.521, box 20, Provincial Archives of Alberta, Edmonton.

Forseth, Gerald, L. "Curator Statement." In *Calgary Modern: 1947–1967*, edited by Geoffrey Simmins, 10–11. Calgary, AB: Nickle Arts Museum, University of Calgary, 2000.

Foster Research and SRI International. *A Re-assessment of the Elements of an Economic Strategy for the Province of Alberta*. Edmonton, AB: Government of Alberta, 1980.

Frascara, Jorge. "Rethinking Design." *Design Issues* 17, no. 1 (2001): 1–4.

Gadbois, Denis. *The History of Industrial Design in Alberta, Canada: 1900–1992*. Calgary, AB: Faculty of Environmental Design, University of Calgary, 1997.

Gignac, Tamara. "BW Technologies Acquired for $260M." *Calgary Herald*, May 7, 2004.

———. "No Wires in Nortel's Future: Calgary Research Facility Points the Way for Telecom Giant." *Calgary Herald*, September 30, 2000.

Gotlieb, Rachel, and Cora Golden. *Design in Canada since 1945: Fifty Years from Teakettles to Task Chairs*. Toronto: Key Porter Books, 2004.

Goyette, Linda, and Carolina Jakeway Roemmich. *Edmonton in Our Own Words*. Edmonton, AB: University of Alberta Press, 2004.

Hanson, Eric J. *Dynamic Decade: The Evolution and Effects of the Oil Industry in Alberta*. Toronto: McClelland & Stewart, 1958.

Hayward, Anne. *The Alberta Pottery Industry, 1912–1990: A Socio-economic History*. Mercury Series, Paper 50, History Division. Hull, QC: Canadian Museum of Civilization, 2001.

MacDonald, Larry. *How Innovation and Vision Created a Network Giant: Nortel Networks*. Toronto: John Wiley & Sons, 2000.

Margolin, Victor. "Design in History." *Design Issues* 25, no. 2 (2009): 94–105.

Mayle, Mary Carr. "DIRTT Manufacturing Plant in Savannah, GA to Bring 150 Jobs." *Savannah Morning News*, January 20, 2009.

Nelson, Barry. "NovAtel: 'Great Reputation' Everywhere But Alberta." *Calgary Herald*, September 26, 1999.

Phillips, Rhys. "Hothouse Grown: Alberta Designers Export Furniture, Accessories to the World." *Calgary Herald*, January 26, 2002.

Pitts, Gordon. "Mogens Smed: Some Chaos, a Little Bit of Anarchy, No Meetings." *Globe and Mail*, March 9, 2009.

Price Waterhouse. *Shaping Canada's Future by Design: Detailed Report*. Sponsored by Human Resources Development Canada, prepared for the Design Sector Steering Committee. Ottawa, ON: Human Resources Development Canada, 1996.

Prochner, Isabel McPherson. "Understanding the Past to Imagine the Future: The History of Industrial Design Practice in Alberta." Master's thesis, Université de Montréal, 2012.

Sammer, Claudia, ed. *Cool Companies: Medical Devices and Technologies in Alberta, Canada 2010*. Edmonton, AB: Cool Companies, 2010.

SMART Technologies, "The History of SMART." Accessed February 20, 2012. http://www.smarttech.com.

Stamp, Robert M. "Suburban Modern: Searching for an Aesthetic in Post-War Calgary." In *Calgary Modern: 1947–1967*, edited by Geoffrey Simmins, 12–25. Calgary, AB: Nickle Arts Museum, University of Calgary, 2000.

Statistics Canada. "Population of Census Metropolitan Areas." 2011. http://www40.statcan.gc.ca.

Stephenson, Amanda. "SMART Technologies to Be Acquired by Taiwan's Foxconn Technology Group." *Calgary Herald*, May 26, 2016.

Teel, Gina. "Nortel Pulling Out of Calgary." *Calgary Herald*, May 28, 2008.

Toneguzzi, Mario. "DIRTT Succeeds with Unique Business Culture and Product." *Calgary Herald*, June 27, 2011.

———. "Global Command Central: Manufactured Here in Calgary." *Calgary Herald*, June 20, 2011.

———. "SMART Sets Sights on $1-Billion Mark." *Calgary Herald*, May 2, 2009.

University of Alberta Archives. *From the Past to the Future: A Guide to the Holdings of the University of Alberta Archives*. Edmonton, AB: University of Alberta Archives, 1992.

Verburg, Peter. "His Party, Your Hangover." *Canadian Business* 72, no. 13 (1999): 36–39.

Voisey, Paul. "Alberta." In *The Oxford Companion to Canadian History*, edited by Gerald Hallowell, 31–32. Don Mills, ON: Oxford University Press.

———. "The Urbanization of the Canadian Prairies, 1871–1916." In *The Prairie West*, edited by R. Douglas Francis and Howard Palmer, 383–407. Edmonton, AB: Pica Pica Press, 1985.

The illustration includes an array of objects that represent the themes in this section as well as the tools designers use throughout their career in Alberta. The style is simplified to help unify the different objects. I chose a bright and varying colour palette to create a fun, energetic feel.

SKYE OLESON-CORMACK

Education Meets Culture and Community

An Inside-Outside View into Design Education in Alberta

MEGAN STRICKFADEN

THIS CHAPTER sheds some light on the nature of design education in Alberta by comparing and contrasting design schools in other countries with some of the major design schools in the province. It explores and critiques design schools in general and looks into some of the details of Alberta design education from the inside and the outside.

Specifically, this chapter focuses on design teaching and learning with regard to design education culture, studio culture, and the socio-cultural capital of individual educators. Design education culture encompasses a set of beliefs that support specific kinds of actions and behaviours, including the values and skills in general that are considered worthwhile for students to learn. At the same time, each design studio has a specific culture that is developed based on the physical space, the tools within (such as computers, pens, paper), and the people who enliven the space (teachers, students, guests). The socio-cultural capital of individual educators includes the kinds of knowledge they value and the vision they have in teaching design.

Study Approach and Methods

Post-secondary schools, particularly universities, that teach toward a career in design are the focus of the study. This chapter is based on in-depth, longitudinal research into design education that includes both the author's engagement in learning and teaching design at institutions in Canada, the United Kingdom, and Europe (a reflexive approach) and extensive field research in and about design schools since 2002 in Canada, the United States, the United Kingdom, Europe, Scandinavia, and China (a case-based ethnography).

The reflexive approach acknowledges the researcher as part of the research process. It involved methods like using a personal journal and being aware of individual-personal research positioning, including biases, preconceptions, and values. In turn, the case studies involved field research in design schools and methods including observation and interviews. The resulting data were compiled, sorted, and cross-analyzed.

This study combines "inside" reflexivity from the author's being a student of design, working as a practitioner, and being a design educator, and her "outside" research into design education, educators, and studios that illuminates information about the capital of design and designers. This combination enables a more holistic understanding of the design educational context, concepts around socio-cultural events, and activities where people engage in interactions and communication.

The next section gives an overview of the basics of design education and some core values of design teaching and learning. This discussion is followed by the Alberta design education context and concludes with some recommendations for and a forecasting of the future of design education in Alberta.

Characterizing the Basis of Design Education

Historically, various major design centres that began formal education systems during the periods of industrialization informed the majority of design schools. These include, but are not limited to, Italian and Parisian schools of architecture; British schools of art and design, including the Royal College of Art;[1] and other European schools of art and design, especially the Bauhaus School[2] and HfG Ulm,[3] both in Germany. Each of these European design schools had a unique focus on a particular aspect of design with accompanying interpretations of how design fit and needed to support society and business.

A number of North American design schools emerged in the twentieth century from these early design or mother schools, mainly as a result of design educators emigrating from various European countries as a consequence of the Second World War. Various educators who had been encultured into design learning and teaching through their mother schools

influenced programming in their new settings, both consciously and unconsciously. *Enculturation* is a term coined by anthropologists to describe the human phenomenon whereby people explicitly and implicitly take on, for example, understandings, beliefs, assumptions, and behaviours that relate to the attributes of culture, subculture, or small culture. In this case, the field of design is referred to as a myriad of small cultures that are not cohesive but have some similar aspects.

The details of teaching, designing, projects and design briefs, studio environments, and resources were all brought to design curriculum despite Canada being a very different context from Europe. These European design educators had been encultured into specific values, beliefs, and behaviours around teaching and learning design (e.g., the belief that drawing, critiquing, form making, the use of elements and principles of design, and other design fundaments were inherent to designing and should be taught), which were then adopted and transformed into design programming in the Albertan context.

The philosophical underpinnings of a particular design program are therefore connected to and embedded with traditions, including values, beliefs, and actions that are traceable through a trajectory of time. These traditions are perceptible through the people (educators, students), spaces (studio set-up, workshop options), and things (objects designed) of each design school. Consequently, design programs take on personalities that continue to evolve while influencing the students who study within. For instance, it seems that design programs sometimes approach designing as a very individual or personal artistic endeavour, and others take more user- or audience-focused approaches that put creation for others at the centre of designing. Furthermore, within a single design school there may be conflicting traditions depending on the interpretations of design, the knowledge or positions held by instructors, and the localized context of the design school. Therefore, design programming is extremely diverse and complex and is not easily generalized.

Nevertheless, areas of common ground exist about designing and design education. On a fundamental level three basic ideas are commonly

understood about design. First, design is known to have a natural link to people within the community (consumers, users, audiences) and within business because designed things—whether custom made or mass produced—are purchased and consumed by people. Second, design is a form of communication between people and things; whether the thing is a poster or an article of clothing, there is an interaction between people and objects that typically begins through the eyes and may continue through the hands or other parts of the body. Third, the act of designing is a process in which designers engage, called production, which involves moving from conception to manufacture, or from conception to specification if the product is being passed off for manufacture by someone other than the designer. These three ideas in design are implicitly present and sometimes taught within design schools, which is evidenced through findings in this research.

In addition to these three fundamental commonalities in design, there are a number of conceptual skills that designers partake of and that educators often teach students. These skills are both explicit and implicit and are understood through the deconstruction of designing and design education. They are as follows: developing knowledge related to the language of design; doing creative problem solving; engaging with and communicating the design process; visually communicating conceptual and concrete ideas; understanding materials and manufacturing processes; working with stakeholders in design (e.g., client, funder, user); identifying pertinent social issues relevant to design projects; and understanding the basics of business and marketing trends.

Some Core Values of Design Teaching and Learning

While the conceptual and physical skills for teaching design are complex, there are a number of central curricular materials, concepts, approaches, and values that prevail in design education throughout the design schools studied here, all of which are considered fundamental to enculturing design students toward being practitioners. These are naturally linked to and stem from the aforementioned three basic aspects of design (people, communication, and production) and the common conceptual

skills indicated previously. Based on visits to design schools that deliver numerous topics—from architecture to graphic design—there is a surprising coherence across curricular materials.

Skills in drawing, basic manufacturing knowledge appropriate to the taught design area, and some form of design history are typically part of the curriculum at every design school. At the same time, these skills and topics are taught quite differently depending on the educators' approach and inherent values. For example, design history is taught sometimes chronologically and at other times according to themes. The design process is also taught in every school, even though sometimes this is done at an implicit level where the students are not especially aware that this is what they are learning. Other schools explicitly teach the generic design process or use specific design methods to assist students through the design of projects. Additionally, design is typically taught using a project-based approach where students engage in creating different projects that emulate different design scenarios or design needs. Students may be engaged in more than one project at a given time; however, this approach is created to emulate designing in a studio environment similar to what the educators and design school perceive practice to be like.

One core value that is relatively common in the majority of the design schools studied is the idea that design is naturally connected to industry. Consequently, most design programming has some aspect where students engage in design competitions and/or industry sponsorship for exposure to what are considered "real design problems" and "real stakeholders."

When it comes to skills taught to student designers, specifically communication through drawings, parts of the design process (hand drawings, three-dimensional models, etc.), materials, and manufacture, the approach to these varies from school to school. There are essentially two basic ways that these skills are approached, leading to various results. One approach enables graduates to work collaboratively internationally (for people or companies in another city or country whom they may never meet), while the other approach enables graduates to work locally (for people or companies in their relatively immediate environments).

For example, students in China are encouraged to hone their drawing and rendering skills so that they can work for companies outside the country, and at the same time they are taught a great deal about local industry so that they can gain employment at a company nearby. Other design programs focus predominantly on hands-on skills such as physical model making and/or explorations in materials and manufacture such as vacuum forming, plywood moulding, and woodworking. This more material-, manufacture-, and craft-based approach enables graduates to work locally because they may not have the knowledge of skills to collaborate internationally or disseminate information over the Internet. Working via the Internet, using computer modelling programs, and collaborating internationally are relatively recent phenomena that require different skill sets than the material-, manufacture-, and craft-based approaches. It is not unusual for a design program to teach a combination of the two different approaches; however, it is important to note that a single program seems to promote one approach above the other. This is likely because it is not possible to teach everything within one program, and educators will typically teach to their expertise.

Significant differences between design schools arise in the delivery of specific curricula and the resources (e.g., computer labs and programs, workshops, and studios) present or at the disposal of each school. One of the consequences of this variation in curriculum and resources is that approaches, concepts, and embedded values are passed on in a variety of different ways, with basically no two ways being the same. A concrete example of this variety is that some design schools begin their program with a foundation year that teaches what are considered the basics of design, while other schools begin with specializing in a particular design field.

With respect to concepts, some schools teach units on people-centred design, while others feel that this is not necessary because design is inherently about designing for others, with the assumption that the students will naturally pick this up. No matter what, core concepts are ultimately decided by the people involved in curriculum development at each school, which varies depending on the leadership of the school.

When it comes to values, some design schools focus on teaching how to get products into the marketplace by coupling design with business or manufacture, while others try to push design as a field that has the power to handle social issues (e.g., sustainability, inclusive design, design for safety, or other socio-cultural concerns). The underlying value system of different programs is often linked to the socio-cultural capital of the individual educators[4]—the backgrounds, experiences, and interests of the design educators—who are often given carte blanche to develop courses and programming that they deem suitable for the field within which they teach.

In terms of resources, each design school has access to different things to support designing endeavours. These are typically linked to the kinds of infrastructure that were put into place and supported over the history of the design school. For example, some schools have plaster reproductions for learning about history, collections of historical artifacts for studying products and processes, exhibit spaces for displaying artifacts or design projects, computer barns with the latest software for engaging in the design process and creating communicative information, workshops for general fabrication of projects, or even mock manufacturing facilities to emulate actual product development. These resources drive the approaches taken to designing, particularly students' focus on hands-on skills, computer skills, or analytical skills in their learning environments.

Naturally all the design schools in this study—whether in Canada, the United States, Europe, or China—are situated in their own contextual, localized network that supports design as a career option. This includes mass production as well as smaller local industries, such as printing, upholstering, metalworking, or cabinet making. As design schools tend to couple with industry or businesses, a symbiotic relationship develops in which students are exposed to the way businesses function and the nature of networks in the location where they are studying.

The general discussion of design education until this point provides a design educational context that is compared and contrasted with Alberta design schools in the next section of this chapter.

Alberta Design Education Context

There are approximately twenty-six post-secondary institutions in Alberta, including universities, colleges, and technical schools, as identified by Alberta Learning Information Services.[5] Of these institutions, eighteen have a range of design programming, including architectural design, clothing and textiles, digital animation, environmental design, fashion and costume design, film and motion image production, furniture design, graphic design, industrial design, interior design and decorating, photography, theatre design, and urban planning.[6] The following nine institutions were researched in detail to understand the overall breadth of the context of Alberta design education: Alberta College of Art & Design, Grant MacEwan University, Mount Royal University, Northern Alberta Institute of Technology, Pixel Blue College, Southern Alberta Institute of Technology, University of Alberta, University of Calgary, and University of Lethbridge.

When one considers design education in the context of Alberta, there are some distinct similarities to what is happening in other design schools, along with some specific characteristics relative to being situated in Alberta, including the local context and relationship to the international context, skill development, and resources (e.g., educators, manufacturing). An abridged snapshot of Alberta shows a province that is rich with resources, including those that come from the land (e.g., food, wood products, natural gas, oil), people, and those that result from human endeavours such as information (e.g., books, policy) and innovation (e.g., medical procedures, equipment design). It is also important to note that, historically, Canada is a country made up of many immigrants (some new to the country and some going back several generations); therefore, educators in design schools in Alberta may have come from various countries.

As seen from the research herein, some of the design schools in Alberta brought in educators from the United States and Europe (especially in the 1960s and 1970s) to teach or lead design programs. Senior educators at the Alberta design schools who were interviewed indicated that they had been recruited from across the country or from abroad. More recently, however, the trend is to hire former program graduates; 50–80 per cent of educators

in most design schools in Alberta graduated from the program in which they work. The apparent reason for this trend is that the various design schools across the province or country have different value systems, and it is easier to employ those who have an inside view on the current situation rather than those who need to be encultured to the system of a design school that is different from their mother school. Even so, design education is such that design curriculum changes frequently and spontaneously due to the complexity of resources (e.g., educators, links to industry, access to a workshop) and the situation (e.g., economy, values, access to global information), where one altered factor has the potential to make a major shift. Therefore, it is clear that the individual Alberta design schools have changed from year to year and decade to decade.

When imparting design skills and knowledge to students, the many design schools in Alberta have a tendency to take a more craft-based approach compared with their counterparts in other places. Alberta education has invested in resources that enable hands-on production; for example, UAlberta and UCalgary have workshops that enable explorations with metals, plastics, wood, and more, whereas their counterparts in Europe typically do not have such extensive facilities. This more craft-based approach to teaching and learning indicates the value placed on students developing the skills to engage in the design process from conception to the final product, which means that they are encouraged to learn a great deal about making and materials along with designing. In many cases these skills supersede the higher-level drawing skills such as producing mechanical drawings that would ordinarily be given to the manufacturers who would make the product. Compared with design schools elsewhere, Alberta design education tends to downplay mass production, which also manifests in a focus on the ideation phase of designing and then leaps into the making phase. Less attention is placed on preparing technical materials that communicate the details of the design for manufacture, and more attention is placed on visual presentation and the final product. The characteristic of learning how to make things means that Alberta design educators are attempting to teach and have students engage in the range

of design process. This approach is taken to match with the production context of the province, which is perceived as being short of large-scale manufacturing facilities (especially when compared with other provinces, such as Ontario and Quebec). The upside of this craft-based approach is that successful graduates from Alberta design schools tend to be more connected to the production process, where they have the potential to become intimately aware of materials and making. At the same time, design programs are not apprenticeship programs; therefore, they do not teach the level of detail that is required for one to become a certified tradesperson, such as a cabinetmaker. Consequently, the downside of the craft-based approach is that not all people have the hands-on capabilities to make things to the level required for selling, or the ability to make a big enough batch for clients. In addition, it requires specific know-how to source parts for manufacture and to market products, which are skills often missed in design programs.

Alberta's manufacturing and industry context has more localized facilities than are available in other contexts, which leads to smaller-scale batches and one-off production rather than mass production. Within the province there are many different manufacturing capabilities, such as woodworking, metal fabrication, upholstery, and clothing manufacture. In addition, there are many studio-based production facilities for more specialized products, such as naturally dyed fabrics, blown glass, and jewellery. There are also design entrepreneurs who run their own businesses and studio-based productions. In terms of the relationship between design schools and industry, the nature of the industry in any local environment will drive the things that are created, and design schools in Alberta are no exception.

When companies that represent different industries sponsor projects, they become stakeholders in the educational scenario and therefore will want the projects that are created at the design school to align with the materials, products, or services they offer. For example, oil consortiums sponsor projects to create protective clothing and textiles for workers in the oil industry, and lumber companies sponsor projects to develop

creative ways in which their product can be used. Industry sponsorship is a complex situation that involves collaboration of all parties involved; that is, the design school with administration, educators, and students is actively involved in collaboration with industry representatives, products, manufacturing, and more. Industry collaboration is also an ever-evolving situation because there are different industry partnership opportunities at various times. There are opportunities for more and continuous industry collaborations that could be capitalized on in the province.

The Future of Design Education in Alberta

The strengths of design education in Alberta are related to the diversity of the design areas that are offered across the province and the breadth of knowledge that can be gained by students. The predominantly craft-based approach to learning about making and materials provides students with many skills that are undervalued and that have the potential to become obsolete within design education in general, yet Alberta design schools are perpetuating this tradition. Compared with other design schools, Alberta education has the resources for teaching materials and manufacturing beyond the theoretical, something that simply is not possible in many other design schools. Furthermore, to some extent design schools in Alberta are teaching to the local context by involving some industry, which has the potential to stimulate the local economy. To build upon the current strengths of Alberta design education, three core aspects are proposed here that could be capitalized on to improve the quality of education being delivered. These core aspects are linked to the values and philosophical underpinnings of each design school, to the resources in the Alberta context, and to the enabling of Alberta design graduates to be more globally competitive.

Communicating the Values and Philosophies of Alberta's Design Schools

There is a lack of communication about the values and philosophical underpinnings of each Alberta design school, which can make it difficult

for people to truly understand, recognize, and capitalize on what Alberta design education and designers can offer. This lack of communication is likely rooted in a lack of understanding of these values. Although the information is contained within design schools, it is challenging to discover and communicate the inherent values without in-depth analyses of the history of each design program, the nature of current leadership, including central goals, and the individual perceptions of the educators. Further, at present it seems as though Alberta design schools do not necessarily have a particular vision, which is evidenced by conflicting stories from educators involved in the same programs.

Resources in the Alberta Context

Design schools need to look critically at the resources at their disposal, which naturally includes how they wish to use these resources effectively. For example, when it comes to design educators, it could be beneficial to have more cross-fertilization between design schools, meaning that educators who graduate from one school could be hired at another, or educators could be brought in from across the country or another country. Strategic planning, critically reviewing curriculum, and refreshing programming are ideally accomplished when new educators are brought in. Rather than simply throwing new faculty into an existing situation, it is beneficial to work carefully to enculture newcomers, while simultaneously deconstructing the inherent values that are embodied in the program. For instance, design educators who are new to a specific design school could be shown and told about the values that are core to the teaching and learning program and those that are superfluous or could be revised. In sum, design schools would begin with a concrete idea of their core identity, reflect upon this identity, and communicate it to newcomers. In this way, design schools will invigorate programming while working toward creating a clearer picture of their identity and the reality of the given design school.

Other resources, such as leveraging relationships with industry, are currently underutilized in Alberta design schools. It is speculated that this underuse is due to a general lack of knowledge and understanding of

the context of Alberta industry. Interestingly, the number one complaint among the educators interviewed in this study was that their design school lacked industry collaboration, yet for the most part there was very little knowledge of the industries that were available to designers and design educators within Alberta. Design schools would benefit greatly from being proactive when it comes to industry relations. This begins by researching and understanding local resources, such as manufacturers, small businesses, and not-for-profit agencies.

Enabling Alberta Design Graduates to Compete Globally

The third core aspect that design schools in Alberta could capitalize on is a clearer understanding of the province's relationship to the international marketplace. That is, design schools could benefit from updating their ideas on how designers work, particularly when considering the use of computers and the Internet. Design programs could investigate the nature of the specific design areas (e.g., graphics, product, costume, jewellery) being taught, in order to recognize the kinds of skills necessary for designers to be competitive internationally. This involves, for example, deciding to what extent and which craft-based skills and computer skills should be taught to support graduates in future employment. In addition, it would be beneficial for design schools to discover whether design graduates will be hired locally, nationally, or internationally, or by more than one; in this way, courses and programming could be established to support graduates better. Another approach to developing the skills of students in the international arena is for design schools to actively participate in competitions offered in other parts of Canada or abroad.

In summary, through the analysis and critique of design schools a series of recommendations that have the potential to hone design education have been proposed. This analysis looks carefully at the strength of current programming and the local context compared with those of the other design schools studied. Forecasting the future of design education in Alberta is not a simple task; however, based on the study, some speculations can be made. If design education continues on its current trajectory, it is speculated that

design schools will evolve based on crisis management rather than on strategic planning. That is, in the design schools visited, consistent concerns were expressed about budget cuts and reduced resources, which certainly affects program planning, but which also results in a crisis management mode of thinking rather than a proactive look toward a sustainable future. Crisis management typically involves creative ways of working with less resources and feeling that loss, which often result in a romanticizing of the past (how much better it was) rather than in forward thinking. If design education in Alberta takes a call to action based on some of the recommendations herein, specifically looking to understand better the culture of individual design schools, including the school's history and the socio-cultural capital of the educators who work there (part and full time), it has the potential to shift to more comprehensive and competitive approaches.

Design schools need to look outside their immediate environments to understand design education well in general, which can be achieved by looking at the design-specific capital that is available through researching academic literature, books, and media available on the Internet. They also need to look inside to their own design school culture and local context to understand better their values, beliefs, and behaviours.

Conclusion

This chapter has explored some of the strengths and areas for potential improvement through a brief look into and critique of design education in Alberta, including comparisons with a variety of design schools across Canada, the United States, Europe, and China. The unique characteristics of Alberta design schools as identified in this chapter are relative to the philosophical underpinnings of the design schools, the relationships with mother schools, the background and experiences of the educators, and the local context that supports design careers and education in specific ways. In this way, the study provides a glimpse into the design-specific capital of the Alberta region and reveals that design education in Alberta is approached in breadth and depth and provides learners with various skills for future employment. Even so, following a critical analysis of Alberta

design education, it is clear that programming and curriculum can benefit from further development, especially by considering the specific context of Alberta. Alberta is a rich province with many resources, including a vibrant and dynamic acceptance of design as a career that is evidenced through various smaller-scale manufacturers, numerous architectural firms, and more. Yet, it is clear that Alberta design schools do not always capitalize on the rich resources that are at their disposal.

In closing, this chapter begins a quest to provoke design schools and educators across the province toward a vision that builds upon the histor-ical foundations of individual design schools, recognizes the socio-cultural capital of design educators, continues to teach skills around making and materials, considers the local and international contexts, further develops relationships between schools and industry, and is proactive in creating an Alberta design education that is valued from inside and outside the province.

Notes

1. Frayling, *The Royal College of Art*; Frayling and Catterall, *Design of the Times*.

2. Wingler, *Bauhaus*; Naylor, *The Bauhaus Reassessed*.

3. Jacob, "HfG Ulm."

4. Strickfaden and Heylighen, "Cultural Capital."

5. This list does not include private colleges that may offer design programming. See http://alis.alberta.ca/ec/ep/aas/post-secondary.html for more information.

6. Based on field research and website content analysis, the following institutions in Alberta offer design programming: Alberta College of Art & Design, Athabasca University, Banff Centre, Grant MacEwan University, Keyano College, The King's University College, Lakeland College, Lethbridge College, Medicine Hat College, Mount Royal University, Northern Institute of Technology, Olds College, Pixel Blue College, Red Deer College, Southern Alberta Institute of Technology, University of Alberta, University of Calgary, University of Lethbridge.

Bibliography

Alberta Learning Information Services. "List of Institutions." 2013. http://alis.alberta.ca/ec/ep/aas/post-secondary.html.

Frayling, Christopher. *The Royal College of Art: 150 Years of Art and Design.* London: Barrie & Jenkins, 1987.

Frayling, Christopher, and Claire Catterall, eds. *Design of the Times: One Hundred Years of the Royal College of Art.* Yeovil, UK: Flaydemouse, 1995.

Jacob, Heiner. "HfG Ulm: A Personal View of an Experiment in Democracy and Design Education." *Journal of Design History* 1, nos. 3 & 4 (1988): 221–34.

Naylor, Gillian. *The Bauhaus Reassessed: Sources of Design Theory.* London: Herbert, 1993. First published 1985.

Strickfaden, Megan, and Ann Heylighen. "Cultural Capital: A Thesaurus for Teaching Design." *International Journal of Art & Design Education* 29, no. 2 (2010): 121–33.

Wingler, Hans M. *Bauhaus: Weimar, Dessau, Berlin, Chicago.* Cambridge, MA: MIT Press, 1981. First published 1969.

From the North

Perspective of an Outlier

Growing Up

I consider myself to be an outlier in the design industry because of my remote, rural background. This has had an impact on my priorities, philosophy, and disposition in a way that makes me considerably different from many of my contemporaries, most of whom grew up in an urban environment and were much more saturated in design than I was during my formative years. The community where I was raised is located about seven hundred kilometres northwest of Edmonton. As recently as 1950, it had no roads, electricity, or running water, though things have developed significantly since then. There is mud, dirt, trees, rivers and creeks, bears and wolves. Life is tough and real. As a result I found myself with a strong connection to nature, the rhythms of weather, and the elements. Where I came from, there was little need for art or frilly things; people were mostly concerned with making things work.

Perhaps that is why I thought, when I was leaving high school, that mechanical engineering was the career for me. My dad cursed most engineers, usually from under tractors and other equipment he was trying to fix. These machines always seemed to break down at an inconvenient time or in an unexpected way. I suppose I thought one of the most valuable things I could do was engineer such equipment so that it worked properly and was easy to fix. Although people had called me artistic all through school, I was reluctant to admit I was interested in art—unless it was industrial art. Industrial art, or shop class as we called it, was my favourite high school class. In it I had the opportunity to use tools with which I was familiar from fixing farm equipment or building things, but now I could

direct my own projects that were exploratory rather than driven by necessity. It never crossed my mind that a person might do that sort of thing as a career. The material was presented (or at least perceived) more as an introduction to separate trades like woodworking, welding, or drafting. I was not interested in any of those fields separately.

University Admission

A real wake-up call came when I went to university. As it turned out, mechanical engineering was not for me, and, to sum it up, I failed. I was told to leave by the faculty and university. Though I was shocked and disappointed in myself, I was also determined to find out what I *could* do. I flipped through the course catalogue and found a blurb about industrial design. Why had I never heard about this before? It sounded like shop class but at a professional level. I had no idea people could do that for a living! From that inspired moment, I endeavoured to make my road one that would include industrial design.

It took a lot of work and many years before I was able to enter the industrial design program at the University of Alberta (UAlberta); it took me three tries over the course of five years before I was accepted. I was not able to successfully compete until I had completed university-level art and design classes. This could be an indication of my poor art and design abilities, or it may speak to the highly competitive nature of the program. In my opinion, an art-based portfolio should not be the largest, or seemingly only, consideration for admission. Industrial design is not limited to artistic aptitude; it also involves familiarity with materials, manufacturing processes, tolerances, efficiencies, applications, and uses. Unfortunately I had no effective way of communicating to the admissions staff or jury, through an artistic portfolio, my years of training on a farm with equipment, mechanics, and construction work. I am not suggesting that practical experience should trump artistic talent. However, in an industry where individuals are marrying function and form, it does not make sense to overlook half of an individual's ability to do so. I believe that greater care should

be taken to treat both aspects of industrial design equally in education and the discipline.

University-Industry Disconnect

Since I needed to work during my studies, I tried to find jobs that were related to design. I initially asked my instructors where I might find suitable work. Their response was almost always something like, "It's a make-your-own-work kind of industry here." I grew tired of that response and eventually quit asking. On my own I found part-time jobs working for a furniture retailer, a plastic manufacturer, and a landscape architect. This work gave me invaluable experience for my studies and my career. During my last summer as a student I wanted to find an exceptional practicum or internship to round out my education. Since there was nothing compelling enough in Edmonton, I decided to find a summer job elsewhere. With no help from the university, I quickly found a job with an architectural firm in Las Vegas and worked as their physical 3-D modeller for a few months.

Looking back, I believe that, at the time, UAlberta's industrial design program did not adequately integrate students into industry or provide students with a concrete idea of what they could do with their education if they chose to stay in Alberta. I have seen other university programs deal with integration in more effective ways by providing more practicum experiences locally and across borders. Students who participate in such programs have a more robust education and are better suited to do design work wherever they end up. I do think that part of the issue revolves around educating local industry, helping them understand what designers actually do, and then approaching more of them to take on students. It is also my belief that many businesses in Alberta would hire in-house designers and, yes, even students if they knew how that would benefit their business.

One positive initiative that does take place is regular design exhibits that allow the public and industry to see the fruits of design thinking. Unfortunately design shows put on by the university or student groups are mostly attended by other designers or family members—certainly not the

general industry or public. In my experience as a student, few of the businesses who may have benefited from hiring designers were ever invited to such shows or given a compelling reason to attend. More time and energy was usually spent trying to get sponsors to pay for the venue, reception, printing, and other costs of the show. I think if this emphasis were channelled in a more thoughtful way, we would see better educational experiences, better integration into the workforce, and better design in our province.

Jumping In

Since there were not (and still are not) many industrial design firms in Edmonton, I decided to start my own design firm. This endeavour began several months prior to my graduation from the bachelor of design program. My goal was to establish a multidisciplinary firm that would offer industrial design, visual communication design, and exhibit-design services. Through experience I knew that having a multidisciplinary firm would be best suited to how I had learned to work. Farm life, or rural life, is multifaceted. There are many things you need to know how to do and to deal with; no two days are ever the same. In hindsight (and having delved headfirst into the world's largest economic downturn in recent history), it is a good thing to have a business and skill set that are somewhat diversified.

Before graduating, I held meetings to convince acquaintances and classmates to join me. Some were interested and wanted to be involved in one or two projects, but most did not want the risk of not having a stable or guaranteed income. Those who decided to jump in for at least one project were Joanna Goszczynski, Joel Harding, and Mark Oswald. My sister, Kendel Vreeling, also joined as our intern, she being partway through a post-secondary design program. I decided to be my own first client in order to establish a reputation of high-quality design work. This seemed to be the best option under the circumstances so that we would have complete creative control over the project (which probably would not have been the case if we had taken on local clients in our inexperienced state). The project was to create a collection of contemporary Canadian home furnishings and accessories

inspired by the semantics of the Canadian North. I named it White Moose. In two months we created the brand, website, catalogue, and prototypes. We immediately exhibited the works in Las Vegas and cities in western Canada. We hoped to sell or license the collection to an interested party who would then take it over. In some way, my instructors were right— design can be a make-your-own-work industry in Alberta. Here I was, starting out by making my own work.

Learning to Swim

For me, the hardest part about working as a designer in Alberta is that I feel virtually alone much of the time. I have not yet found others to partner with or to bring on as employees. I still regularly collaborate with other designers on projects, but even those who were involved with White Moose have moved away, extended their education, or taken jobs with other firms or in other fields. Many people ask why I have not moved to a more design-savvy area where I might have a more stable or certain career. Many designers do leave Alberta, especially if they are any good. I am trying to stop that trend. If talent continues to leave, we will simply continue importing design and ways of thinking that do not fit our climate, culture, or people. I am not interested in supporting such a model. As Albertans, we should be doing everything we can to support and export our design and ways of thinking to the world. At the very least, we should be creating design solutions that work for us. It might feel like swimming upstream at first, but we will be stronger in the end.

There is no certainty about what the future will bring, but that is what makes pursuing goals and taking risks so appealing, and critical. I have worked hard to achieve my goals, and I can say that by "simply" starting a design firm in Alberta, I have truly lived my dream. A few years ago I came across a statement that stuck with me, and the more I reflect on it, the more it resonates with me: "In 1985, when I was 28 years old, I took all of my savings—C$35,000—and invested it in starting up this company. I was confident it would fail, and I simply wanted to get my failure behind me. I thought that if I ever woke up at 50 (my age now) and hadn't tried to have

FIGURE 4.1. *Canada Games Medals designed by Tyler Vreeling. The design explores the struggles and successes of athletes through the metaphor of the Red Deer River.* Photograph by Tyler Vreeling.

my own shop, I would be despicable in my own eyes. I'm still waiting to fail. And believe me, it's still a possibility."[1]

Staying the Course

If you had told me when I was a boy on a farm in the middle of nowhere that someday I would establish a big-city design firm, work with and for leading architects, engineers, and designers, and become a design consultant who, along the way, would design medals for the Canada Games (figure 4.1), design and direct Alberta-landscape-themed furnishings for ATB Financial (figure 4.2), create graphics for the Alberta Association of Architects' Banff Session, provide stage furnishings for the Alberta Emerald Awards, direct the design of a national-award-winning logo for an

FIGURE 4.2. *Mountain table designed by Tyler Vreeling. It has an Alberta landscape theme, interpreting prominent and familiar features that are millennia in the making. Photograph by Tyler Vreeling.*

architectural studio, create prototypes for a rugged tablet, design futuristic reception desks, speak on sustainability, inspire people to up-cycle, create a collection of furniture influenced by natural features in our province, and put a white moose in urban galleries around Alberta, I probably would have laughed it off and continued shooting beaver in the creek. My approach and the resulting journey have not been typical, although I have found a way to produce meaningful and usually highly customized work for select clients. Through it all, I have watched patterns and rhythms emerge. Clients and the public seem to be increasingly aware of the value of design, which strengthens their desire and capacity to use it. This current has been growing deeper and stronger over the past few years, providing more momentum.

Over the years there have been many successful businesses in Alberta offering design as a service. Architecture, interior design, and visual communication design firms have all experienced success. Firms that have industrial design as their focus usually struggle and dry up in a few years, or their members move on in search of more impressive opportunities. Consequently many people wonder if good industrial designers can survive here. In my opinion, we absolutely can survive in Alberta, but it takes guts to stay. And it is my hope that someday we will thrive because we chose to transform the waters here. I look forward to a day when we have a world-class design museum showcasing the wealth of grit, determination, and design excellence found right here in Alberta. We will be quite amazed at the vastness of the collection!

Alberta truly is a land of opportunity that offers an amazing ride for those who are brave enough to embark on the adventure. Success comes as we work our dreams into reality by observing the things around us, anticipating challenges, and staying the course. Whether we succeed or fail, we should be grateful to God to be a part of it, and do our best to make it better.

Note

1. Doyle, "Choose a Job, Choose Life."

Bibliography

Doyle, Stephen. "Choose a Job, Choose Life." *I.D. Magazine* 55 (2008): 84.

Vreeling, Tyler. Vreeling Design. https://vreeling.design/.

The works in this section revolve around the notions of emerging and catching up. In my view, these concepts connote movement surrounding a change or advancement in the entrepreneurial workforce. I convey the idea of movement in this illustration with the image of a young creative entrepreneur in action, surging forward from a crowd of greyed-out characters that represent the more traditional idea of a businessperson or "suit." I represent the Creative as youthful and eager, casual yet professional. The bright colour palette and a variety of tones are distinctly energetic and enthusiastic, shown in stark contrast to the darker, murkier, and monochromatic mass of box-like Suit characters in the background. The Suit figures are faceless, impersonal cut-outs, almost indistinguishable from one another, whereas the Creative is at once unique, engaging, and memorable.

COURTENAY MCKAY

The Creative Economy and Design Work in Alberta

Expanding the Creative Economy in Alberta

TIM ANTONIUK

Creative Hybridity from Small Producers

IF YOU HAVE BEEN in the labour force or have run a business in Alberta over the last fifteen to twenty-five years, it is likely that you have encountered a wide assortment of positive and negative consequences of globalization. Whether it is the pressure to use offshore production, to connect better to social networks, or to capitalize on incredible advances in materials and manufacturing techniques, professionals of all kinds are being forced to expand, update, and perpetually critique all of their assumptions just to maintain relevance and market share.

Certainly, this situation applies to designers. At the same time, however, the role of industrial designers has never been more important.[1] Charged with enhancing the functionality and usability of products, services, and experiences (PSEs), many contemporary industrial designers also see empathic approaches and inclusive and pleasurable PSEs as essential ingredients of good design. The contemporary industrial designer's goal is no longer just to enhance object usability or desirability; it is to use design thinking techniques and methods to create healthier and more balanced environments for people.[2]

This evolving role for industrial designers has introduced tremendous complexity into projects. Over the last few decades we have seen the continual blurring of design's boundaries, not only because of what we design but also because of who we design for and who we work with. Often in search of highly precise consumer research that will reveal product opportunity gaps and emerging markets, contemporary designers collaborate more than ever with cultural anthropologists, human factors specialists, and end-users.

These significant changes to practice suggest that we are slipping into a new era—not only in industrial design history but also in design history. This era requires companies to adopt new approaches for creating our material world and to engage with diverse types of economies. Furthermore, this rapid change allows creative industries to insert refreshing new levels of empathy into the design stream and encourages the design industry and other parallel sectors to question what "innovation" means.

This topic, which is addressed in a variety of ways by authors such as John Howkins, Malcolm Gladwell, and Thomas Friedman, is more accurately touched on by the work and research of Richard Florida. A prolific writer on the creative economy, Florida notes that creativity is not easily replicated (or ripped off) and that creativity is the backbone of the growing creative economy.[3] With this economy being driven by diverse knowledge and supported by connectivity, it is important to recognize that we have left the era where granting access to unlimited amounts of information and connectivity is a competitive advantage. Today connectivity and machine learning are opening the door to a new generation of PSEs. There is a new type of corporate promise which suggests that in the near future everyone will be able to enjoy ultra-personalized products that will fulfil their deepest desires. The problem, however, with this "enhanced access" is that it is not socially or environmentally balanced because it focuses on a single person's desires as opposed to considering the broader societal and ecosystem within which the person lives.

Driven by the analysis of clicks and purchasing habits, this contemporary approach to research provides a wide array of important insights into consumer behaviour, but it further isolates people from understanding the harmful socio-economic and environmental consequences of their consumption habits. Being served by today's massive online retailers is convenient at the consumer level, but it has some distinct downsides.

One of the items Florida highlights is the significant effects that globalization, offshoring, and the digital era of design have had on consumption and well-being. It also reveals the fact that many designers, companies, educational institutions, and government bodies are not fully prepared to

deal with where the world is headed. As the creation of new service, information, and communication platforms continues to grow and influence people's interests, desires, and purchasing habits (think Facebook, Twitter, Instagram, etc.), fickle short-term human desires are eroding the health of our planet. Statistics and reports by organizations like the Center for Disease Control and the American Academy for Family Physicians show that despite the medical breakthroughs and improvements in health care over the last few decades, life expectancy in the United States (and in many other developed nations) is decreasing.[4] In stark contrast to the idea that precise data on consumer lifestyles and consumption habits should improve quality of life, health, and well-being, statistics like these suggest that precise data does not necessarily equate with higher levels of well-being. Though infinitely complex in scope and scale, a part of the solution that I propose in this chapter is for designers to take on a larger and more meaningful role in understanding and combating these "wicked" problems.[5] I believe that designers can contribute to more meaningful and positive outcomes, in part because of our heightening awareness of these issues and our work in multidisciplinary and transdisciplinary manners.

Though highly skilled at working with and between a wide assortment of fields, designers need to become better at determining what should and should not be designed, especially at the stage in the design process where the collection and analysis of information or data is translated into some form of PSE. In this moment of the design process, which I often refer to as "the grey space of design," designers need to be aware of people's day-to-day living habits and their various needs, wants, expectations, desires, and limitations and then to morph this data into a product, service, experience, and system. Though wrought with complexity, the grey space is made even more complex when we are asked to be empathetic to the broader ecosystem in which people live and by which they are supported.

This idea, of moving from designing isolated PSEs toward a systems-based approach using design thinking for a greater system, is not necessarily new to many designers. What is new or newer is our need to take responsibility for influencing the greater society and the material world with our

outputs. In the context of this chapter and broader discussions about Alberta's place in the design world, I believe that Alberta and other small design centres can benefit from our smaller population base and geographical isolation. Despite the fact that many small design centres like Edmonton, Calgary, and other smaller cities and towns throughout the province have continued to see high levels of urban sprawl,[6] we have also seen a renewed demand and appreciation for local and community-oriented approaches to living, shopping, and socializing. Expressed through increased attendance at farmers markets and at local urban eating and drinking establishments such as microbreweries, restaurants, and coffee shops, these changes are perhaps best understood as being a social and economic expression of peoples' changing tastes and preferences and their desire to access new hybridized PSES. As more PSES continue to be commoditized because of availability or price, new hybrids naturally replace older ones and better represent the place, space, situation, and lifestyle in which people want to live. As a consequence of this increasingly diverse design, production, distribution, and communication system in which we live today, the supply system (and its designers) are continuously reacting to and influencing people's lifestyle and consumption habits. This very organic system, I argue, is the natural home of creativity, design, and the arts; interestingly, it is hard to replace and replicate effectively without deep human input. For example, it is hard for a big-box store to replicate the authenticity and empathy that a small local producer or store could have for its local clients, but it is easy for the big-box store to beat a small local company on price.

As the tensions between price, quality, style, durability, accessibility, and desire continue to affect local economies and the creative sectors, it is important to explore the ways in which empathy is a fundamental part of contemporary design, and design as a professional activity affects the economy. Through looking at areas like fashion, furniture, and technology, and how many consumer segments are making their purchases online while others continue to purchase local design, we can see better what is easily replaced, replicated, and commodified and which sectors need the support of a local production and distribution system. As the intellectual

and technical capacity gap between big and small design centres continues to shrink (to a point where it is potentially non-existent today), this chapter also explores how it is important for small design centres like Alberta to contemplate deeply the hidden competitive advantages of being situated in Alberta.

For example, do designers in small design centres like Edmonton have a unique advantage being situated in the same city as a world-class artificial-intelligence and machine-learning institution—the University of Alberta—compared to the equivalent school being situated in a large design centre? By pairing outstanding design and architectural schools in Alberta with a potentially more empathetic approach to designing for people, could we offer "more human" PSES that are highly sustainable and innovative compared to those of our big design city counterparts? Could we help produce a new-generation global designer who is trained to use emergent technologies but in a more empathetic way?

Given the potential of this idea, which is explored in greater detail throughout this chapter, it is important to acknowledge the fact that changes in technology, economy, and thinking have always had a direct impact on both society and economy. Of equal importance, we must remember that design and the creative industries are key shapers of societal tastes and preferences and that this allows our profession to affect the economy as a whole. Just as the Industrial Revolution led to the growth of major cities and stimulated urban migration, the continual expansion of the creative economy is allowing new forms of social reorganization to take place. As our world continues to become increasingly decentralized, and as universal access to new forms of education, communication, and knowledge continues to grow,[7] it is important to recognize that this unique socio-economic structure is where design is situated. It is one of the ways that exceptional design from small design centres can be important on a global level.

With this perspective in mind, I believe that four critically important shifts are occurring in the industrial design field and that Alberta is strongly situated to capitalize on these changes. First, I contend that the

world needs the training of more expert generalist designers. These are highly skilled individuals who understand the importance of using creative, holistic, systems-based thinking throughout every part of a project and company. Second, this new role requires designer-creatives to become highly skilled at addressing their clients' entire business model by recognizing that innovation can occur anywhere within the greater ecology of a business's competitive space. Third, small design centres like Alberta have a vital role to play in creating new generations of PSEs, both for our local and regional economy and for export to other economies around the world. And fourth, new funding programs need to be created for design—especially for creative-based, multidisciplinary projects that encourage people, practitioners, and researchers to work inside and outside of their native areas of expertise.

In the next three sections of the chapter I examine these ideas through the lens of the creative economy, both globally and within Canada. I situate design within the creative economy and explore the idea of the expert generalist industrial designer who needs to become more skilled at addressing business models. In the fourth section I describe the Luxury of the North, an international design project that I co-developed with Droog (Netherlands), as a way of looking at hidden knowledge parallels[8] and how old knowledge, wisdom, and locality can help induce positive shifts in the industrial design field. In the final two sections of this chapter I use Frans Johansson's exploration of the Medici effect to highlight how diversity propels the creative economy and to explain my contention that it is essential for governments and other funding bodies to support design better.

Design and the Creative Economy

Since publication of *The Creative Economy* by John Howkins in 2001, an increasing number of researchers and authors have attempted to define the boundaries of the creative economy and quantify the transformation of global consumption patterns by rapid advances in technology and connectivity.[9] In *The Rise of the Creative Class* (2002), Richard Florida made

a significant contribution to this emerging body of research by broadly defining the creative community and its economic contributions to the global economy. In his view, the creative class comprises "people in science and engineering, architecture and design, education, arts, music and entertainment whose economic function is to create new ideas, new technology, and new creative content."[10] Though Florida has been criticized for some of his claims about the size and economic power of the creative class,[11] his writing has made a significant impact on government policies around the world and on the development of creativity-funding programs. His work has also encouraged other authors and organizations to investigate how creative communities have a positive impact on the global economy. Hidden in Florida's research and highlighted in the United Nations' *Creative Economy Report 2010* is an interesting statistic: Despite a 12 per cent decline in global trade during the 2007–2008 economic recession, world trade of creative goods and services rose at an average annual rate of 14 per cent.[12]

While it seems counterintuitive that creative (and potentially luxury) goods sales would increase during a recession, this growth pattern suggests that creative industries are one of the strongest, most durable, and most dynamic sectors in the contemporary global economy. It also hints at the impact of design and creative industries on companies and nations that are investing in this rapidly expanding sector.

Despite the strength of the creative industries in the global economy, tragically Canada lags far behind all other developed nations in creative export growth. The United Nations' report (the largest creative economy report ever conducted globally) suggests that the creative economy is one of the most misunderstood and perhaps most undervalued economic engines in Canada.[13] The report shows that we had negative export growth of creative goods and services between 2005 and 2014 (with 2014 being the lowest year since the report began in 2002). Canada also has the dubious honour of being the only developed country in the report with negative export growth. This statistic is even more startling when we realize that Canadian creative imports rose during the same period (see figure 5.1).

Canada Creative Industries Trade Performance, 2005–2014 (Value in millions USD)

	2005	2006	2007	2008	2009	2010	2011	2012	2013	2014
Export	10,422.95	10,264.88	9,803.48	9,337.48	6,501.29	7,005.72	7,211.07	6,245.26	6,292.42	6,242.54
Import	10,429.97	11,528.94	14,182.68	15,312.96	12,951.34	14,516.55	14,527.01	14,571.41	14,674.18	14,288.50
Balance of Trade	−7.02	−1,264.06	−4,378.95	−5,975.48	−6,450.05	−7,510.83	7,315.94	−8,326.15	−8,381.76	−8,045.96

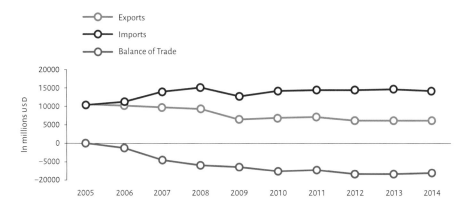

FIGURE 5.1. *Canadian creative economy performance. United Nations,* "*Country Profiles, 2005–2014*,"
in Creative Economy Outlook: Trends in International Trade in Creative Industries, 2002–2015, 120.

I doubt that Canada's dismal performance is because Canadians simply
prefer other country's goods and services to our own. Instead, I believe we
underestimate the tangible and intangible value of creative work and
good design.

While other developed nations in the UN report tended to see export
growth rates in the 75–90 per cent range over a ten-year period, we had
negative export growth and missed out on money that could have contrib-
uted to our economy and society. Yet, these statistics also suggest opportunity.
They allude to the importance of creating vibrant cities, strong creative
sectors, and design training systems.

The Evolution of the Expert Generalist

How does industrial design, a field that has resisted definition, boundaries, and efforts to attain professional status (as offered by architecture or engineering degrees), fit into a province's growth plans or into a country where many companies struggle for survival during a global economic recession? Is not design a luxury, an add-on, a signal of excess, or the superficial application of aesthetics? Is design, as it is so commonly understood by the mass market, the application of beautiful materials, finishes, and technologies that are carefully wound up in multimillion-dollar marketing campaigns?

Although some industrial design was historically limited to stylizing products throughout the early part of the twentieth century, the contemporary reality is that the profession has matured to a level at which its professionals are trained to work closely with end-users in a creative, empathetic, inclusive, adaptable, and highly participatory manner. But how do these competencies translate as the creative economy continues to become ever more powerful? Is it enough for industrial designers (and all members of design and creative communities) to merely tweak what they have been doing? Or will designers need to develop a new set of design skills and tools that can address new complexities within the creative economy? Further to this point, is it conceivable that designers could help direct where the creative economy is headed? In a visionary paper included in the *Creative Economy as a Development Strategy* publication,[14] Pernille Askerud proposed just that. She notes: "[A] shift in trade and economy towards knowledge-based production is not only a shift from one kind of product to other goods and services. It is a fundamental shift in the way production and businesses are organized, as well as in the way we live our lives and understand ourselves."[15] This insight shows that restructuring what people, designers, and businesses do on a day-to-day basis is not a trivial act; it forces fundamental shifts in our training and in the levels of our knowledge base and adaptability. Further, I contend that a shift to diverse and deeply interconnected forms of global production, consumption, and communication is moving industrial designers from being the visionaries of material goods toward being important shapers of social values and expectations.

Although the PSEs created or co-created by industrial designers may seem like isolated creations, in the most effective cases they are tangible and intangible agents of change that affect short- and long-term needs, wants, desires, and expectations.

Recognizing that the creative economy is one of the most powerful, durable, and influential economic sectors in the world,[16] that design is the largest contributor to this economy based on export numbers (see figure 5.2), and that industrial designers are central within design and the creative economy, one could add new meaning and content to what Peter Drucker, one of the best-known authors on the knowledge economy, wrote: "The basic economic resources—'the means of production'...[are] no longer capital, nor natural resources...nor 'labor.' It is and will be [how] knowledge [will be used and disseminated by and among the creative communities]."[17]

If we agree that knowledge is not static, that the Industrial Revolution was driven, in large part, by the ability to enhance production efficiencies through the evolution of knowledge, and that the knowledge economy has been leveraged by people's ability to access and manage increasing flows of information, a simple yet deeply important question could be asked about my thesis that creativity (and design) will be a fundamental part of directing major parts of the next great global economy: If knowledge has always been a central driver of all economies, and if knowledge flows are getting faster, more manageable, and more accessible, what happens when knowledge and access become ubiquitous?

Put differently, what happens when a person can access anything, at any time, and get precisely what they want with virtually no delay? Will there be an increased demand for highly personalized PSEs? Will people tire of everyday off-the-shelf products? Will they seek unique new services and experiences that are deeply meaningful to them? Will a concern for the greater good and for equity become important? The answer to these questions, which many others have contemplated and written about in far greater detail, I believe, is "yes." Given the diversity of the global consumer base, the variety of needs, wants, expectations, and desires, and the fact that lack of knowledge and access is a shrinking barrier, developing highly

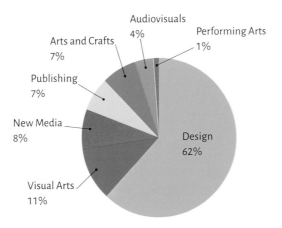

Audiovisuals
4%

Performing Arts
1%

Arts and Crafts
7%

Publishing
7%

New Media
8%

Visual Arts
11%

Design
62%

FIGURE 5.2. Shares of creative goods exports by category, globally in 2015. United Nations, "Country Profiles, 2005–2014," in Creative Economy Outlook: Trends in International Trade in Creative Industries, 2002–2015, 22.

personalized PSEs will not only require designers to understand people, companies, and economies at a deeper level but also require a new genera-tion of holistic system-based creative thinkers. As mentioned earlier, this is the realm of design and the creative fields. I propose that it is the realm of the expert generalist designer-creative—people, teams, and hive-thinking groups who make sense of the intangible, fickle, and indescribable tastes that ebb and flow over time.

However, practically speaking, what does this emergent trend and the new mix of artificial intelligence and machine learning mean for practising designers, companies, and educators? Is it necessary that all designers and design schools, especially those in smaller design centres like Alberta, train and hire expert generalist designer-creatives? Or will computers take over all analysis? Although it is increasingly apparent that Google, Amazon, and many other mega data–driven companies are making huge strides in identifying (and even directing) tastes and preferences, I strongly believe that there are innumerable volumes of softer emotional intangi-bles that machine-learning programs will always struggle to make sense of (especially when blended with a desire to improve social and environ-mental well-being). Whether it is the challenge of identifying a person's

ultra-specific aesthetic tastes related to a forgotten memory in the past, or even a reaction to computers analyzing our every preference, it seems plausible that designers from small design centres have an increasing role and importance in our evolving economy and in the shaping of our society.

From the perspective of a pedagogical, knowledge, and creative execution, it is worth contemplating the logic of training and employing the same types of designers we may find in major design centres like San Francisco, New York, Tokyo, or Berlin. More to the point, is it logical for Alberta and other smaller design centres around the country (and world) to train and employ a slightly different kind of design expert? Is there a unique contribution that we can make to the local and global design world that is, at least partially, rooted in geographical isolation and how we identify problems and opportunities? This idea loosely relates to the eighty-twenty rule. For example, is it logical that people working in large or major design centres can do better design work than their peers working in small design centres. Or is it possible that people working in these smaller design centres have other skills, unique approaches, or techniques that could allow them to identify better the smaller granular problems and opportunities at social and environmental levels? Could a portion of the 20 per cent part of this "rule" come from expert generalist designers who have a unique ability to be more empathic to various social conditions, to community, to the environment, or to well-being? From a strategic perspective, this unique skill set could become an important selling point for Alberta designers. I believe that designers from small centres like Alberta can focus more holistically and empathetically than can many of our larger city counterparts.

Drawing on this unique specialization would require us to continuously zoom in and out, from micro issues and opportunities to larger macro issues and opportunities. It is a deeply human and community-centred front-end approach that could help us develop a greater understanding of the natural and man-made ecological systems within which we exist and that influence us.

I believe this intellectual and empathetic flexibility seems to exist somewhat naturally in all types and forms in small to medium-sized cities

and towns, no matter whether they would normally be called a small design centre. Based on higher levels of interdependence, openness, and sharing, when paired with contemporary approaches to design (i.e., co-design, strategic design, etc.), this unique skill set also has the potential to be valued and needed in larger design centres—where analysis and production cycles typically take on a much more frenetic pace.

This thesis is supported and leveraged by a variety of significant shifts in what is being designed by whom, and how things are being sold, distributed, and marketed in a flatter, more distributed economy (e.g., Etsy, KickStarter, StockX). It is also backed up by noting the significant number of small and medium-sized enterprises in the local, Canadian, and global economy.[18] As the design pace and production of PSE creative hybrids speed up, so too does the importance of using small design centre expert generalists, and, equally, so does the importance of understanding our potential and natural skill sets.

Designing Innovative Business Models for the Creative Economy

Given that design is the largest contributor to the global creative economy (figure 5.2) and that the cultural and creative industries generated US$2.25 trillion in revenues in 2015,[19] it is important to understand fully how design affects daily consumption habits, tastes, and even conceptions of well-being. It is well understood that information mediums (i.e., people and the Internet) can dramatically alter the pace of information flows and the development of knowledge. These mediums in turn affect consumer desires and influence what designers create, and as such, designers are actively participating in altering the global economic, environmental, and socio-cultural landscapes. As we continue to move from being strictly aesthetic mirrors of society to being key shapers of social values and expectations, the stakes are higher than ever before, considering the ecological, socio-cultural, and economic concerns that exist regionally and globally. The solution is not just to be an expert generalist but also to become advocates and educators for our clients and for our client's clients. We must find ways of understanding the greater ecology of our PSEs and, more

holistically, the people who use them. We must aim to understand the people, the places, the spaces, and the larger ecological systems that our designs live within, and how they affect people. Ultimately expert generalist designers need to be involved sooner, longer, and more meaningfully throughout an entire project if this is going to happen. For example, do the idea, the scope of design, and the potential outcomes improve if designers provide input to investment stakeholders? What if designers could explore more fully the boundaries between distribution, strategic partnering, key partners, revenue streams, and resources?

Business model canvases are one of the most effective tools for exploring these opportunities.[20] A business model canvas is essentially a visual and strategic planning tool that seems inherently biased toward the business community and start-ups. Alex Osterwalder, an innovator of business model canvases, helped to popularize a highly visual system that breaks a company into nine easy-to-understand components. He intended to challenge assumptions about how a business could run and to expose the interdependent relationships among a company's traditional silos. In my view, Osterwalder inadvertently exposed the importance of using and integrating designers throughout every part of a project, company, and business model.

These canvases provide visual maps that, when used by expert generalist designers and other stakeholders, allow managers, directors, and entire teams to see the greater landscape of problems, issues, and opportunities that exist in their and other stakeholder domains. They allow new and unanticipated tangible and intangible ideas to emerge, simply because the greater ecology of the project, the company, and its user base can be seen and understood holistically. Most importantly, these canvases ground ideas, inspirations, and hypotheses within a meaningful architecture that all stakeholders can understand.

Most readers will understand the differences and relationships between tangible or physical products and intangible products (e.g., a record versus a downloaded song), but it is nonetheless important to address how the word *design* is being used day-to-day and how a business model canvas

can enhance innovative outputs. The term *design* is most often associated with physical things or tangible goods (*design* as a noun), but for many of the most successful design firms and schools around the world, there is a constant reframing of the word *design* throughout a project and curriculum. To these groups and organizations, *design* is much more than a thing, especially in the beginning stages of a project. It is a noun, but it is also a verb (a process or action) that is intended to enhance creative and holistic thinking.[21] Certainly not a new idea to most design schools and highly effective design studios (e.g., Stanford's d.school, Savannah College of Art & Design, IDEO, and Frog), this type of thinking not only requires designers to work with experts from diverse disciplines and professions outside design (e.g., cultural anthropologists, sociologist, psychologists, and MBA-degree holders), but also requires them to work collaboratively within, outside of, and between these disciplines. Analogous to working with a dozen people from different cultures who talk in different languages, having the ability to effectively work with colleagues from these areas is one thing, but being able to develop compelling and innovative ideas during the grey space of design (again, the space between the gathering of information or data and the time that PSEs begin to be fully visualized) is challenging, to say the least. With this in mind, expert generalist designers are in an important position because they can help train and educate, and navigate the messy spaces that allow design outcomes to expand into unsuspecting areas inside and outside of a company. Through using visualization tools like business model canvases and allowing designers to help direct these discussions, traditional silo approaches to growth and innovation can be broken down and replaced with highly inclusive teamwork efforts. Being that the role of most (industrial) designers is to work on highly diverse projects and with team members from different fields, allowing information and knowledge to flow seamlessly between fields is utterly important.

Epistemology refers to the study of the foundations of knowledge. It questions decision-making and the distinction between true (or adequate) knowledge and false (or inadequate) knowledge. This study of knowledge applies to issues of scientific methodology, and questions how new theories or models could be better than older ones. Though discussions of epistemology can seem heavily philosophical and far removed from the day-to-day practice of design, I believe that philosophy is deeply relevant to the evolution of the creative economy and the field of design. Exploring how new knowledge is formed, who its participants are, what the emerging "truths" appear to be, and how knowledge grows and is disseminated is important to understanding how innovation and sustainable growth can occur within the creative process.

As disruptive social networks and technological breakthroughs continue to infiltrate society with more opportunities for purchase and consumption, I believe that it is important for designers to question where our information is coming from and how our outputs can form new knowledge. Furthermore, not unlike the saying "Those who win wars write history," I believe that designers need to become increasingly aware of how design outputs influence tastes and preferences and help write history.

Further to my discussion about the importance of small design centres, it is important to explore more rigorously what Edmonton, Calgary, and smaller cities like Lethbridge can teach and offer society. Is there knowledge that we could share that could positively influence the global design landscape?

Related to this last point, I also believe that some of the most important, misunderstood, and under-recognized sources of knowledge are in the work, traditions, products, and cultural rituals of remote and Indigenous communities. Can smaller communities, regions, and countries around the world that have a deep Indigenous history become a focal point of creative envy and inspiration? What strategic advantages do small producers and remote and Indigenous communities have over their counterparts in large,

design-oriented cities? How can people from remote towns and hamlets inform the rapidly changing world of design?

Acutely aware that Canada, Alberta, and especially Canada's Far North have not been recognized as global design centres for innovation, I reached out to the renowned design group Droog in 2008. Droog is a truly iconic Dutch design studio known for its fearless exploration of global design topics. I believed that working with their designers would help me understand better the local knowledge and gain more critical insights into global perceptions of Canadian design.

Through a stroke of lucky timing and parallel thinking, Renny Ramakers, the co-founder of Droog, informed me that the studio had recently set up Droog Lab to explore "the next generation of global design." After innumerable discussions and many months of consultations, Renny and I developed a collaborative project titled Luxury of the North.[22] The two-year project explored concepts of sustainability and luxury from a northern perspective and had four primary goals:

1. Explore and demonstrate that creative-based research teams can collaboratively test and develop new models for building creative capacities and exports.
2. Identify and exhibit untapped sources of inspiration and economy at a local level that can be relevant to people regionally, nationally, and internationally.
3. Demonstrate, reinterpret, and enhance the capacities of the creative community to become leaders in identifying, designing, developing, producing, and distributing innovative ideas and PSES.
4. Build intellectual, economic, and social bridges between contemporary markets and rich sources of knowledge in remote or traditional communities.

Based on these goals and a year of background research, eight members of the Luxury of the North team flew to Pond Inlet, Nunavut, in June 2010

FIGURE 5.3. Pond Inlet, Nunavut, June 2010. Photograph provided by Tim Antoniuk.

FIGURE 5.4. Pond Inlet, Nunavut, June 2010. Photograph provided by Tim Antoniuk.

(see figures 5.3 and 5.4). External team members in the project were Winy Maas, Ole Bouman, Christien Meindertsma, Ed van Hinte, Cynthia Hathaway, Agata Jaworska, Stuart Sproule, Pirjo Haikola, and myself. Local collaborators and advisors to the trip included Sheila Watt-Cloutier, Aqqalu, and Nicole Jauvin.

Pond Inlet is one of the most remote and traditional northern communities in the world. It was immediately evident upon arrival that not a single member of the external team —which included some of the greatest creative minds, researchers, and practitioners of our time—had ever been to such a unique and inspiring environment. We were in awe of the endless white Arctic landscape, twenty-four hours of sunlight, and the flawless functionality of artifacts that the Inuit had developed over millennia. One of the most profound sources of inspiration, however, was that the community did not have a written history. Knowledge was transferred orally through storytelling or by physical means. Somehow the community had, over time, become experts at teaching through the process of doing. They had incredibly effective storytelling techniques and were able to share knowledge with and through artifacts.

Our deeply moving experiences with elders and community members exposed so much unique knowledge. The community has an incredible amount to teach the rest of the world about natural and built environments. This includes practices that draw on embedded knowledge and their understanding of links between people and objects.

Each member of the design team developed work inspired by this visit. These Luxury of the North outputs were highly diverse and quite conceptual in nature (those who know the work of Droog will understand this). Winy Maas, an internationally acclaimed architect and director of the Why Factory (the architecture academy at Delft University), proposed five architectural concepts influenced by environmental qualities of the Canadian Far North. Christien Meindertsma proposed two deeply practical concepts of how to create a wild tea herbarium and how to use "wild bone china" in innovative ways. My concept was inspired by nomadic Inuit rituals and lifestyles. I explored the ways in which a nomadic businessperson could

FIGURE 5.5. *The Nomadic Home Concept by Tim Antoniuk. Image provided by Tim Antoniuk.*

redesign how they travelled and what parts of "home" they would bring with them (see figure 5.5).

Cynthia Hathaway, a Canadian-born designer now living and running a design studio in Amsterdam, showed the importance of engaging directly with remote communities, seeking out ancient knowledge parallels, finding new ideas and inspirations for contemporary culture, and exploring new approaches that conveyed meaning. She designed a northern city

or community concept inspired by Inuit hunting and food-sharing rituals (figure 5.6). Cynthia's concept was exhibited in Edmonton and Toronto where the Luxury of the North team created a one-hundred-seat supper with "big food."

Food is often evenly distributed in Inuit communities because of a belief that nothing can be owned. This is a powerful approach for sustainable consumption and community building. The idea of big food was further inspired by the tradition in which a group of men hunt a whale and share their kill with the entire community, as well as by the ability to grow massive vegetables in the twenty-four-hour summer sun. Cynthia's event reflected these ideas and lessons about the importance of continual storytelling with and through objects, services, and experiences (PSES).

Though unrealistic for most design projects (of any size), our trip to one of the farthest inhabited points in the Canadian Arctic offered important lessons for sustainable communities and economies. It taught us how to move from being isolated product designers to being systems-based creators of new opportunities.

The experiences, lessons, and outcomes of the Luxury of the North project, though somewhat conceptual, reinforced an important contemporary reality for the team—that creative communities have access to many knowledge parallels. There is a wealth of knowledge and experiences across the world. It is our responsibility to continuously seek, learn from, and be inspired by these ideas, while remaining conscious of the give-and-take in relationships and ethics of exchange.

The Medici Effect and Knowledge-Transfer Mediums

The Medici Effect by Frans Johansson gives historic examples of the ways in which groundbreaking ideas emerge more often through collaboration between people from diverse backgrounds[23] than from situations where people with similar perspectives work together. Johansson also investigates the reasons that many world-changing insights come from people with little or no experience in the fields they have changed. He shows how breakthrough innovations tend to come from bringing concepts from

FIGURE 5.6. XXL *City Harvester Complex, a scenario of a future city or community built around "big food" and sharing, and exposing the production-consumption cycle. Concept and design by Cynthia Hathaway. Image used with permission of Cynthia Hathaway.*

one field into a new one. It seems that innovation expands when diversity flourishes.

As the creative economy continues to expand globally, it is interesting to see socio-economic parallels to what happened during the time of the Medicis and to what I am proposing in this chapter. Well-being and progress are not driven strictly by the development of new technologies or the training of more experts for the same siloed professions; they are seeded when diversity, inclusivity, and creative talents are allowed to flourish and inform all levels of society. Assuming this is true, what are some of the lessons that contemporary designers, businesses, politicians, and small creative producers can borrow from Johansson and his writings about the Medicis? For this family of bankers, who grew their wealth, fortune, and global influence in less than one hundred years, one of the most important

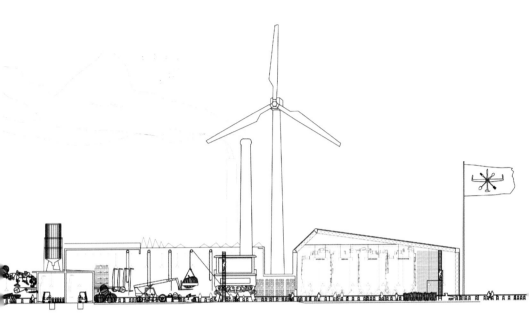

aspects of their rise to power and influence was their insight into the deep interconnectivity of artists, poets, designers, builders, architects, scientists, and the economy of Florence. Believing that a highly skilled workforce resulted from the continual development of new skills, the efficient transfer of knowledge, and ongoing diverse inspiration, the Medicis encouraged and supported the cross-pollination of the creative and scientific fields. This approach to enhancing humanism helped usher in the Renaissance, produced a culture rich in art, politics, and architecture, and spurred economic growth. Further, the Medicis' philosophy (though driven in large part by their thirst for power) proved that supporting creativity, diversity, and inclusivity at local levels could promote widespread socio-cultural and economic growth.

Despite the diversity found on today's post-secondary campuses and the fact that many people around the world have access to an unlimited volume of information through the Internet, I propose that most cities, regions, and countries in the West lack three key ingredients that

the Medicis encouraged. First, truly diverse inclusivity is missing in most professional projects and throughout our educational systems. Second, this lack of diversity and inclusivity is caused, in part, because our educational systems are not focused on training and using highly skilled, creative, systems-based thinkers. Third, our contemporary political and societal obsession with mass industrial production has led most companies, industries, and markets to compete on the lowest common denominator—price—instead of using and enhancing the diversity of skills and knowledge that is embedded within our local and regional communities.

These ideas, which relate to how and what people learn, how they consume, and what they desire, also highlight a transition that could occur from the supplying of people with unlimited volumes of information to a position where action is driven by diverse knowledge. Although instant connectivity and a new generation of analytics have a positive effect on economies and many aspects of well-being, it is important to remember that information, data, and analytics are not the same as knowledge or truth. Within a design context this only suggests what people have liked and what they might continue to like in the future. Viewed from the lens of a designer who constantly seeks meaningful insights, like *The Medici Effect* suggests, the development of holistic insights about individual and community needs, wants, desires, and aspirations requires not only a unique set of skills and knowledge sources but also the unique and fuzzy skill set of being able to translate diverse information into tangible and intangible PSEs. Great design from small design centres and regions— like Alberta—holds the potential to offer something more promising than a new product aesthetic, a better interface, or a faster performing device. Great design from small design centres could offer a deeper and more human experience and could more seriously consider pressing issues like the environment, well-being, equality, and happiness.

These possibilities suggest that the scope of design is increasing and that designers need greater knowledge diversity in their research and creative systems. In a time when digital information and distribution systems are creating and breaking old knowledge conduits, as the Medicis

encouraged, the enhancing of tacit knowledge is an important ingredient for firmly linking people, community, and sustainable progress. As trust is formed, stronger skills and connections form between people, empathy increases, and new insights into issues and opportunities emerge. In comparison to the fast-paced speed of big-city life and big-scale corporate design, insights from highly skilled designers in small design centres not only need to be celebrated more, but I would suggest that this potential needs to be explored much more.

Investing in the Creative Economy: Why Support Design?

I believe that Alberta and other small design centres around Canada are well situated to significantly increase our export numbers to global averages. The ultimate question becomes, Do we have the necessary support mechanisms to help local cultural and creative industries to compete? Is it the responsibility of creative communities to promote and sell their own work in a competitive global marketplace? Or is there also a responsibility at government, policy, and funding levels to provide better support to diverse forms of prosperity and export? Considering that the cultural and creative industries generated US$2.25 trillion in revenues in 2015, providing stronger support for these industries seems important, if not essential.

There has been a reasonable level of support for arts and culture through national organizations such as the Canada Council for the Arts. However, there is a difference between the arts and culture projects that are commonly funded and projects that have design thinking, outputs, and methodologies at their core. There is also a surprisingly low number of funding programs available for cross-disciplinary and multidisciplinary design-centred projects at academic and professional levels.[24] Commonly, design projects fit in the space between art and engineering or technology-based projects. Design is all too often considered an addition to projects instead of being the lead and focus. Similarly to what other countries,[25] and even provinces like Quebec, have done in forming provincial and national design councils, Alberta and Canada need to look more seriously at how to fund, leverage, and promote exceptional Albertan and Canadian design.

Conclusion

When I was first developing the Luxury of the North project with Renny Ramakers, I took a trip to Amsterdam to meet our team of designers and consultants. Honoured to be working on a project with all of these acclaimed researchers and practitioners, I asked a simple, straightforward question: "What do you think about Canadian design?" After a long silent pause and people looking at each other with a degree of confusion, all I could get from this group of design icons was adjectives like *pure, white, honest, stark, clean,* and *sustainable*. Though initially taken aback by the lack of anything "designerly," I realized many months later that this absence of a creative image was an asset—Canada has not been branded or constrained by a man-made aesthetic or by a past trendy era. We seem to be defined by our natural landscape, by a sense of integrity, and by simple, honest living. To me, this is an incredible opportunity for our people, communities, and businesses, both inside and outside of the Albertan and Canadian creative communities. It is something we can collaboratively expand, leverage, and develop. Fundamental to design and the expansion of the creative economy, small creative producers across Alberta are in a unique position: people inside and outside our borders respect and admire our landscapes, our cultural practices, and the perception that we are inclusive, adaptable, and respectful of multicultural practices, rituals, and traditions. This is fertile ground on which creatives and designers can develop a new generation of global design.

Notes

1. Although industrial designers are commonly perceived to use both applied arts and engineering techniques to improve and/or evolve a product's aesthetics, ergonomics, functionality, and usability, the role has been significantly expanded in recent decades to include the design of experiences and services.
2. My understanding of design thinking parallels the writing in Tim Brown's *Change by Design: How Design Thinking Transforms Organizations and Inspires Innovation*.
3. Florida, *The Rise of the Creative Class*.

4. See, for example, Center for Disease Control and Prevention, *Mortality in the United States*, 2017.

5. Originally coined by Horst Rittel, a theorist and professor of design methodology at the Ulm School of Design in Germany, the term *wicked* refers to problems with many interdependent factors that make them seem impossible to solve. See Rittel and Webber, "Dilemmas in a General Theory of Planning."

6. Urban sprawl is an urban system that can (though does not always) disburse and disconnect people, community, and creative production.

7. Askerud, "The Creative Industries."

8. Shared common experiences, and the idea that these experiences, ideas, and modes of learning can be taught, point to the existence of knowledge parallels.

9. Reis, *Creative Economy as a Development Strategy*.

10. Florida, *Rise of the Creative Class*, 8.

11. Moss, "Deconstructing Richard Florida."

12. United Nations, *Creative Economy Report*, 2010, 127.

13. Since the report began in 2002, 138 countries have been surveyed (United Nations, *Creative Economy Report*, 2010, 126).

14. Reis, *Creative Economy as a Development Strategy*.

15. Askerud, "The Creative Industries," 234.

16. United Nations, *Creative Economy Report*, 2010.

17. Drucker, *Managing for the Future*, 8.

18. "The Gross Domestic Product (GDP) in Canada was worth 1709.30 billion US dollars in 2018. The GDP value of Canada represents 2.76 percent of the world economy" (Trading Economics, *GDP in Canada*, para. 1); small and medium-sized enterprises, for example, represent nearly half of the GDP, most net job growth, and 60 per cent of jobs (Lawrence, "Examining the Factors"); Alberta's GDP in 2017 was over C$329 billion (Duffin, *Gross Domestic Product of Alberta*, https://economicdashboard.alberta.ca/grossdomesticproduct).

19. EY, *Cultural Times: The First Global Map of Cultural and Creative Industries*, 15.

20. For examples of business models that work well for designers, see Alex Osterwalder's online content at http://alexosterwalder.com and https://www.youtube.com/watch?v=QoAOzMTLP5s.

21. See Tom Kelley, *The Art of Innovation*, or Tim Brown, *Change by Design*.

22. Luxury of the North was supported by a one-year Killam Cornerstone Grant. Additional information on the Luxury of the North project can be found at http://www.droog.com/event/amsterdam/.

23. Johansson suggests that designers, researchers, companies, and organizations should seek input, direction, inspiration, and guidance from those with diverse cultures,

ethnicities, genders, religions, experiences, political beliefs, and economic and educational backgrounds.

24. The Social Sciences and Humanities Research Council must be credited with introducing a fine arts research creation grant in the mid-2000s. I received a three-year grant. However, this grant is no longer available. See http://www.sshrc-crsh.gc.ca; http://www.nserc-crsng.gc.ca.

25. For example, the UK's Design Council, https://www.designcouncil.org.uk; the German Design Council, https://www.german-design-council.de; and the Dutch Creative Council, https://europeandesign.org/submissions/dutch-creative-council/.

Bibliography

Askerud, Pernille. "The Creative Industries: Asia-Pacific Perspective." In *Creative Economy as a Development Strategy: A View of Developing Countries*, edited by Ana Carla Fonseca Reis, 232–54. São Paulo, Brazil: Itaú Cultural, 2008.

Brown, Tim. *Change by Design: How Design Thinking Transforms Organizations and Inspires Innovation*. New York: Harper Business, 2009.

Canada Council for the Arts. *Canada Council for the Arts: Funding to Artists and Arts Organizations in Alberta, 2012–13*. Ottawa, ON: Canada Council for the Arts, 2014.

Center for Disease Control and Prevention. *Mortality in the United States, 2017*. National Center for Health Statistics, Data Brief no. 328, November 2018. https://www.cdc.gov.

Drucker, Peter. *Managing for the Future*. Oxford: Butterworth-Heinemann, 1992.

Duffin, Erin. *Gross Domestic Product of Alberta, Canada from 2000–2018*. Statista, November 18, 2019. https://www.statista.com.

EY. *Cultural Times: The First Global Map of Cultural and Creative Industries*. Report, December 2015. http://www.unesco.org.

Florida, Richard. *The Rise of the Creative Class*. New York: Basic Books, 2002.

Howkins, John. *The Creative Economy: How People Make Money from Ideas*. London: Penguin, 2001.

Johansson, Frans. *The Medici Effect: What Elephants & Epidemics Can Teach Us about Innovation*. Boston: Harvard Business School of Publishing, 2006.

Kelley, Tom. *The Art of Innovation*. With Jonathan Littman. New York: Doubleday, 2001.

Lawrence, Japhet Eke. "Examining the Factors That Influence ICT Adoption in SMES: A Research Preliminary Findings." *International Journal of Technology Diffusion* 6, no. 4 (2015): 40–57.

Moss, Ian David. "Deconstructing Richard Florida." *Createquity*, April 27, 2009. http://createquity.com.

Reis, Ana Carla Fonseca, ed. *Creative Economy as a Development Strategy: A View of Developing Countries*. São Paulo, Brazil: Itaú Cultural, 2008.

Rittel, Horst W. J., and Melvin M. Webber. "Dilemmas in a General Theory of Planning." *Policy Sciences* 4, no. 2 (1973): 155–69.

Trading Economics. *GDP in Canada*. Accessed February 28, 2020. https://tradingeconomics.com/canada/gdp.

United Nations. *Creative Economy Outlook: Trends in International Trade in Creative Industries: 2002–2015.* United Nations Conference on Trade and Development, 2018. https://unctad.org.

———. *Creative Economy Report, 2010.* New York: United Nations, 2008.

Designer Founders and the Start-Up Revolution

KEN BAUTISTA

THERE IS A GROWING TREND among today's technology start-ups that places as much importance on designers as on software engineers and programmers. Mobile applications, software services, and hardware devices are winning and losing based on a product's designed user experience and user interface. Designers as entrepreneurs have vision, problem-solving approaches, and new ideas. They are creating bold new companies, new approaches in established organizations, and new products and jobs in every industry. Alberta is seeing an emergence of designer founders who are following the example of technology entrepreneurship and founding, building, and leading a new generation of design-driven start-up companies.

In this chapter I present the unique strengths of designer founders, explore typical paths from designer to company founder and entrepreneur, and discuss the training and support that can enable designer founders to succeed. I link this discussion to the context of Alberta to understand what is needed to support designers. My goal is to provide information that can help local designer founders raise their game and become successful entrepreneurs.

Design Skills: Designers Are the Champions of User Experience

Technology is advancing at a staggering pace all around us—in the home, the workplace, and public spaces. Technology that used to seem like science fiction is now integrated into everyday products, such as mobile tablets, touch-screen walls, telepresence video conferencing, and wearable computing devices.

As the Internet, mobile networks, and computing continue to mature, the way in which regular people interact with these technologies is fundamentally changing. Consumers are demanding products that address problems, make lives easier, and create delight. So, while the underlying technology behind these products becomes more complex and powerful, design and user interfaces are expected to be simpler and more efficient.

This is where designers come in. As champions of the user experience, designers—graphic designers, interaction designers, and industrial designers—have integral roles at technology start-ups focused on building products that are aimed at an evolving consumer market.

Designers consider the bigger picture, caring as much about their product's function as they do about reaching the consumer on an emotional level. Designers go beyond the look and feel of products and explore cohesive brand and product experiences using touch, sound, and movement. This approach contrasts with that of engineers and programmers, who seek absolute solutions around how to make a product work. Engineered products work; designed products work well.

The Path from Designer to Founder

Founding and building a start-up company is not the path that designers traditionally explore. Many designers opt to start and join client-driven agencies and studios. Creatively, agencies and studios offer variety in work, with opportunities to create for different campaigns and clients, often on a one-time basis. Financially, agencies are built on established business models based on hourly or pay-per-fee rates—what you make corresponds to the time you are able to put in.

With start-ups, designers have creative opportunities to iterate a single product based on ongoing customer feedback. Financially, start-ups have scalability (allowing them to increase revenue while marginal costs decrease), which creates opportunities to catch significant upside earning potential in the long term.

As design becomes a key differentiator for companies to succeed, more designers are being drawn to the world of product-driven technology

start-ups. Even major players like Facebook, Apple, and Google are placing more emphasis on design and user experience and are building and acquiring design teams to work on their products.

Designing a winning product for a targeted audience can be tricky, which is why designers are becoming so highly coveted. Let us consider the stories of a few highly successful design-driven technology start-ups founded and led by designers. These examples demonstrate the path from designer to founder and provide successful models for local entrepreneurs.

Pinterest (2010–Present)

Evan Sharp, co-founder of Pinterest, was in graduate school studying architecture when he developed his start-up idea to collect and share architectural drawings and building plans on the Web.[1] He used a simple, grid-based layout to drive the product experience and interface. Pinterest users can upload, save, sort, share, and organize their "pins" (which can be images, videos, and other media content) onto a virtual "pin board." As the Web becomes even more visual and shareable, Pinterest is quickly growing into one of the world's most popular places to connect people through the things they find interesting. Pinterest had 250 million regular users as of 2018.[2]

Airbnb (2008–Present)

Brian Chesky and Joe Gebbia were classmates at the Rhode Island School of Design before they moved to San Francisco to start their careers.[3] Their initial concept for AirBed & Breakfast came together during a national conference; all the local hotels were sold out, and Chesky and Gebbia offered their apartment, breakfast, and hospitality to conference attendees.[4] Soon after, programmer Nathan Blecharczyk joined the Airbnb team as the third co-founder.[5] As a result of being conceived by designers, Airbnb puts equal importance on design and engineering teams, as they continuously refine the user experience for customers both on- and off-line.[6] The result? Airbnb has enabled more than seven million bookings on listings in 191 countries.[7]

Instagram (2010–Present)

Kevin Systrom worked as a product designer at Google before teaming up with his co-founder Mike Krieger[8] to build a new start-up "focused on being really good at one thing."[9] They sought to design "a high-quality mobile photos app with great connectivity, get feedback from users, and build a huge following of loyal fans, without any attempt to monetize."[10] After studying every single app in the photography category, Systrom and Krieger used their user-experience (UX) skills to refine Instagram from both a design and a function perspective.[11] Photographs could be posted in less than three clicks, and, like in Twitter, every photograph was public by default.[12] In only two and a half years, Instagram grew the number of its registered users to over forty million; it was acquired in 2012 by Facebook for US$1 billion in cash and stock.[13]

Veer (2001–16)

Sheldon Popiel was one of the co-founders of Veer, a Calgary-based stock photography company.[14] He studied painting, illustration, and photography at the University of Alberta, which led him to work as an art director at Eyewire (a Calgary-based stock photography company that was acquired by Getty Images).[15] At Veer, Popiel was responsible for growing the company's brand and "creating a way, look and a voice" for communicating with Veer's growing community of creatives.[16] In 2007, Veer was acquired by Corbis, one of the world's largest stock photography companies.[17] Veer and Corbis were acquired and closed in 2016.[18]

Veer, the last of these four examples, is one of only a few design-driven technology start-ups founded in Alberta. Far more designers are starting at, or being recruited into, one of the hundreds of creative agencies and studios across the province. In a market where the largest buyers are government, finance, energy, health, and educational institutions, there are many client-driven businesses to go around.

So, how can we encourage more designers to start or join a scalable, product-driven start-up in Alberta? This will be discussed in the next section.

Investing in Designer-Driven Start-Ups

In Alberta there is some creative work that pays well, but it is not often breakthrough work. Graphic designers, interaction designers, and industrial designers find themselves choosing between freelance or agency opportunities in a local market or creating their own products aimed at a global market. Some designers even leave Alberta altogether to find opportunities in other major markets. Unfortunately this is a vicious cycle. Without breakthrough companies we cannot reinvest to help develop more talent, products, and scalable companies locally.

I believe the solution lies in cultivating a culture of innovation that drives designers to be breakthrough thinkers and doers across disciplines. We need to encourage designers to tackle big problems and design product ideas and solutions that can move beyond the local market. This is the context that enabled high-performing, disruptive start-ups like Pinterest and Airbnb to develop and thrive.

Product Design Culture

The choice for many designers in Alberta comes down to client-driven services versus product-driven start-ups. Rarely is one able to provide both services and product. The design talent exists in Alberta, but much of it is locked in locally focused agencies and studios. A beginning would be to see more products developed in-house or spun out from these agencies and studios, and to see ultimately a transition in talent from client work to product design and development.

One local example is Lift Interactive, a digital agency based in Edmonton. Lift's founders have created a company culture that embraces much of the design-oriented philosophies of the start-ups mentioned earlier. It chooses clients that are product-driven start-ups based outside Alberta, such as Appboy and Gamestaq. The team at Lift has also parlayed its design and engineering skills into new product spin-offs, including Openfield (online applications for scholarships, grants, and awards), Monogram (public profiles and portfolios), and Parade (a photography portfolio site builder).

Spaces to Collaborate

In Alberta, designers, engineers, and entrepreneurs continue to train and operate in silos. This means that opportunities for innovation resulting from the collision of ideas and people do not happen nearly enough. Consider Stanford University's d.school, a collaborative hub where students, faculty, and industry come together to prototype, design, and engineer solutions to the world's problems.[19] New products are developed and refined, and new start-ups begin to form and grow.

We need more of these collaborative spaces and programs in Alberta. It is essential that designers-turned-entrepreneurs have opportunities to find co-founders, collaborative partners, and investors. These resources provide the necessary feedback as products and start-ups take shape. In Edmonton I have been involved in building Startup Edmonton, a campus and co-work-space that is bringing together designers, engineers, and entrepreneurs to build products and start-ups. We provide mentorship, training, and space to help kick-start product ideas that have the potential to become a scalable start-up.

Funding the First Steps

One of the main roadblocks for many designers to choose a path toward entrepreneurship is funding. For this reason many designers (and developers) choose the consulting or agency route where the path to cash flow is immediately apparent: find a project, get paid, and repeat.

Why, then, put time into designing a product that will not immediately generate revenue? Founders of start-ups see it another way. Their approach is to start building and designing something and to put that product into the hands of customers as soon as possible, and then doing this until they have proof that they have created something that customers love and value. To arrive at this stage takes more than simply money. It takes a lot of hustle.

However, having some money as you work through these early stages is useful. At this stage, venture capital is not an option, but more and more resources and seed-stage funds are available to designers and developers who are founding start-ups.

The Designer Fund is an angel fund[20] and community that invests capital and provides mentorship and connections to designer founders who are seeking to develop "businesses with positive social impact."[21] The company was founded by designers from companies like YouTube, Facebook, Google, IDEO, Frog, and Path who came together to invest in designer founders.[22] I am a partner in an early-stage seed fund called Flightpath Ventures,[23] which invests in technical and design founders in Edmonton and Calgary. We provide a combination of cash, mentorship, and workspace in exchange for a small equity stake in each company in which we invest.

Conclusion

Alberta is a province rich in resources and talent. We need to cultivate a high-performance culture that challenges our smart, ambitious entrepreneurs to build and grow scalable companies that can compete in the global knowledge economy. It will take not only entrepreneurs and engineers but, increasingly, designers who can unleash their creativity to build products that people love and to tackle the world's problems in areas like health, energy, and education.

If Alberta is going to make its mark in the global start-up revolution, we will need more designers to raise their game and step out onto the field of entrepreneurship.

Notes

1. Drell, "Pinterest."
2. Cooper, "23 Pinterest Statistics That Matter to Marketers in 2019."
3. Airbnb, "Story."
4. Airbnb.
5. Airbnb.
6. Carr, "For Turning Spare Rooms."
7. Airbnb, "Fast Facts."
8. Instagram, "About Us."
9. Kevin Systrom, cited in Guenther, *Intersection*, 416.

10. Sowards, "Startups, Focus on Quality First," 5.

11. Cutler, "From 0 to $1 Billion."

12. Cutler.

13. Etherington, "Facebook Closes Instagram Acquisition."

14. Ciccone, "Sheldon Popiel."

15. Ciccone.

16. Ciccone.

17. Ciccone.

18. Pickerell, "Veer Closed."

19. Stanford University Institute of Design, "Tours."

20. Angel funds are "groups of investors who pool money to invest together, usually alongside extra investments from individual members" (Tozzi, "Angel Funds on the Rise," 2).

21. Designer Fund, "Who We Are."

22. Designer Fund.

23. For more information, visit http://flightpathventures.com.

Bibliography

Airbnb, "Fast Facts." Accessed December 7, 2019. https://news.airbnb.com/fast-facts.

———. "Story." Accessed May 17, 2013. https://www.airbnb.ca/story.

Carr, Austin. "For Turning Spare Rooms into the World's Hottest Hotel Chain." *Fast Company*, February 7, 2012. https://www.fastcompany.com/3017358/19airbnb.

Ciccone, Carla. "Sheldon Popiel: Creative Director of Global Brands: Corbis." *Avenue Magazine*, October 26, 2009. http://www.avenuecalgary.com.

Cooper, Paige. "23 Pinterest Statistics That Matter to Marketers in 2019." *Hootsuite*, February 27, 2019. https://blog.hootsuite.com.

Cutler, Kim-Mai. "From 0 to $1 Billion in Two Years: Instagram's Rose-Tinted Ride to Glory." *Tech Crunch*, April 9, 2012. http://techcrunch.com.

Designer Fund. "Who We Are." 2012. http://designerfund.com/.

Drell, Lauren. "Pinterest: Behind the Design of an Addictive Visual Network." *Mashable*, December 16, 2011. https://mashable.com.

Etherington, Darrell. "Facebook Closes Instagram Acquisition, Instagram Announces 5B Photos Shared." *Tech Crunch*, September 6, 2012. http://techcrunch.com.

Guenther, Milan. *Intersection: How Enterprise Design Bridges the Gap between Business, Technology and People.* Waltham, MA: Elsevier, 2013.

Instagram. "About Us." 2021. https://www.instagram.com/about/us/.

Pickerell, Jim. "Veer Closed: Corbis Will Close May 2." *Selling Stock: Inside the Stock Image Industry*, April 7, 2016. http://www.selling-stock.com.

Sowards, Andy. "Startups, Focus on Quality First: The Instagram Model." 2013. http://www.andysowards.com/blog/.

Stanford University Institute of Design. "Tours." 2013. http://dschool.stanford.edu/about/.

Tozzi, John. "Angel Funds on the Rise." *Bloomberg Business Week*, October 9, 2009. http://www.businessweek.com.

The illustration represents the complexity and dynamism of sustainability both as a concept and in practice in Alberta design. My work is a visualization of three pillars of sustainability: environmental, economic, and social. I represent the pillars not as static columns but as an intricate network that is continuously expanding. The grey "pillar" is inspired by the major, complex role that oil plays in the Alberta economy. The greens and yellow of the environmental "pillar" draw from the Alberta landscape and its representation in the crest on our provincial flag. The multicoloured social "pillar" acknowledges the great diversity among Albertans. The role of the designer is represented both by the points in the network that have been altered and by the dotted lines, which can be seen as the many explorations and sketches that help designers solve problems and form ideas that bring about change and growth.

ELIZABETH SCHOWALTER

Sustainable Design Practices in, for, and from Alberta

CARLOS FIORENTINO

Sustainability in Alberta

Experiences and Impressions by Design

MANY PEOPLE THINK OF ALBERTA as one of the worst places in the world for trying to change the mainstream mentalities of consumerism, waste generation, fossil fuel dependency, corporate capitalism, and wild industrialism, among other unsustainability evils. An examination of statistics, government actions, and media discussions and debates makes it clear that the sustainability planning of Edmonton and Calgary is far behind that of cities like Vancouver and Portland (two recognized leaders in sustainability planning in North America) or, especially, Copenhagen and Singapore (two recognized global leaders in the matter). Instead, many Albertans are proud to be compared to places like Texas, to locations that are recognized for their particular set of social values, their conservative approach to progress, all interwoven with economies that are strongly dependent on the infinite availability of fossil fuels. Though Texans might boast a high quality of life,[1] their lifestyle requires too high a price if the rest of the world follows a similar pattern.

Our Sustainability Report Card

It is well known that the richest 20 per cent of the world's population earn around 80 per cent of the world's income and use the most resources of the planet.[2] In addition, the richest 1 per cent earn the combined annual income of the poorest 57 per cent.[3] Canada alone has a big slice of this cake.[4] A better distribution of material and human resources is essential to the sustainability equation implied in the triple bottom line of sustainable development.

According to the United Nations' 2009 *Revision* of *World Urbanization Prospects*, 82 per cent of the population in North America is concentrated in urban areas (cities), and this level is expected to continue rising, so that by 2050 it will be more than 84 per cent.[5] If the whole world lived in the same way that people do in North American cities, we would need resources from two and a half planets to cover the demand by 2050.[6] Edmonton and other Alberta cities rank above average; more than three planets would be required to share our lifestyle with the rest of the world.[7] Mark Anielski, economist and professor at the University of Alberta School of Business, noted that Edmonton had the second highest ecological footprint of all Canadian cities in 2004.[8] Edmonton's ecological footprint was 30 per cent larger than the Canadian average, 3.2 times greater than the global average, and 4.1 times greater than earth's biocapacity.[9] In 2005, Calgary reached the top of the footprint ranking at 9.86 global hectares per person (the Canadian average is 7.25 global hectares).[10] Similar to Edmonton's, Calgary's ecological footprint is 30 per cent higher than the Canadian average.

Sustainability through Design: A Model for Alberta

Many innovative sustainability projects involve design thinking. According to economist and ecologist Paul Hawken, "a sustainable world is a design problem, rather than a management problem."[11] Design is about change. We can manage our resources better if we first design better systems to execute with current engineering and technology, like producing more renewable energy and planning our cities to be self-sufficient and carbon-neutral. Planning the future of our systems based on using finite resources until depletion, managing crisis after crisis, is an unrealistic plan. Our choice is to either change by design or change by disaster.

Thus, Alberta can and must work toward a sustainable future by focusing on a review and redesign of the way the city was conceived during booming periods, when high revenues from oil created fast new employment, rapid population growth, and urban sprawl, all with little or no long-term planning for future generations living in the urban spaces created.

Design innovation requires shared information, collaboration, and working for the common good. Design is an interdisciplinary field. Designers need to work closely with other experts in the areas where design is called to intervene, in order to approach problems with a holistic view. In particular, designers for sustainability cannot afford to work in silos and lose perspective of the whole. When designing a sustainable future for Alberta, we might envision designers working side by side with urban planners, industrialists, biologists, and other scientists to achieve sustainable results. Victor Papanek defines this approach to design as "generalism"; he suggests, "Man is a generalist that, by designing his environments, tends to achieve specialization."[12] This tendency can create overspecialization and isolation. Arthur Koestler describes the overspecialization of species as "a detour in their evolution, contrary to diversifying"; he points out that "over-specialization is the principal cause of stagnation and extinction."[13]

Designers must look for the right sources of inspiration and the right examples to mimic. In planning cities like Edmonton, for example, why do we need to mimic US cities in Arizona or Texas? Would it not make better sense to take a look at other Nordic cities that have similar weather characteristics, such as cities in Finland? Why not mimic the natural patterns and diversity found in Alberta when designing Alberta's urban spaces?

Alberta's Potential

Alberta is a rich space for design intervention. If you really want to make a difference as a designer, you should not go where everything is well designed. That is one of the reasons I choose to stay in this part of the world, where everything in terms of sustainable design needs to be done, undone, and redone. This situation provides me with many opportunities to explore alternative solutions to ill-formulated problems, discuss controversial issues where they are created, and teach and learn in contact with the source of the problems.

I believe that Alberta has all the necessary resources to make sustainable futures a reality. For instance, this province is among the best spots on

earth to collect solar power. The number of sunny days a year (comparable to some sunny destinations in Brazil), in addition to good air quality and the geographic characteristics of the prairies, make the perfect conditions. Not too many habitable places meet all these factors.

German parliamentarian and solar energy advocate Hermann Scheer once explained that "the sun offers to our globe, in eight minutes, as much energy as the annual consumption of fossil and atomic energies. Arguing if there would be enough renewable energy for the replacement of nuclear and fossil energies is ridiculous. There is by far enough."[14] Thus, Alberta has the potential to become a leading player in a sustainable energy market. In addition to natural resources, Alberta offers cultural diversity and high-quality minds. Cultural diversity is key to enhancing the social aspect of the triple bottom line of sustainability, and it provides the community with a broader perspective. Local universities are home to extraordinary scientists, scholars, and professionals from Alberta and around the world. With these resources combined, we can approach the design problem of sustainability through multidisciplinary collaboration and research excellence. This, however, is not enough to make Alberta sustainable in the long term unless we also make some lifestyle changes in the short term. Political will and intelligent leadership also play a crucial role in these changes. What might hold us back and make this process longer is the one bottom line mentality mentioned earlier in this chapter: a short-sighted, linear way of thinking.

At this point you may ask, "Why haven't we done this already?" I can answer that we have already started in some intangible aspects such as design education, by teaching with a different approach and giving future generations of local designers a broader set of conceptual tools to design a sustainable future. This is a change in mindset and a long-term pros-pect that could take even longer in a place like Alberta, but this change is inevitable.

Ideal Changes

Alberta's new political agenda could be more influenced by emerging concepts adopted by design and could include promoting and consuming

local products; switching to renewable energy sources; designing houses and buildings to be self-sufficient (to produce the energy they need and to export the excess back to the energy grid); planning and building in favour of walkable and bikeable cities; increasing the density of the city core to avoid urban sprawl; considering education to be an important public investment rather than an expense; and creating proactive health programs. The list grows even longer as we start to implement some of these concepts. Together these changes will have an impact on sustainability. Alberta's political agenda also involves Alberta's education agenda: one of the fronts for preparing the province for a qualitative change of direction is the inclusion of education focused on sustainability.

To achieve a sustainable future in Alberta we need to start by admitting that change is required. Many Albertans may ask, "How realistic is this approach to making changes?" To such a question I can answer with another question: How realistic is it to keep doing over and over the same business as usual—or design as usual—that has driven us to the crisis of unsustainability we face today, and expect different results in the future? This behaviour has been defined as "madness."[15]

Conclusion

In conclusion, I have presented in a nutshell Alberta's sustainability report card, discussed promising models for sustainable practices in Alberta, and addressed Alberta's potential for a sustainable future. Through this discussion it is clear that Alberta must make significant changes to become sustainable and to approach an ideal sustainable future. The question arises, How far away are we from seeing changes toward real design for sustainability in Alberta?

Notes

1. Callahan, "Austin Named Best City." Perhaps overrated, Austin, Texas, was ranked "the best city of the decade" in the United States for "starting your life over."

2. UNDP, "*International Human Development Indicators.*" In addition to UNDP statistics, UNDP interactive tools help visualize the magnitude of these numbers.

3. World Bank, *World Development Indicators 2011.*

4. According to the UNDP *Human Development Report 2011*, Canada and the United States are ranked fourth and sixth respectively. Human development indicators include key aspects of human development in countries and regions, such as the gross national income per capita.

5. United Nations, *2009 Revision of World Urbanization Prospects.*

6. Global Footprint Network, "World Footprint."

7. Anielski and Wilson, *Ecological Footprints.*

8. Anielski and Wilson.

9. Anielski and Wilson.

10. The ecological footprint ranking forms part of the *Alberta Genuine Progress Indicator Report* (Anielski and Wilson, 2008) and the *Ecological Footprint of 18 Canadian Municipalities* (Wilson and Anielski, 2004), using standard ecological footprint accounting methods developed by the Global Footprint Network.

11. Hawken, "*The Ecology of Commerce*," xiii.

12. Papanek, *Design for the Real World*, 326.

13. Koestler, *The Ghost in the Machine*, 161–71.

14. Goodman, "Hermann Scheer," para. 6. Hermann Scheer (1944–2010) was a member of the German parliament, president of the European Association for Renewable Energy, and chairman of the World Council for Renewable Energy.

15. The statement, often misattributed to Albert Einstein, is: "Madness is doing the same thing over and over again and expecting different results." According to WikiQuote, the earliest known occurrence and probable origin of this quotation is a 1981 text from Narcotics Anonymous. http://en.wikiquote.org/wiki/Albert_Einstein (accessed March 29, 2013).

Bibliography

Anielski, Mark, and Jeff Wilson. *Alberta Genuine Progress Indicator Report*. Edmonton, AB: Anielski Management, 2008.

———. *Ecological Footprints of Canadian Municipalities and Regions*. Prepared for the Federation of Canadian Municipalities. Edmonton, AB: Anielski Management, 2005.

Callahan, James. "Austin Named Best City for Starting Your Life Over." *The Digital Texan*. Accessed March 29, 2013. http://digitaltexan.net.

Global Footprint Network. "World Footprint: Do We Fit on the Planet?" 2012. http://www. footprintnetwork.org.

Goodman, Amy. "Hermann Scheer (1944–2010): German Lawmaker, Leading Advocate for Solar Energy and 'Hero for the Green Century' in One of His Final Interviews." *Democracy Now!* 2010. http://www.democracynow.org.

Hawken, Paul. *The Ecology of Commerce*. New York: HarperBusiness, 1994.

Koestler, Arthur. *The Ghost in the Machine*. New York: Macmillan, 1967.

Papanek, Victor. *Design for the Real World: Human Ecology and Social Change*. 2nd ed. New York: Van Nostrand Reinhold, 1985.

United Nations. *2009 Revision of World Urbanization Prospects*. New York: United Nations Population Division, 2009.

UNDP (United Nations Development Programme). *Human Development Report 2011: Sustainability and Equity; A Better Future for All*. New York: UNDP, 2011.

———. *International Human Development Indicators*. New York: UNDP, 2011.

Wilson, Jeff, and Mark Anielski. *Ecological Footprint of 18 Canadian Municipalities*. Ottawa, ON: Federation of Canadian Municipalities, 2004.

World Bank. *World Development Indicators 2011*. Washington, DC: World Bank, 2011.

World Commission on Environment and Development. *Our Common Future*. New York: United Nations, 1987.

The Forgotten Sustainability

JANICE RIEGER & MARK IANTKOW

A Socially Conscious, Paradigmatic Shift in Design

TO MEET THE RESPONSIBILITY of socially conscious design, educators, practitioners, and students have to deal with the myths around sustainable design and the overarching assumption that it refers to green design alone. We need to reclaim sustainable design in its holistic frame and weave *socially* sustainable design into the fabric of our designs. If we expose the misconceptions of sustainable design that have unfolded in Alberta over the last several decades, we can carve out a new paradigm for socially conscious sustainable design and make it the foundation of our design education and practice.

To situate design in Alberta today, it is necessary to articulate both universal design and inclusive design because these terms are used interchangeably in the province and country. This points to a shift that we are currently experiencing in Alberta specifically and Canada broadly; we are slowly moving away from the term *universal design* and entering the inclusive design era. A socially conscious, paradigmatic shift in design has been very slow to evolve in Alberta, but it has evolved nonetheless—from industry and practice, to design education and process, to community education and the marketplace. Even after these evolutionary shifts, universal or inclusive design is still seen today by many design educators and practitioners as a specialization or as a movement outside and parallel to sustainable design. In order to create socially inclusive and sustainable designs, we must come to understand that universal or inclusive design principles are already embedded in the holistic frame of sustainable design and that now it is our task to reveal them and support the emergence of this new paradigm.

Defining or Redefining Sustainable Design

To understand the relationship of inclusive or universal design to sustainability, it is essential to peel back the layers of sustainability and examine what defines sustainable design. *Sustainability* is often defined as the relationships and overlapping of environmental, economic, and social concerns.[1] It is clear from this definition that there is indeed a strong understanding of sustainability as holistic and inclusive of economic, social, and environmental spheres. Nevertheless, during the last several decades, sustainability has lost this holistic framework and has been aligned primarily with the "green revolution" and environmental concerns.

This understanding of sustainability can also be applied to sustainable design. One only has to open a magazine, turn on the television, or enter a new building proudly displaying its LEED accreditation plaque to understand that the last several decades have seen a clear trend and cultural acceptance of green design and environmental responsibility. This unbalanced emphasis on only one aspect of sustainable design ruptures the cohesive relationship of all three spheres of sustainability. We require a redefining of sustainable design in that the pendulum has swung in one direction for far too long. Sustainable design must be equitable, socially responsible, fiscally sound, and environmentally responsible.

To simplify our understanding of sustainable design beyond the concept of the three spheres, we can define *sustainable design* as a practice that causes no harm. Sustainable design should cause no harm to the environment, it should cause no fiscal harm, and it should cause no harm to its users. Using the "no-harm" definition of sustainable design reinforces most professional designers' codes of ethics in Alberta and Canada. The Interior Designers of Canada states that interior design "is about finding creative design solutions for interior environments while supporting the health, safety and well-being of occupants and enhancing their quality of life."[2] The Royal Architectural Institute of Canada has a similar code of ethics; it states that architects provide solutions through the use of "practical and technical knowledge to create spaces that are safe, efficient, sustainable, and meet economic needs."[3] Furthermore, the institute identifies environmental

responsibility as one of its four core values: it "actively promotes sustainable design and operates in the most environmentally sustainable manner possible."[4] Interestingly, it would appear that the Royal Architectural Institute of Canada is defining sustainability as environmental responsibility. These definitions are not clear in their interpretation of safety and sustainable design, but what is definitely missing from these codes of ethics and value statements are the concepts of inclusivity, accessibility, and equitable design.

If we create designs that are only environmentally and fiscally responsible and not socially responsible, these designs are not sustainable and they also cause harm in that they still contain many barriers to users of the built environment. Sustainable design can result in socially inclusive, meaningful innovations that increase the quality of life for everyone.

An Inclusive Approach to Design

Herein lies the first challenge of many: incorporating social sustainability into the design process so that it is integrated into the way we design and not applied as an afterthought or a specialization. "Good design is sustainable design,"[5] announced the strategic plan of the United Kingdom's Design Council in 2008, but we must go one step further, making sustainability not only part of best practices in design but also part of all design practices and education. According to the Commission for Architecture and the Built Environment, "an inclusive approach to design offers new insights into the way we interact with the built environment. It creates new opportunities to deploy creative and problem-solving skills."[6] Thus, by integrating social sustainability into the design process, we can help support long-term functionality and pleasant or efficient relationships between the user and the space "without compromising the ability of future generations to meet their own needs."[7] This is sustainable design.

Adaptability is paramount to sustainable design and to socially inclusive design, and it requires an understanding of the needs of many users and how to incorporate those needs into the design. We cannot rely on staid and prescriptive models for our design process any longer; we must

FIGURE 8.1. *Doorless public-restroom entrance at Mount Royal University, Calgary. Also referred to as an L-shaped or labyrinth entrance, it is inclusive in its design and its colour contrast.*
Photograph by Janice Rieger.

look beyond minimum standards and allow ourselves and our designs to be flexible.

An example of an inclusive approach to sustainable design is in the labyrinth-style or doorless entrances to public restrooms (see figure 8.1). By eliminating a major barrier—a door and its handle—this design creates an entrance that is more hygienic, easier to maintain and clean, and easier to navigate by those with physical and sensory disabilities; it is also easier

for use by children, parents with strollers, and seniors. This design solution, framed around an inclusive and sustainable design process, generates a long-term relationship between the user and the space without compromising the ability of future generations to meet their own needs. The design fulfils all three spheres of sustainable design in that it is socially responsible and economical and causes no harm to the environment. Well-designed public-restroom facilities like these improve the experience of both those who operate the facilities and those who use them. This design also reduces misuse and is safer in that there are no doors to close, and sound carries farther; thus it deters criminal activity. The insightful sustainable design causes no harm, eliminates potential hazards, and is equitable. This is an example of a design that is holistic in its understanding of sustainability and also framed within an inclusive approach.

An Evolutionary History toward Socially Sustainable Design in Alberta

Certainly Alberta—and Canada, for that matter—has witnessed potentially transformational opportunities in access design over the past half-century (access design referring to the paradigmatic shifts from handicapped access to barrier-free design to more recent universal design and inclusive design). Shortly after the first edition of the *Alberta Building Code* in 1974, the province saw the establishment of the Committee for Review of Building Standards for the Physically Disabled.[8] This first committee was mandated under Alberta Labour Building Standards Branch, but not legislated, to represent the access-to-built-environment requirements of various disability populations and to function as a cross-disability advisory body to provide input on each ensuing *Alberta Building Code*. Such committee roots led to the Barrier Free Design Advisory Committee under Alberta Municipal Affairs during the mid-1980s and throughout the 1990s, with the final and formal integration of the current Barrier Free Council by the middle of the first decade of the new millennium.[9] This council has been legislated under Alberta's Safety Codes Act and is one of ten recognized

sub-councils of Alberta's Safety Codes Council,[10] highlighting its equal status and responsibilities to recommend building code adjustments and its function as a specialized review body on access issues for safety code systems, and ensuring ongoing updates of what has now evolved into Alberta's *Barrier-Free Design Guide*.[11]

Since the 1960s we have also seen the creation of two accessible housing societies in Alberta[12] and the emergence of the philosophy of people with physical disabilities hiring their own caregivers and living in a relatively independent group setting. The Premier's Council on the Status of Persons with Disabilities was formed in 1989, and its corresponding *Action Plan* in 1990 emphasized the need for improved access to community and related environments.[13] Internationally, seminal theories on access design have ventured far beyond simply entering a building and using some of the most basic facilities; developed countries have grown from having such basic access considerations to conceiving of more holistic and inclusive design and construction for as many diverse building users as possible.[14]

Despite all the foregoing, seemingly transformational, milestones for equitable and functional access for Alberta residents with varied disabilities, we have yet to experience a major professional cultural shift toward more socially inclusive design. The design and construction industries still build for the average able-bodied citizen and then design for diverse populations after the fact. There are exceptions to this rule, but those anomalous accessible projects are just that—exceptions. It is important to recognize how our design, construction, and related regulatory systems have actually manifested evolutionary rather than revolutionary shifts in access design to built environments over the years. They have not manifested general professional cultural change toward more socially sustainable and universally inclusive designs.

One can reflect on the evolution toward more socially responsible and sustainable design in Alberta through the growth and development of four access-design-paradigm eras with roots in the mid-twentieth century. These four eras of access design—handicapped access, barrier-free, universal, and inclusive—are discussed next.

Handicapped Access Design

The 1960s were immersed in revolutionary movements, with people from diverse populations and perspectives speaking out and taking action to guarantee more equitable involvement in North American society. People with disabilities were no exception to this rule; they conceived adaptations or designs that would ensure physical (and, to some degree, perceptual) requirements. This handicapped access era established the roots of access to the built environment.

The first evidence of formal shifts toward improved access to public structures in Canada can be traced to the building code regulatory systems and the publication *Building Standards for the Handicapped: Supplement No. 5 to the National Building Code of Canada*.[15] The handicapped access formulation, however, was rudimentary, aimed only at ensuring the ability to enter a structure, with some functional capability to use essential public supports within the building. One might expect, for example, access to parking, entry to the building, and the basics in entering and using washroom facilities, but there were no guarantees that a person with a disability would have equitable and safe access to the building's primary function. While the initiation of handicapped access encouraged a change in mindsets, from traditional institutional living for people with disabilities to entry into the surrounding community, architectural barriers continued to be incorporated into designs.

Barrier-Free Design

While the handicapped access paradigm improved entry into and use of basic supports in public buildings, such features were not often connected or well coordinated. For example, a structure might have a washroom with handicapped access features, but the washroom might be located on a level that was accessed strictly by a flight of stairs. In contrast, a structure incorporating the barrier-free design paradigm aimed to ensure a barrier-free path of travel from the building's entry to relevant public facilities and the primary functional areas.[16] The paradigm also expanded the target

population to include seniors and people with cognitive and/or communi-cation disabilities.[17]

While the social policies of the 1970s and 1980s—as presented in such documents as the *Obstacles* report[18] and the World Health Organization's *International Classification of Impairment, Disability and Handicap*[19]—focused on overcoming barriers and concentrated on what truly defined a disability, such policies still underlined a separate and distinct population with "special needs" and defined disability through a biomedical rather than social lens. Regardless of overcoming barriers and connecting or coordi-nating access to main functions of buildings, then, the barrier-free design paradigm had its limitations. Unless a regulator or designer was very sensi-tive to the underlying basics behind how persons with disabilities used their surroundings, such professionals could only follow the prescriptive dimensions and various templates set out for fundamental access.

Considering all the topical discussions and how Alberta Labour's Committee for Review of Building Standards for the Physically Disabled noted that designers, builders, and regulatory officials could learn more about the principles of designing for users with disabilities, a provincial guide was conceptualized and recommended. The purpose of this first *Barrier-Free Design Guide* (1987), fully complementing the 1985 *Alberta Building Code*, was threefold: (1) to cite all articles, sentences, and clauses in the building code associated with barrier-free requirements and to explain the rationale behind them; (2) to list and emphasize salient best practices in access design (i.e., going above and beyond the code); and (3) to describe the basic principles for designing environments for building users with disabilities.

Universal Design

While the prescriptive mechanisms and building code requirements based on the barrier-free paradigm continued from the late 1970s through the 1980s, some design professionals were searching for a holistic model of design with a more performance-oriented and less prescriptive foun-dation to accommodate the widest range of diverse building users. Ron

Mace introduced such a paradigm in 1985 with *Universal Design: Barrier-Free Environments for Everyone*.[20] This new universal design paradigm was more flexible than the earlier barrier-free design paradigm to allow for future growth and evolution of structures. It also promoted more integration of design elements with often more subtle design outcomes; that is, built-environment users would often not realize they were navigating a more universally designed environment.

Even though the universal design paradigm integrated access performance criteria to improve access by diverse populations (e.g., children, seniors, parents with strollers) and allowed the functionality of activities such as moving furniture, cycling, and rollerblading, the paradigm could also be too broad, and building users with disabilities could be lost in the complex mix of diverse populations. The concept of universal design stretched designers' mindsets from the prescriptive and reductionistic underpinnings of barrier-free access to the most malleable, flexible, and performance-based concepts of designing for diverse populations.

The social policies of the late 1980s and 1990s also reflected a more integrated and aggregated voice of people with disabilities, with the government of Canada promoting a national strategy on equitable access to facilities owned or operated by the federal government.[21] Then, well after the introduction of the Americans with Disabilities Act in the United States,[22] the Ontarians with Disabilities Act was proclaimed at the outset of the new millennium.[23]

Inclusive Design

In the inclusive design era, universal design continued, with social inclusion implied.[24] Social inclusion and social sustainability have been important within universal design, yet incidental to a focus on the principles behind the physical implementation of such designs.

In North America the term *inclusive design* has become a synonym for *universal design*,[25] but the former term actually originated in the United Kingdom, where it was first used to address the functional access requirements of seniors.[26] Nussbaumer has defined its focus and purpose as

follows: "Inclusive design means more than catering to the needs of people with disabilities. Inclusive design is about designing places that everyone can use. If [a space is] designed inclusively, everyone can move, see, hear, and communicate [in it] effectively."[27]

The subtle difference between inclusive and universal design, then, is that the former places more of an emphasis on social sustainability and social inclusion. That said, however, some of the latest writings of universal design proponents have been growing closer to a social inclusion focus.[28]

The past fifteen to twenty years have also witnessed a shift toward a more integrated societal approach to diverse populations in social policies. Whereas people with disabilities tended to be identified as separate and distinct populations in the 1980s and 1990s,[29] the new millennium has seen social policies that reflect a more diverse perspective.[30]

Current Era: Toward More Socially Sustainable Design

Only now, a quarter-century after the introduction of universal design and in conjunction with inclusive design conceptions, have some countries grown to understand how, by designing in a truly socially sustainable way, we can address both the commonalities and the simultaneous paradoxical differences of diverse users. A person with multiple sclerosis, for example, cannot rely on building designs and/or adaptations for people with visual disabilities alone, nor can they rely on designs oriented only to physical disabilities. This is where a more universal, organic, and holistic approach has always been essential but has not always been well recognized. Paradoxes of design between, and even within, disability populations have been endemic and implicit within the universal and inclusive design paradigms over the years, but only over the last decade are such paradoxes beginning to be addressed through socially sustainable and more holistic design perspectives. One of the first examples of design paradoxes was the degree of slope of curb ramps on street corners. A too-gentle slope eliminated vital cane detectability for pedestrians with visual disabilities; yet if the slope of such curb ramps was too steep, people using wheelchairs could not realistically navigate the ramp. Until a true understanding of

overall social sustainability had been conceived, a design modification that appeared to be universal might, in fact, have not been sufficiently universal or inclusive.

Design Education and Practice

The most salient change we have observed over the last decade in Alberta is that universal or inclusive design has altered our design thinking. It has allowed us to learn from the lived experiences of others and to reflect critically on those experiences in order to create socially inclusive and sustainable design solutions. A second-year interior design student emphasizes the impact that inclusive design has had on her and how it has altered her design thinking:

> I found the course that I took in universal design was very informative and it gave me the information and insight to see space in a way I'd never really seen it before. Learning about universal design enabled me to think critically of my designs to better accommodate the needs of others that are different from my own at this point of my life. Universal design is a way of "future proofing" space for future inhabitants as well as the aging population.[31]

This student testimonial reinforces the idea that an inclusive approach to design can create new opportunities to employ creative and problem-solving skills. The student situates universal design within sustainable design by looking at universal design as a way of "future proofing." Future proofing refers to design that addresses long-term functionality and relationships between the user and the space without compromising the ability of future generations to meet their own needs. Future proofing is fundamental to inclusive design and sustainable design practices. This paradigmatic shift in design education and its accompanying focus on exploration and experiential learning allows us to embrace socially sustainable design. It also allows students to explore socially inclusive and sustainable design and to eventually pass on their design education and experiences as design educators, practitioners, and mentors. Here a

first-year interior design student comments on her education in universal design and her new understanding of sustainability:

> Universal design has shown me how the "lived experience" is imperative to the design process; speaking to individuals with disabilities about their concerns with space and their desire for change can greatly impact the work we produce. This course introduced me to a new form of sustainability, one in which the environments we design will be sustainable if they can adapt over time and be fully accessible for those who inhabit and visit them. What affected me the most was the new interpretation of sustainability: that sustainable design can cause no harm, both to the exterior environment and to the people who require access to it.[32]

This student speaks to the importance of the user's lived experience and how a co-design practice and design process allow for inclusive and sustainable design solutions. Socially sustainable design—and specifically universal design—has and will alter the design thinking of students, educators, and practitioners alike.

In our research we have seen universal design education and practice move from a prescriptive approach to a performative approach and now to a participatory approach— what we refer to as the three Ps of inclusive design.[33] These three shifts are evident not only in the evolution and history of universal design but also in design education, practice, and process. The prescriptive approach was seen in the codes and standards of the barrier-free design era. The performative model of inquiry refers to an observational approach similar to that of empathic design; it was part of both the inclusive design and the universal design era. Lastly, the participatory approach to design involves a co-design process, wherein the user becomes a co-designer, and the user's lived experiences and personal testimonies provide the foundation of the design solution. This shift toward the participatory model of design is further evidence that we are beginning to understand the asymmetrical balance between designer and user, and the

power exchange that occurs in that relationship. Strickfaden and Devlieger explain:

> An inclusive design process...takes into account the particular capabilities and dispositions of people through a discussion of techné, which is described as embodied know-how enacted through daily life. People, with and without disabilities, achieve an increasingly more symmetrical negotiation as they work together towards a common goal. Techné is identified as key to engaging in a co-creation process towards developing empathy with users and discovering the nuances of users' authentic needs, and has the potential to impact design outcomes in profound ways.[34]

Strickfaden and Devlieger's concept of techné is in line with our concept of the participatory process, in that the latter aims to create a more symmetrically balanced negotiation between user and designer. Their concept of techné also reinforces how an inclusive approach to design can affect our designs in profound ways.

The ways in which we educate designers about socially sustainable design and inclusive solutions in Alberta have not evolved alongside this paradigmatic shift in universal design. There is still a large gap in our understanding of how to teach socially sustainable design and its importance to practice. Understanding the design process is essential for all designers, but the application of inclusive design criteria will reframe our understanding of design and allow design to become socially sustainable and, in turn, holistically sustainable. Universal or inclusive design then becomes a part of the holistic concept of sustainability and not a specialization or field of design.

Community Education and Marketplace

What constitutes community and what constitutes community education? With complex and often chaotic political, fiscal, social, and environmental influences, these are not simple concepts to define. The following section

outlines our concept of community education in relation to the slow unfolding of access and social sustainability in Alberta.

Community

Community not only involves where we live or where we work and play; it is the cultural history of our families, our neighbourhoods, our regions, our province, and our country. Community is "a coming together; a mutual caring for one another; having a sense of at-one-ment."[35] Simultaneously, community embraces pluralist values from the widest range of diverse and sometimes marginalized members.

We are integrally involved and immersed in our own specific corporate communities as well, to the extent that we subconsciously adopt culturally distinct communication forms, work habits, and socially oriented attitudes and behaviours. Genuine communities of practice, in fact, often grow out of, or alongside, where we work.[36] Our sense of community, then, can range from being very broad, intricately involving our overall culture, ethnicity, and national identity, to encompassing our local neighbourhood, to establishing a common identity with others in a virtual community, such as over the Internet, to including how we relate and with whom we relate in our work and play.

Community Education

Community education, for the purposes of this chapter, refers to more than aspects of education or learning within a community; it also emphasizes the education of communities. Communities, as collectives in and of themselves, gain in knowledge and understanding; they are organic and dynamic entities that grow and develop or undergo metamorphosis as members shift and as external and internal impetuses for change occur.[37]

When we are addressing communities in the workplace, we are talking about learning organizations,[38] communities of practice,[39] leadership development and practice,[40] and even self-directed learning.[41]

When we talk about education in the broader sense of the word, however—learning about or within, and developing our neighbourhoods

FIGURE 8.2. *Socially sustainable streetscape, Calgary. Photograph by permission of the Iantkow family, in memory of Louis Iantkow, architectural designer.*

and cultural communities—we are talking about more intuitive and often global kinds of education, such as experiential learning,[42] informal or unconscious ways of learning,[43] and even social activism or the expansion of our social discourses.[44] Furthermore, when it comes to learning communities, we are even talking about the way we learn, from pedagogical epistemologies and learning to more anagogical means (that is, from the ways we know and learn in childhood compared to the ways we know and learn in adulthood).[45]

Accessible features in the built environment have slowly and incrementally become part of our culture over the years: we now view curb ramps on street corners as commonplace; we have become used to the audible signals for pedestrians with visual disabilities; we walk through automatic door-opening systems with greater frequency as new shopping malls open. We assume that infrared-activated washroom fixtures will be in place for us—to the extent that we have to look closely at the faucet controls of a lavatory if the water surge is not immediately activated. We have even now evolved to the extent that universally designed ramps are situated for all pedestrians, replacing stairs entirely.

Truly inclusive and more socially sustainable designs for streetscapes and even light-rail-transit stations eliminate stairs and incorporate fully integrated and entirely ramped sidewalks, as seen in figure 8.2.

By exploring a multiplicity of perspectives and activities, our North American culture has learned and slowly embraced more universally designed environments. Our communities and overall culture have learned and developed access to environments through experiential learning,[46] through involving those who experienced the barriers in the first place,[47] and through embodied means by trying to simulate the disability experience.[48] Our communities have also learned through group processes and regulatory mechanisms,[49] often associated with effective leadership.[50] In short, our communities have learned about more holistic and inclusive forms of design through heuristic, evolutionary, or iterative processes, often stimulated by community leaders and societal change agents.

The Marketplace in Relation to Community Education and Socially Sustainable Design

The dominant discourse of our day considers how the marketplace has driven the designs of our built environment, but in actuality it is often a new design or a technological advancement—and change agents willing to experiment—that stimulates the marketplace. Consider the introduction of perimeter or forced-air heating to housing design in the mid-twentieth century: there was significant push-back from industry and the marketplace

to the introduction of such a new technology at the time. The point is that the marketplace has often been driven by research into new building practices and into design, with technological underpinnings; the marketplace in and of itself has not been the catalyst for design and construction shifts. Even the most modest bungalows of the mid-twentieth century were adopting perimeter or forced-air heating systems, not because of any formal marketing but because of the new technologies that allowed for more economical or efficient heating of one's home.

Statistically, the Participation and Activity Limitation surveys in Canada during the new millennium illustrate that over 12 per cent of adult Canadians have some form of disability.[51] Combine such a statistic with the projection that one in five people in Alberta will be seniors by 2031,[52] and this alone guarantees a decent marketplace for more accessible, affordable, functional, and socially sustainable design.

What many demographic projections do not directly reflect, however, are the shifts in our Canadian social psyche, where our burgeoning cohort of baby-boomer seniors will expect living, working, and leisure environments to accommodate their aging needs fully (unlike previous generations who accommodated themselves or simply accepted what was available). Combine such a shift in social consciousness with constantly advancing technologies and an increasing demand for accommodating very diverse human needs in higher density living and working built environments, and the North American marketplace for more inclusive and socially sustainable design is emphasized even further. In short, our design and construction industries can no longer afford to consider the social aspects of design simply as an assumed or implicit concept; we must explicitly plan for such socially inclusive intricacies, and the marketplace will follow suit.

Conclusion

Sustainable design must first and foremost recognize, nurture, exhibit, and apply socially inclusive solutions. It is also vital that sustainable design recognize the malleability of accommodating access for diverse

populations, but with individual requirements being considered and responded to appropriately. Social sustainability must also recognize and work with community and cultural norms, while stimulating transformational shifts for full participation and respect for often disenfranchised or marginalized populations.

The evolution toward more socially sustainable design requires further investigation and attention in Alberta so that it no longer remains the forgotten sustainability. One of Alberta's outstanding issues is the lack of knowledge of this evolution. Many design educators and practitioners are still working within the barrier-free design era of the 1980s, whereas other countries have been working within the inclusive design era since the 1990s. This puts Alberta's knowledge and practice of socially inclusive design decades behind those of other nations.[53]

Universal or inclusive design is still not a part of the design curriculum of many institutions in Alberta, nor has it become an accepted part of practice. So even though accessible design has evolved considerably in Alberta over the last several decades, not everyone has evolved at the same pace. This evolution remains on the periphery, outside of the overall sustainable design paradigm and outside of most design curricula. Among those institutions in Alberta that integrate universal or inclusive design into their design curriculum, there is still a great inconsistency in the way this knowledge is delivered. Some design programs integrate universal design into their design studios and core classes, others teach stand-alone courses on universal design, and still others do not teach any universal or inclusive design. There are inconsistencies in the way that universal design education is acknowledged and delivered in design programs in Alberta because it has evolved on the periphery, just out of sight. In order for universal design to become a part of sustainable design and good design, it has to move beyond its isolation. It has to be seen as integral to design, the design process, and design education and not as a stand-alone concept. For this reason, it is necessary to frame universal design within socially sustainable design and, in turn, holistically sustainable design. Universal design should

not be thought of in terms of minimums and best practices; it should be thought of as integral to design practice.

With the socially conscious shift in design that we are starting to see, and the understanding that universal design is not an afterthought or a parallel movement but rather a part of the structure of sustainable design, we hope that these inconsistencies in design education and practice will disappear. We are at a turning point in our understanding of socially inclusive design and its relationship to sustainable design. Our hope is that universal or inclusive design moves into the main field of vision for design educators, students, and practitioners and does not remain on the periphery as the forgotten sustainability.

Notes

1. Dale, *At the Edge*, 18.
2. Interior Designers of Canada, "What Is Interior Design?," 1.
3. Royal Architectural Institute of Canada, "What Is an Architect," 5.
4. Royal Architectural Institute of Canada, "Vision, Mission and Values," 5.
5. Design Council, *Good Design Plan*, 8.
6. Fletcher, "Principles of Inclusive Design," 1.
7. World Commission on Environment and Development, *Our Common Future*, 15.
8. Alberta Public Safety Division, *Evolution of Alberta's Public Safety System*.
9. Barrier Free Council, *Barrier Free Council Guiding Principles*.
10. Safety Codes Council, *Barrier Free Council Terms of Reference*.
11. Alberta Labour, *Barrier-Free Design Guide* (1987).
12. Accessible Housing Society, "About Us."
13. Premier's Council on the Status of Persons with Disabilities, *Action Plan*.
14. See Coleman, *Designing for Our Future Selves*; Coleman, "The Case for Inclusive Design"; Goldsmith, *Designing for the Disabled*; Goldsmith, *Universal Design*; Imrie, *Accessible Housing*; Mace, *Universal Design*.
15. Associate Committee on the National Building Code, *Building Standards*.
16. Canadian Paraplegic Association, *Access*; Public Works Canada, *Update 87*.
17. Alberta Labour, *Barrier-Free Design Guide* (1987); Safety Codes Council and Alberta Municipal Affairs, *Barrier-Free Design Guide* (2008).
18. Special Committee on the Disabled and the Handicapped, *Obstacles*.

19. World Health Organization, *International Classification*.

20. Mace, *Universal Design*.

21. Department of Canadian Heritage, Parks Canada, *Design Guidelines for Accessible Outdoor Recreation Facilities*; Department of Canadian Heritage, Parks Canada, *Design Guidelines for Media Accessibility*.

22. U.S. Access Board, *Americans with Disabilities Act Accessibility Guidelines*; U.S. Access Board, *Americans with Disabilities Act and Architectural Barriers Act Accessibility Guidelines*.

23. Lepofsky, "Long, Arduous Road."

24. Goldsmith, *Universal Design*; Imrie, *Accessible Housing*; Lidwell, Holden, and Butler, *Universal Principles of Design*; Preiser and Ostroff, *Universal Design Handbook*; Preiser and Smith, *Universal Design Handbook*; Steinfeld and Maisel, *Universal Design*.

25. IDEA Center for Inclusive Design and Environmental Access, http://www.ap.buffalo.edu/idea/home/; Ostroff, "Universal Design."

26. Fletcher, "Principles of Inclusive Design."

27. Nussbaumer, *Inclusive Design*, 32.

28. Preiser and Smith, *Universal Design Handbook*; Steinfeld and Maisel, *Universal Design*.

29. U.S. Access Board, *ADA Accessibility Guidelines*; U.S. Access Board, *ADA and ABA Accessibility Guidelines*; Lepofsky, "Long, Arduous Road"; Premier's Council, *Action Plan*.

30. Canadian Centre on Disability Studies, "Liveable and Inclusive Communities Project"; Federal/Provincial/Territorial Ministers for Social Services, *In Unison*; Nussbaumer, *Inclusive Design*; Ostroff, "Universal Design"; Premier's Council, *Action Plan*; Premier's Council, *Alberta Disability Strategy*.

31. Rachel Walstra, second-year interior design student, email message to author, September 25, 2012.

32. First-year interior design student, email message to author, February 14, 2013.

33. Rieger, "Universal Design."

34. Strickfaden and Devlieger, "Empathy through Accumulating Techné," 207–8.

35. Iantkow, "Significance of Community."

36. Wenger, McDermott, and Snyder, *Cultivating Communities of Practice*.

37. Bridges, *Managing Transitions*; Bridges, *Transitions*; Burke, *Organization Change*.

38. Bratton and Gold, *Human Resources Management*; Senge, *Fifth Discipline*.

39. Lave and Wenger, *Situated Learning*; Wenger, McDermott, and Snyder, *Cultivating Communities of Practice*.

40. Apps, *Leadership for the Emerging Age*; Bass, *Handbook of Leadership Research*; Burns, *Leadership*; London, *Leadership Development*; Northouse, *Leadership Theory and Practice*.

41. Garrison, "Critical Thinking and Self-Directed Learning."

42. Kolb and Kolb, "Learning Styles and Learning Spaces"; Kolb and Kolb, *Kolb Learning Style Inventory*.

43. Boucouvalas, "Consciousness and Learning."

44. Brookfield, "Self-Directed Adult Learning"; Foucault, *Discipline and Punish*; Freire, *Politics of Education*.

45. Dewey, *Art as Experience*; Knowles, *Modern Practice of Adult Education*; Knowles, *Self-Directed Learning*; Knowles, *Using Learning Contracts*; Lindeman, *Meaning of Adult Education*.

46. Kolb and Kolb, "Learning Styles and Learning Spaces"; Kolb and Kolb, *Kolb Learning Style Inventory*.

47. Merleau-Ponty, *Phenomenology of Perception*.

48. Brockman, "Epistemological Relationship"; Brockman, "Somatic Epistemology for Education"; Titchkosky, "Governing Embodiment"; Titchkosky, *Reading and Writing Disability Differently*.

49. Alberta Labour, *Barrier-Free Design Guide* (1992); Alberta Public Safety Division, *Evolution of Alberta's Public Safety System*; Safety Codes Council and Alberta Municipal Affairs, *Barrier-Free Design Guide* (2008).

50. Apps, *Leadership for the Emerging Age*; Bass, *Handbook of Leadership Research*; Burns, *Leadership*; London, *Leadership Development*; Northouse, *Leadership Theory and Practice*.

51. Statistics Canada, *Participation and Activity Limitation Survey* (2001); Statistics Canada, *Participation and Activity Limitation Survey* (2006).

52. Government of Alberta, *Aging Population Policy Framework*.

53. Nussbaumer, *Inclusive Design*.

Bibliography

Accessible Housing Society. "About Us." Accessed April 14, 2013. http://www.ahscalgary.ca/about/.

Alberta Labour. *Barrier-Free Design Guide*. Edmonton, AB: Technical Services, Client Services Division, Alberta Labour, 1987.

———. *Barrier-Free Design Guide*. 2nd ed. Edmonton, AB: Technical Services, Client Services Division, Alberta Labour, 1992.

Alberta Public Safety Division. *The Evolution of Alberta's Public Safety System: 100 Years of Public Safety in Alberta*. Edmonton, AB: Alberta Municipal Affairs, 2005.

Apps, Jerold W. *Leadership for the Emerging Age: Transforming Practice in Adult and Continuing Education*. San Francisco, CA: Jossey-Bass, 1994.

Associate Committee on the National Building Code. *Building Standards for the Handicapped, 1965. Supplement no. 5 to the National Building Code of Canada*. Ottawa, ON: National Research Council of Canada, 1965.

Barrier Free Council. *Barrier Free Council Guiding Principles*. Edmonton, AB: Safety Codes Council, 2006.

Bass, Bernard M., ed. *Handbook of Leadership Research, Theory and Managerial Practice*. 3rd ed. New York: Free Press, 1990.

Boucouvalas, Marcie. "Consciousness and Learning: New and Reviewed Approaches." *New Directions for Adult and Continuing Education* 57 (1993): 57–70.

Bratton, John, and Jeff Gold. *Human Resources Management*. 2nd ed. Mahwah, NJ: Lawrence Erlbaum, 2000.

Bridges, William. *Managing Transitions: Making the Most of Change*. Philadelphia: Da Capo Press, 2009.

———. *Transitions: Making Sense of Life's Changes*. Philadelphia: Da Capo Press, 2004.

Brockman, Jeff. "The Epistemological Relationship between Culture and Embodiment: Ethics and Christian Education in a Plural World." PhD diss., Claremont School of Theology, 1997.

———. "A Somatic Epistemology for Education." *Educational Forum* 65, no. 4 (2001): 328–34.

Brookfield, Stephen D. "Self-Directed Adult Learning: A Critical Paradigm." *Adult Education Quarterly* 35 (1984): 59–71.

Burke, W. Warner. *Organization Change, Theory and Practice*. Thousand Oaks, CA: Sage, 2002.

Burns, James MacGregor. *Leadership*. New York: HarperCollins, 1978.

Canadian Centre on Disability Studies. "Liveable and Inclusive Communities Project: March 2011 Workshop Findings." Winnipeg, MB: Canadian Centre on Disability Studies, 2011.

Canadian Paraplegic Association, Manitoba Division. *Access: A Guide for Architects and Designers*. Winnipeg, MB: Canadian Paraplegic Association, 1984.

Coleman, Roger. "The Case for Inclusive Design: An Overview." Paper presented at the Twelfth Triennial Congress, International Ergonomics Association and the Human Factors Association, Toronto, Ontario, 1994.

———. *Designing for Our Future Selves*. London: Royal College of Art, 1993.

Dale, Ann. *At the Edge: Sustainable Development in the 21st Century*. Vancouver, BC: UBC Press, 2001.

Department of Canadian Heritage, Parks Canada. *Design Guidelines for Accessible Outdoor Recreation Facilities*. Access Series. Ottawa, ON: Supply and Services Canada, 1994.

———. *Design Guidelines for Media Accessibility*. Access Series. Ottawa, ON: Supply and Services Canada, 1994.

Design Council. *The Good Design Plan: National Design Strategy and Design Council Delivery Plan, 2008–11*. http://www.designcouncil.org.uk.

Dewey, John. *Art as Experience*. London: Penguin, 1934.

Federal/Provincial/Territorial Ministers for Social Services. *In Unison: A Canadian Approach to Disability Issues*. A Vision Paper. Hull, QC: Human Resources Development Canada, 1998.

Fletcher, Howard. "The Principles of Inclusive Design: They Include You." Commission for Architecture and Built Environment. 2006. http://www.cabe.org.uk.

Foucault, Michel. *Discipline and Punish: The Birth of the Prison*. London: Allen Lane, 1977.

Freire, Paolo. *The Politics of Education: Culture, Power and Liberation*. New York: Bergin & Garvey, 1985.

Garrison, D. Randy. "Critical Thinking and Self-Directed Learning in Adult Education: An Analysis of Responsibility and Control Issues." *Adult Education Quarterly* 42 (1992): 18–33.

Goldsmith, Selwyn. *Designing for the Disabled: A New Paradigm*. Oxford: Architectural Press, 1997.

———. *Universal Design: A Manual of Practical Guidance for Architects*. Oxford: Reed, 2000.

Government of Alberta. *Aging Population Policy Framework*. Edmonton, AB: Alberta Seniors and Community Supports, 2010.

Iantkow, Mark. "Significance of Community." Presentation to Calgary Block Watch Presidents, January 14, 2009, at the City of Calgary By-Law Enforcement Office, Calgary.

Imrie, Rob. *Accessible Housing, Quality, Disability and Design*. New York: Routledge, 2006.

Interior Designers of Canada. "What Is Interior Design?" 2010. http://www.idcanada.org.

Knowles, Malcolm S. *The Modern Practice of Adult Education: From Pedagogy to Andragogy*. 2nd ed. New York: Cambridge Books, 1980.

———. *Self-Directed Learning*. New York: Association Press, 1975.

———. *Using Learning Contracts: Practical Approaches to Individualizing and Structuring Learning*. San Francisco, CA: Jossey-Bass, 1986.

Kolb, Alice Y., and David A. Kolb. *Kolb Learning Style Inventory*. Version 4. Experience Based Learning Systems, Inc., 2013. http://learningfromexperience.com.

———. "Learning Styles and Learning Spaces: Enhancing Experiential Learning in Higher Education." *Academy of Management Learning and Education* 4, no. 2 (2005): 193–212.

Lave, Jean, and Etienne Wenger. *Situated Learning: Legitimate Peripheral Participation*. Cambridge: Cambridge University Press, 1991.

Lepofsky, M. David. "The Long Arduous Road to a Barrier-Free Ontario for People with Disabilities: The History of the Ontarians with Disabilities Act—The First Chapter." *National Journal of Constitutional Law* 15, no. 2 (2004): 125–33.

Lidwell, William, Kritina Holden, and Jill Butler. *Universal Principles of Design: 125 Ways to Enhance Usability, Influence Perception, Increase Appeal, Make Better Design Decisions, and Teach through Design*. 2nd ed. Beverly, MA: Rockport, 2010.

Lindeman, Eduard C. *The Meaning of Adult Education*. Norman, OK: Harvest House, 1989.

London, Manuel. *Leadership Development: Paths of Self-Insight and Professional Growth*. Mahwah, NJ: Lawrence Erlbaum, 2002.

Mace, Ronald. *Universal Design: Barrier Free Environments for Everyone*. Los Angeles, CA: Designers West, 1985.

Merleau-Ponty, Maurice. *Phenomenology of Perception*. New York: Routledge Classics, 2002. First published 1945.

Northouse, Peter G., ed. *Leadership Theory and Practice*. 2nd ed. Thousand Oaks, CA: Sage, 2001.

Nussbaumer, Linda L. *Inclusive Design: A Universal Need*. New York: Fairchild, 2012.

Ostroff, Elaine. "Universal Design: An Evolving Paradigm." In *Universal Design Handbook*, 2nd ed., edited by Wolfgang F. E. Preiser and Korydon H. Smith, 1.3–2.0. Toronto: McGraw-Hill, 2011.

Preiser, Wolfgang F. E., and Elaine Ostroff, eds. *Universal Design Handbook*. Toronto: McGraw-Hill, 2001.

Preiser, Wolfgang F. E., and Korydon H. Smith, eds. *Universal Design Handbook*. 2nd ed. Toronto: McGraw-Hill, 2011.

Premier's Council on the Status of Persons with Disabilities. *Action Plan, Spring 1990*. Edmonton, AB: Government of Alberta, 1990.

———. *Alberta Disability Strategy*. Edmonton, AB: Premier's Council on the Status of Persons with Disabilities, 2002.

Public Works Canada. *Update 87: A Workshop on Barrier-Free Design*. Ottawa, ON: Government of Canada, 1987.

Rieger, Janice. "Universal Design: A Shifting Paradigm." *IDEC Exchange*, Summer (2012): 24.

Royal Architectural Institute of Canada. "Vision, Mission and Values." 2013. http://www.raic.org.

———. "What Is an Architect." 2013. http://www.raic.org.

Safety Codes Council. *Barrier Free Council Terms of Reference*. Edmonton, AB: Safety Codes Council, 2005.

Safety Codes Council and Alberta Municipal Affairs. *Barrier-Free Design Guide*. Edmonton, AB: Safety Codes Council and Alberta Municipal Affairs, Safety Services, 1999.

———. *Barrier-Free Design Guide*. 4th ed. Edmonton, AB: Safety Codes Council and Alberta Municipal Affairs, 2008.

Senge, Peter M. *The Fifth Discipline: The Art and Practice of the Learning Organization*. New York: Currency, 1994.

Special Committee on the Disabled and the Handicapped, House of Commons, Canada. *Obstacles*. Ottawa, ON: Supply and Services Canada, 1981.

Statistics Canada. *Participation and Activity Limitation Survey*. Ottawa, ON: Statistics Canada, 2001.

———. *Participation and Activity Limitation Survey*. Ottawa, ON: Statistics Canada, 2006.

Steinfeld, Edward, and Jordana L. Maisel. *Universal Design: Creating Inclusive Environments*. Hoboken, NJ: Wiley, 2012.

Strickfaden, Megan, and Patrick Devlieger. "Empathy through Accumulating Techné: Designing an Accessible Metro." *Design Journal* 14, no. 2 (2011): 207–29.

Titchkosky, Tanya. "Governing Embodiment: Technologies of Constituting Citizens with Disabilities." *Canadian Journal of Sociology*, 28, no. 40 (2003): 517–42.

————. *Reading and Writing Disability Differently: The Textured Life of Embodiment.* Toronto: University of Toronto Press, 2008.

U.S. Access Board. *Americans with Disabilities Act Accessibility Guidelines for Buildings and Facilities.* 1991, as amended through September 2002. http://www.access-board.gov/adaag/html/adaag.htm.

————. *Americans with Disabilities Act and Architectural Barriers Act Accessibility Guidelines for Buildings and Facilities.* August 5, 2005. http://www.access-board.gov/ada-aba/final.cfm.

Wenger, Etienne, Richard McDermott, and William M. Snyder. *Cultivating Communities of Practice: A Guide to Managing Knowledge.* Cambridge, MA: Harvard Business School Press, 2002.

World Commission on Environment and Development. *Our Common Future.* New York: United Nations, 1987.

World Health Organization. *International Classification of Impairments, Disabilities and Handicaps* (In accordance with resolution WHA 29.35 of the World Health Assembly). Geneva: World Health Organization, 1980.

It Is Just Good Design!

RON WICKMAN

AS AN ARCHITECT who was born and raised in Edmonton, Alberta, I have always been amazed by the abundant sunshine, beautiful blue skies, and vast open spaces that we in Alberta are surrounded with every day. Natural light is the architect's greatest design tool, and the manipulation of space is a close second. However, the single greatest influence on my design sensibility was growing up with my father being in a wheelchair.

What motivates me to practise architecture is my desire to build an environment that is more accessible for everyone—especially those with disabilities. When I was a child, my father and I would need to enter buildings in different ways than other users would; we would often enter a restaurant, recreation facility, or hotel through a back or side entrance. Even as a child, I knew there was something terribly wrong with that.

I remember strategically planning every new or unknown journey. This usually involved several phone calls to see if a facility was accessible. Upon arrival at the supposedly accessible building, we would find that we needed to enter through the back door or use the freight elevator. I pulled my father up more stairs and curbs than I would like to count. The experience and knowledge that I gained revealed that my father, a wheelchair user, was afforded fewer choices than most other citizens.

Design practice and education often neglect accessibility for people with disabilities. There is a growing need for designers to invest their energy in inclusive design (see Rieger and Iantkow's chapter for a discussion of this approach). In this chapter I detail nine concepts for inclusive design that all designers should know and apply. Each concept is illustrated through an

example of a local architecture project that I have been involved in developing.

Nine Concepts for Inclusive Design

I developed these nine concepts through personal experience. I started my architectural practice in 1995 with a focus on inclusive design. Ten years later I would only take on work involving persons with disabilities. Currently my smallest project is a residential bathroom modification for an owner with multiple sclerosis, and my largest project is a forty-two-dwelling, four-storey housing project for people who are currently homeless. In the last five years I have given a great deal of attention to influencing other designers through writing and public presentations on inclusive design. I even make presentations at architecture schools in cities that I visit with my family. My desire is to raise awareness of the importance of inclusive design early in an architectural education.

Inclusive Design Accommodates as Many People as Possible in the Best Way Possible

The intent of inclusive design is to simplify everyone's lives by making products, communications, and the built environment as usable as possible by as many people as possible. Inclusive design benefits people of all ages and abilities. A good example of this concept is the office space for the Premier's Council on the Status of Persons with Disabilities, which is located on the eleventh floor of the HSBC building in downtown Edmonton.

The mandate for this project, which was completed in 2005, was to create good design, not just good inclusive design. To accommodate as many people as possible in the best way possible, I designed meeting rooms and offices of varying sizes, support spaces, and an accessible washroom. Space, light, colour, texture, and materials were applied and manipulated to help users make positive and purposeful choices for independent move-ment. Although these design details are functional, they are also beautiful,

FIGURE 9.1. *Interior view of the waiting area, Premier's Council on the Status of Persons with Disabilities, Edmonton. Photograph by Ron Wickman.*

and they help all users enjoy the space. I find that when we design space and provide details that are easier for people with disabilities to use, everyone benefits.

When one enters the office, the most immediate feature is its tremendous spaciousness (see figure 9.1). The waiting area is extensive, and meeting rooms, offices, and cubicles are comfortably roomy. Curved walls and the circular washroom amplify this feeling. Spaciousness is important because functionally there is adequate room for a person in a mobility device to move about and because it provides a comfortable work environment for everyone. People want to experience a space that makes them feel confident that they will not bump into objects or people. This is especially important to persons who have low vision or are blind.

Visual and textural cues are included throughout the space to help people navigate. The most important and noticeable feature of the design is the squares (1.5 m^2) cut into the carpet to indicate where users need to

make a decision to change direction in their path of travel. The squares' contrasting colour and texture assist people with visual limitations to make purposeful choices in movement without the use of a cane or guide dog. This design feature is also aesthetically interesting and improves the visual appeal of the space. Again, I find that when I design to accommodate people with disabilities, everyone benefits.

A wooden handrail attached to the curved wall not only separates the waiting area from the office cubicles but also helps users with mobility and visual limitations to navigate the office space. Three grooved rings are cut into the handrail to indicate entrance areas to each cubicle. When users, especially those who are blind, feel these grooves, they can feel confident they have arrived next to a cubicle space.

Designers Must Not Think of Inclusive Design as a Code Compliance Issue

When I speak to students, I ask if meeting the bare minimum grade to pass the class is good enough. When architects design to meet the requirements outlined in the *Barrier-Free Design Guide*[1] of the Alberta Building Code,[2] they are barely getting a passing grade. They are not designing for inclusive design. Most architects I talk to do not understand this very important concept.

In 2008, I was hired by Alberta Infrastructure to complete an accessibility audit for the Edmonton Law Courts building. I identified many possible modifications for accessibility and was invited to design four new inclusive toilet rooms to be constructed in the lobby and waiting areas of the courtrooms. Inclusive toilet rooms must accommodate a user and a family member or an attendant (not always of the same sex) so that hygiene may be carried out with dignity and privacy. Inclusive toilet rooms are only required by the Alberta Building Code in regional transportation terminals and shopping centres. The new toilet rooms in the Law Courts building exceed the code requirements. As discussed in the first concept, inclusive design can benefit all users (with and without disabilities). In this example, inclusive toilet rooms are helpful for families with young children.

The design of each room is identical and includes a toilet, sink counter, and baby-change-area counter; the room is large enough to enable a person in a scooter to turn around. The washroom's interior is constructed to exceed all barrier-free requirements in the Alberta Building Code. The toilet is surrounded by an angled grab bar mounted on the wall and a second, flip-down grab bar in the open space beside the toilet on the other side. The second grab bar is not required by code but is important because it offers greater safety and flexibility for more users. Ten years ago, clients would have rejected this "optional" accessible feature for cost-saving reasons, but today the culture has changed. I almost always include this flip-down grab bar in my designs, and it is no longer questioned by my clients.

The sink and counter is a one-stop area where a user in a wheelchair can approach the sink, wash with soap, rinse and dry their hands, and throw away the paper towel without needing to move and touch the wheels of the wheelchair with wet hands. I learned this design concept only after talking to a friend who uses a wheelchair. An additional benefit has to do with safety and maintenance in that all users wash and dry their hands without spreading water all over the floor. The code identifies the maximum height at which washroom accessories can be mounted, but not the most strategic location for the accessories.

Inclusive Design Means Choice

I learned by growing up with my father that he really wanted to move around in the built environment easily and without assistance. He wanted the same choices to move about as anyone else had. In my work I design circulation spaces to afford more people, especially those with disabilities, greater choice for independent movement. This strategy is most evident in a small home that I designed in 2001 in Edmonton for Kathleen and her son Daniel. Due to a severe illness, Daniel's legs and arms were amputated when he was six years old. After this tragic event Kathleen decided to design and build a home to enable her son the same choices for independent movement as anyone else in the home had. She was also looking to

the future when she might not be able to carry him up and down stairs or when Daniel might want more privacy.

Together Kathleen and I explored a variety of design options. We could not expand the main floor of the home (to transform the home into a single-level bungalow) because Edmonton bylaws restrict the percentage of the lot area that the home can cover. A residential elevator would not work either because Daniel would have trouble operating it himself. Thus, we decided to design a four-level split with interior ramps between levels. I am sure most people think that ramps are expensive, impractical, and a waste of space. The truth is that the ramps need more space than stairs do, which adds some cost, but Daniel's ability to access all parts of the home from his power wheelchair is priceless. An added bonus is that when a refrigerator or washing machine is delivered, the movers love the home.

All four levels of the home add up to 2,400 square feet. The living, kitchen, and dining levels are accessed at grade. Inside, a thirty-foot ramp leads to the uppermost level, and a fifty-foot ramp leads to the lower level. The lowest level is also accessed by a ramp.

Daniel's bedroom is located on the second storey. His bedroom window is low so that he can easily see outside when he is sitting in his wheelchair or even when he is on the floor. Trust me, people in wheelchairs like to get out of them once in a while; this is particularly true for children. Daniel's bathroom includes a wheel-in shower, a bathtub, change table, sink, and a toilet complete with a remote-controlled bidet seat. These features provide Daniel with choice because he can do activities without his mother's assistance.

What struck me when I first met Kathleen and Daniel was how happy they both were. Daniel was like any other eight-year-old boy: he wanted to play games, wrestle, and tell stories. Each day for Daniel and Kathleen is a little harder than for the average family, but they strive to live their lives to the fullest. At the time of this writing, Daniel was nineteen, and his favourite aspect of his home was that it accommodated his friends. He simply did not have the choice to visit his friends' homes. It was too hard to carry him up stairs with his power wheelchair. This is exactly the way I grew up: with my father's friends visiting him instead of the other way around.

Inclusive design eliminates the need for special features and spaces for persons with disabilities, seniors, or families with young children. It does not consider each as a separate group requiring specialized design features; instead, it addresses the needs of all users together. I understand this concept well through my experiences with my father. Accessible design features (or the lack thereof) were often stigmatizing and undignified. These brought attention to my father and reminded him constantly that he had less independence than others had. In addition to public buildings, private homes were also difficult to navigate. He often needed to be carried up the front steps, which was dangerous, frustrating, and a disincentive to visit friends in their homes. If there was a ramp leading to the front door, it was steep and certainly did not fit the style of the home. Many people fear this type of ramp because it can lower the value of the home and identify that a vulnerable person may live inside. For this reason, the wheelchair-accessible pathway must be designed to not stand out, to be invisible.

Visitability is a key inclusive design principle that ensures that everyone—regardless of mobility—will be able to, at least, visit someone else's home and use the washroom. It is one of the simplest and most economical approaches that can address homeowners' and community needs over time and contribute to a more flexible and sustainable built environment. Visitable homes must have one entrance into the home with no steps, a minimum thirty-two-inch clear passage through all main-floor doors and hallways, and an accessible bathroom on the main floor. Creating visitability that is invisible and beautiful can be a tremendous challenge, especially in renovation projects.

In new house designs I typically create one sloping pathway, not a ramp, that all people use. Therefore, people do not see this as an accessibility feature. In renovations most often we must add a ramp so there are two pathways—one for individuals in wheelchairs and one for others. In this case, it is much harder to design the ramp to seem invisible.

In 1998, I was hired to design a renovation for visitability in Edmonton. The family wanted their home to be accessible to many good friends who

use wheelchairs and scooters. The family held many functions at their home and wanted to make it welcoming for them.

A ramp addition would have been steep and dangerous. The addition of a mechanical porch lift would have been unsightly, and an addition to house the porch lift inside would have been expensive. For this project I took advantage of the site and the fact that the house sat on a corner lot. I proposed to re-pour a concrete sidewalk to gently slope from the attached garage driveway around the side of the house to the front door. From this sidewalk one can turn ninety degrees to move up a sloping sidewalk that runs parallel with the house to the existing stairs, with a second ninety-degree turn to the front door. The homeowners did a new landscape plan with low-maintenance planting to allow the new sidewalk to blend aesthetically with the house. Overall, the style and look of the house was not compromised. Independent access for persons in wheelchairs was achieved without making it obvious. The accessibility is invisible.

Inclusive Design Is Sustainable, Adaptable, and Flexible

I think designers often believe that inclusive design is limiting. This is not true. Inclusive design has the potential to bring value and meaning to any design. It is sustainable, adaptable, and flexible.

In 1995, I won the FlexHousing competition sponsored by Canada Mortgage and Housing Corporation (CMHC). *FlexHousing* is a term coined by CMHC in 1995 for housing based on four concepts of flexible design: adaptability, accessibility, affordability, and occupant health.[3] FlexHousing "should continue to provide the initial occupants and subsequent occupants with accessibility, safety, security, ease-of-operation, convenience, and comfort as their needs change over time."[4] FlexHousing includes many inclusive design features. Homes are sustainable when they are designed to provide three key features: no steps to an entrance (visitability); stairs designed to accommodate a future platform lift, or stacked closets to house a future residential elevator; and at least one bathroom that could accommodate a homeowner in a wheelchair. The home is sustainable because a

FIGURE 9.2. Exterior view of the back of two FlexHomes, Edmonton. Photograph by Ron Wickman.

modification for accessibility would require less energy and material waste than in a home without these features.

In 1996, I worked for Habitat for Humanity Edmonton, which built two houses based on my award-winning FlexHousing design. Figure 9.2 shows the two completed FlexHouses from the street. The homes attempt to provide the ideal combination of adaptability, flexibility, sustainability, and affordability. Through these features the homes are inherently inclusive. They are intended to grow over time to accommodate a family's changing needs. For example, if a young family purchases the house, over the years it can morph to suit the needs of teenagers and eventually empty nesters (see figure 9.3). Bedrooms can be converted to home offices, and a separate suite can be constructed. Other types of families would be equally well served, including single parents, roommates, seniors, and persons with disabilities.

The houses were designed with flexibility and affordability in mind. However, the real success of the home designs is that they are inclusive.

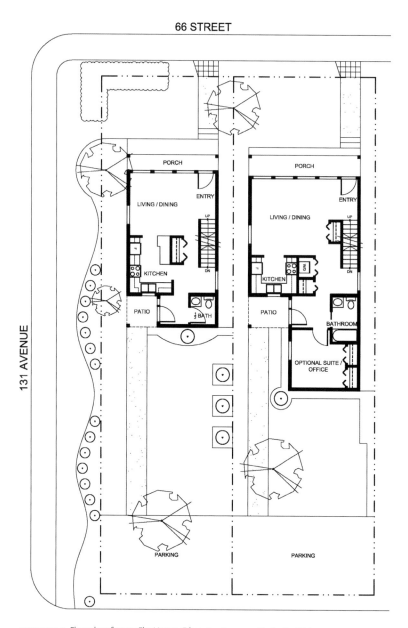

FIGURE 9.3. *Floor plans for two FlexHomes, Edmonton. Image provided by Ron Wickman.*

Designed to satisfy users with varying disabilities, the project provides on-grade access, open floor plans, adjustable kitchen counters, lever door handles, adjustable closet-rod and shelf heights, extra reinforcing for the future installation of grab bars, easy-to-grasp handrails, rocker-style switches, lower light switches, and outlet locations, all to help individuals in wheelchairs. Again, because all of these accessibility features will accommodate residents with disabilities, expensive and energy-wasting modifications will not be required.

Inclusive Design Must Be a Part of the Design Process Right from Its Inception

Buildings designed in the past rarely incorporated inclusive design features. Today we are working hard to upgrade these buildings to conform with contemporary requirements for inclusive design. This is a difficult job that is often exponentially harder and more expensive than it would have been to incorporate inclusive design features in the initial design process.

A particularly difficult task is the upgrading of historic buildings to contemporary standards for accessibility. As an architect specializing in accessibility, I have been part of many such projects. Often the need to maintain the historical significance of the building, especially from the outside and the front entrance, takes precedence over accessibility. In the following paragraphs I will outline a project that I conducted for Alberta Infrastructure and the historically recognized Government House located at Edmonton's (now former) Royal Alberta Museum site.

In 2010, I was asked to modify the existing ramp to meet contemporary code requirements. Though the building was somewhat accessible with the original ramp, the design presented several key problems: the ramp led to a secondary entrance to the building, it was too steep, it was too narrow, and the top landing was too small. When originally built, this ramp met the barrier-free design code requirements of that day. The current code requirements ask for a more spacious ramp that can better accommodate persons in motorized wheelchairs and scooters.

FIGURE 9.4. *New ramp at the (former) Royal Alberta Museum, Edmonton.* Photograph by Ron Wickman.

As more people are using larger wheelchairs and scooters, it is clear that code requirements will continue to change. Thus, I designed the ramp to exceed current standards in the hopes that the design will continue to be appropriate for many years to come. Since this was a redesign project on a historic building, I had less freedom in the design, but I was able to construct a larger ramp with larger landings (see figure 9.4). Feedback from visitors in larger power wheelchairs has been extremely positive.

This ramp modification was expensive and difficult to incorporate into the historical look of Government House. It provides an important lesson that reinforces how we must include inclusive design features in a design right from the beginning.

Inclusive Design Does Not Need to Be Expensive

Incorporating accessible features in new home construction is not costly. For example, a thirty-six-inch-wide door costs only a few dollars more than a thirty-inch-wide door, whereas to enlarge an existing thirty-inch doorway

to thirty-six inches would cost over c$1,000. Designing a home to be adaptable, complete with features such as backing in bathrooms for the future installation of grab bars, and a shaft for the future installation of a residential elevator, will add only 1 per cent to the overall construction costs. When accessible features such as grab bars and an elevator are added to new home construction, the additional costs are approximately 5 per cent. With the increasing growth of our senior population, the demand for at least adaptable homes will be staggering.

In 1994, I prepared a design for the Affordable Housing Demonstration Project, which was the winner of an open competition initiated by the City of Edmonton's Planning and Development Department and Innovative Housing Committee. The goal of the competition was to develop an affordable and innovative duplex or triplex for an inner-city, single-family lot.

I designed a triplex that was guided by four central aspects: community, affordability, accessibility, and flexibility. The project is separated into two buildings (one building houses a three-bedroom dwelling, and the other is a stacked duplex) with a courtyard in the middle. The ground-level unit of the duplex was designed for wheelchair accessibility. Since the units were to be sold at reasonable prices, the construction also needed to be completed on a low budget.

The real economy in this triplex was achieved by designing simple footprints and uniform roof shapes that accommodated standard building materials. The accessible dwelling did not add significant extra costs to the project. This one-bedroom home contains a conventional kitchen with a lower portion of counter, and hardware that allows upper-cabinet shelves to be pulled out and down. The bathroom is no larger than one in an average home; however, it is constructed as a large wet room with a curbless shower area. Overall, these accessible features cost less than C$500.

Inclusive Design Is Beautiful

As architects, we are trained to find creative and beautiful solutions to design problems. Contrary to popular belief, accessible features need not look institutional or "ugly." I usually have to explain this to most of my

FIGURE 9.5. *Exterior view of a new accessible home, Edmonton. Photograph by Ron Wickman.*

home clients with disabilities. I always confirm that their house can look any way they want it to, whether it be a traditional or more contemporary style. Inclusive design is not a look or a style; it is an approach to design. I encourage other designers to incorporate inclusive design into their design methodology when they begin to design, not after. Beautiful solutions that accommodate people with disabilities rarely occur when inclusive design is introduced to a design that has already been effectively worked out.

In 2006, I was invited to design the home of Peter and Alison, an "empty-nest" couple (see figure 9.5). They wanted to construct a new home that would allow them to age in place. They understood the importance of an accessible home through witnessing the experiences of their parents and friends. However, they also valued beautiful design and wanted a new home that they could be proud of and that would represent their style and tastes.

The home was designed and made beautiful with typical details like large windows, nice paint colours, and the personal objects collected by the couple. The accessible design features were carefully and thoughtfully integrated into the design. Many features were subtle. From the exterior, the front door is located at grade and has a broad entranceway to enable wheelchair or walker access. A high bench is also provided for putting on shoes. Inside the home, accessible features were incorporated into every room. A residential elevator enables access to all levels of the home. The elevator is essentially invisible, as one would not know it was there if the door was closed; it looks like a door to a closet. The main floor and walkout basement levels house the bedrooms and office spaces. The second-floor level of living, kitchen, and dining is open and spacious with vaulted ceilings and large windows opening up to spectacular views of the North Saskatchewan River valley in Edmonton. The master ensuite houses a large shower and can accommodate someone in a wheelchair. However, it was designed following a chic contemporary style with glass walls and ceramic tiles. A stylish grab bar was also installed in the shower. Product designers have not traditionally focused on the look of accessible design products; therefore, we had to do a great deal of research to find the right products for this home. The great news, though, is that more and more choice exists in the variety of styles of accessible features. That is, there is no longer just one type of grab bar.

There Is an Emotional Aspect to Inclusive Design

I experience great personal satisfaction when I see someone independently access a home or a public building for which I was responsible. Probably the best example comes from my involvement in home renovations for clients who suddenly find themselves in wheelchairs. In these cases, I often see my clients sleeping in the dining room of their homes or in a hospital setting until the accessible renovations have been completed. After the renovations my clients often tell me how their three-hour morning routine of getting ready for the day has been reduced to one. This is all achieved through good design.

After all my experiences helping others enjoy their spaces, I needed to make sure that my own home was accessible. For too many years my home was not freely accessible to my father, as it had three steps leading to the front door. Finally I poured a new (sloping) sidewalk leading to the front door to provide on-grade access. I cannot explain the joy I felt when our doorbell rang unexpectedly one Saturday afternoon. It was my father, who was now able to wheel straight into my family home. It was a seemingly small design gesture—with huge physical and emotional impact.

When I reflect on these projects, I realize each has had an emotional impact on me personally. Since completing the Premier's Council office space, I have become very good friends with Diane, an employee in the space. We often do lectures together, and I consult with her frequently on my latest projects. I visit Kathleen and Daniel frequently, as they open up their home to out-of-town visitors wanting to learn more about inclusive design. Daniel is considering becoming an architect. My personal experiences and the friendships I have made with so many individuals with disabilities have greatly influenced my attitude to life. I am more patient and thankful for the great life I am able to live. That is my emotional reward.

Conclusion

I read architectural journals and pay close attention to innovation in design. In these magazines, innovative use of materials and natural light and the manipulation of space are most often celebrated. Seldom is innovation in function and accessibility lauded. Even in the most beautiful designs, when buildings cannot accommodate people with disabilities, the strength of the design is compromised.

The nine concepts of inclusive design presented in this chapter focus on a design-driven process. Inclusive design must be a part of the design process right from its inception. Inclusive design is not about limiting design options; it is about bringing value and meaning to them. Each project I have discussed exemplifies one of the nine concepts. However, it must be noted that all nine concepts are a part of each project.[5]

Although I am recognized as an expert in design for people with disabilities, my architectural education was traditional, and I am no different from other architects. I believe that other designers care about this work, but I do not think they know where to begin or how to incorporate inclusive design into their practice. Most of them do not have the life experiences of knowing or working with individuals with disabilities to understand how to design for accessibility. Further, without these experiences, they may not understand the huge value of accessible design or the significance that it has on an individual's life.

The key to progressing the inclusive design movement is education. Designers must understand that individuals with disabilities are ordinary citizens who must have equal choices for movement in building environments to those of everyone else. Too often, architects treat accessibility as a technical issue to be dealt with after a design has been worked out. This approach is dangerous and greatly compromises accessibility.

Inclusive design focuses heavily on function, in the most positive sense possible: function that forms a setting for—and frames—human activity. For example, a ramp could be a design afterthought, added to the building in a clumsy manner. A ramp can also be thought of as a building code necessity designed simply to meet its minimum requirements. With inclusive design, however, the ramp can be so much more. It can be a gentle, spacious pathway complete with oversized landings that house sitting and gathering space. The ramp can be thought of as more than just a means to get from point A to point B. It can be thought of as a place for gathering and for human encounters and a place for relaxation, reflection, discussion, and debate.

I hope that the nine concepts presented in this chapter will inspire other architects and designers to incorporate inclusive design in their practice and outlook. When inclusive design becomes natural for more designers, the results will be outstanding.

Notes

1. Safety Codes Council, *Barrier-Free Design Guide*.
2. Alberta Municipal Affairs and Housing, *Alberta Building Code, 2006*.
3. Canada Mortgage and Housing Corporation, "Sustainable Housing and Communities," 3.
4. Canada Mortgage and Housing Corporation, *Pocket Planner*, 4.
5. Newly constructed projects typically represent the nine concepts better than renovations do.

Bibliography

Alberta Municipal Affairs and Housing. *Alberta Building Code, 2006*. 8th ed. Ottawa, ON: National Research Council, 2006.

Canada Mortgage and Housing Corporation. *Pocket Planner: Homes That Adapt*. Ottawa, ON: CMHC, 2009.

———. "Sustainable Housing and Communities—Flexible Housing." In *Canadian Housing Observer, 2012*, 6.1–6.13. Ottawa, ON: CMHC, 2012.

Safety Codes Council. *Barrier-Free Design Guide*. Edmonton, AB: Safety Codes Council, 2008.

Contributors

Tim Antoniuk is an associate professor of industrial design at the University of Alberta and is the owner of ARCHITURE, a micro space design and research studio. Antoniuk co-founded Hothouse Design Studio in the early 1990s and has worked with international design companies such as Droog over the last twenty years. His research and practice have explored the production of morphing or shape-shifting products and interior spaces. More recently, he has worked to improve housing affordability, spatial functionality, and the emotional durability of living spaces through developing highly integrated and physically transformable furniture and living spaces for large multi-unit developments.

Ken Bautista is a co-founder and the chief executive officer of Startup Edmonton and Flightpath Ventures, which work to amplify creative innovation and activate start-ups in Edmonton. He has been an entrepreneur in the technology field for over ten years. Bautista founded Hotrocket and Rocketfuel Games, award-winning interactive companies, and spearheaded community initiatives including TEDxEdmonton and artsScene Edmonton. In addition, he was recognized in *Avenue Magazine*'s "Top 40 Under 40" and was named one of Alberta's fifty most influential people by *Alberta Venture* magazine.

Carlos Fiorentino is a design educator, researcher, and practitioner. He teaches in the Department of Art & Design and the Department of Human Ecology at the University of Alberta and in the Design Studies Program at Grant MacEwan University (Edmonton). Fiorentino is a co-founder of Biomimicry Alberta's regional network, an initiative modelled on the Biomimicry 3.8 global network.

Maria Goncharova is a multidisciplinary design researcher, art director, and educator. She is especially interested in the convergence of ecology, activism, and social structures, creating engaging frameworks and experiences that are socially beneficial and environmentally resilient. With a master's degree in exploring the relationships and impact of active learning, play, and visual storytelling, Goncharova brings almost a decade of participatory design and co-creation experience to her academic and creative practice.

Andrea Hirji is the in-house graphic designer at West Canadian Imaging. She also works as a freelance illustrator with clients around Edmonton, including CJSR-FM 88, Common Ground Arts Society, and 22 Faces. Hirji graduated from the University of Alberta with a degree in visual communication design in 2011. She designs for happiness and explores how design can put a smile on people's faces, one pen stroke at a time. Hirji's website is www.mountpioneer.com.

Mark Iantkow has over forty years of experience in and contributions to the access design continuum. He has worked in middle management with the Canadian National Institute for the Blind and as an access program manager with Parks Canada, developing barrier-free access to national parks and national historic sites. Iantkow has also devoted his expertise to accessible housing, advised on the human rights of people with disabilities, and from 1979 to 2014 was heavily involved in advising on building codes and related regulations for a wide range of disability populations. Iantkow continues his research and theory development on the access design continuum, having completed his interdisciplinary doctoral thesis entitled "Inclusive Design Education of Environmental Designers: A Transdisciplinary Approach," which was partially sponsored by a Canadian Disability Policy Alliance scholarship.

Barry Johns is an architect in Edmonton, Alberta. He was chancellor of the College of Fellows, Royal Architectural Institute of Canada, from 2011 to 2017 and has been a director of practice for the Alberta Association of Architects since 2015. His award-winning career achievements began in working with Arthur Erickson in Vancouver and span private prac-tice, teaching, and public service. He is a member of the Royal Canadian Academy of Arts and was the first international recipient of the Leslie M. Boney Medal (2018) from the American Institute of Architects—where he is an honorary fellow—for outstanding service to the profes-sion. A monograph entitled *Barry Johns Architects* was published by TUNS Press in 2000, and a new e-book, *Beyond Green—Going Nature-al*, is available at www.bjalstudio.ca.

Lyubava Kroll is a visual communication designer, illustrator, and researcher. Her inter-ests include interdisciplinary learning and participatory design as methods to promote social awareness. She has previously worked as a design consultant for the Government of Alberta, the University of Alberta, National Research Council of Canada, Sustainable Waterloo Region, World Animal Protection (New York), and National Dance Institute (New York). Kroll is currently overseeing brand at the United Nations Global Compact (New York) as a senior design manager.

Courtenay McKay is a graduate of the bachelor of design program at the University of Alberta, specializing in visual communication design. Her passion lies in typography and illustration, and her work has been featured in local print publications, around the Web, and in international exhibitions. She currently resides in Edmonton. McKay's website is www.courtenayruth.ca.

Skye Oleson-Cormack is a designer, illustrator, and photographer from Edmonton. She is a graduate of the University of Alberta's bachelor of design program, specializing in visual communication design. Oleson-Cormack has worked as a resident designer at Latitude 53 and photography editor for *The Wanderer Online*, where she ran a series on street fashion that was featured in *Maclean's* "On Campus" and in the *Huffington Post*. Oleson-Cormack is interested primarily in brand and identity design. She draws on a combination of old and new aesthetics by contrasting handmade and digital techniques. Her website is www.skyeoc.com.

Isabel Prochner is an assistant professor of industrial and interaction design at Syracuse University (New York State). Originally from Canada, she lived for many years in Alberta and Quebec. Her research and practice focus on socially and community-oriented industrial design. This includes an emphasis on regional design practice and professional communities, as well as critical and feminist work. Prochner has received research funding from the Social Sciences and Humanities Research Council of Canada, including the prestigious Vanier Canada Graduate Scholarship for her doctoral research. In addition to her role at Syracuse University, Prochner is online editor for the renowned Design Research Society.

Janice Rieger creates cultures of inclusion for accessible housing by teaching universal design, curating inclusive exhibitions, and co-designing inclusive films and products. For her advocacy of people with disabilities, she was awarded a Mayor's Award and a Government of Alberta Award and was recently invited to be the first overseas member of the European Institute for Design and Disability. In Canada Rieger co-founded a national certificate program in accessible housing design, and in Europe she co-facilitated the international doctoral school, Disability Mundus. Her work in inclusive design has led to code, policy, curriculum, and legislative changes in Australia, North America, and Europe. Rieger is currently a chief investigator with the QUT Design Lab and the Centre for Justice and an associate professor in the School of Design at Queensland University of Technology (Brisbane, Australia).

Elizabeth Schowalter is a graphic designer, art director, and passionate communicator. She earned a bachelor of design degree from the University of Alberta in 2011. Schowalter currently works as the director of operations at Berlin Communications, a strategic advertising agency in Edmonton that positions its clients to win on issues of public interest.

Megan Strickfaden is a design anthropologist and migrant who has lived in seven countries. She currently teaches at the University of Alberta in the Department of Human Ecology, Edmonton. As a professor, Strickfaden solves complicated problems for people who live without sight, move around speedily on wheels, and/or process the world differently from the way others do. She has also done extensive research on design education on three continents. Strickfaden uses ethnographic and co-created film to explore with and provoke change. She has directed and produced twenty-one films, including *Light in the Borderlands* (2013), *Dementia Care by Design* (2015), and *Smoke Break* (2019). Her films are used to teach concepts related to caregiving, engineering, nursing, and design in Canada, the United States, China, and Europe.

Tyler Vreeling is an Alberta farm kid turned designer. He is the founder of Fat Crow Design (2007–16), former chair of MADE (in Edmonton), and an *Avenue Edmonton* "Top 40 Under 40" alumnus. He holds a bachelor of design degree from the University of Alberta and has received local, regional, and national recognition, publication, and awards for work produced under his direction. Vreeling has worked in-house and in collaboration with notable architecture and design firms, for some of the province's leading organizations, and is currently an independent consultant at Vreeling Design with an aim to produce meaningful, optimistic, and enduring work.

Ron Wickman is the principal at Ron Wickman Architect, Edmonton. He has extensive expertise in barrier-free design that accommodates the needs of individuals with disabilities. He has a special interest in multi-family housing and urban and community planning. Wickman is committed to providing affordable, accessible, and adaptable housing and has won several housing competitions.

Index